A Country Boy

A Country Boy:

From Sussex to the Canadian West

R. D. Symons

a new memoir

Library and Archives Canada Cataloguing in Publication

Symons, R. D. (Robert David), 1898–1973, author
 A country boy : from Sussex to the Canadian West / R.D. Symons.

(Hagios prairie classics)
ISBN 978-1-926710-24-2 (pbk.)

 1. Symons, R. D. (Robert David), 1898-1973—Childhood and youth. 2. Naturalists—Saskatchewan—Biography. 3. Painters--Saskatchewan—Biography. 4. Ranchers—Saskatchewan—Biography. 5. Authors, Canadian (English)—Saskatchewan—Biography. 6. Game wardens--Saskatchewan—Biography. 7. Sussex (England)—Biography. 8. Saskatchewan—Biography. I. Title. II. Series: Hagios prairie classics

SK354.S95A3 2013 639.9092 C2013-902213-9

Edited, designed, and typeset by Donald Ward.
Cover Art: "Rye (Sussex, England), 1945," Watercolour on paper, 9" x 11", by R.D. Symons. Image provided courtesy of The Gallery/art placement inc., Saskatoon.
Author illustration: Anthony Jenkins, originally published in *Stories about Storytellers*, Douglas Gibson (ECW Press)
Cover Design: Tania Wolk, Go Giraffe Go.
Set in Minion Pro.
Printed and bound in Canada.

The publishers gratefully acknowledge the assistance of the Saskatchewan Arts Board, The Canada Council for the Arts, and the Creative Industry Growth and Sustainability program, made possible through funding provided to the Saskatchewan Arts Board by the Government of Saskatchewan through the Ministry of Tourism, Parks, Culture, and Sport.

Editor's note

In preparing this memoir, R. D. Symons borrowed from previously published works, all now out of print. Brief excerpts from the following works appear in *A Country Boy*:

The Broken Snare (Doubleday, 1970)
Many Trails (Longmans Canada Ltd., 1963)
Still the Wind Blows (Prairie Books, 1971)
Where the Wagon Led (Doubleday, 1973)

In addition, the publishers gratefully acknowledge a grant awarded to J. A. Weil and C. S. Houston in 1997 from the University Publications Fund, University of Saskatchewan, for the purpose of preparing Symons' original manuscript for publication.

HAGIOS PRESS
Box 33024 Cathedral PO
Regina SK S4T 7X2
www.hagiospress.com

Contents

Introduction
by C. Stuart Houston

R.D. Symons played his first role in the Saskatchewan Natural History Society by initiating publicity to protect the then-small and threatened colony of Black-tailed Prairie Dogs. In turn, the Saskatchewan Natural History Society made possible publication of Symons' largest and most important book, *Hours and the Birds*.

In 1962, some ranchers south of Val Marie were determined to eradicate the Prairie Dog. Conservation Chairman R.D. Symons recommended that the Saskatchewan Natural History Society (SNHS) "buy, or encourage the government to buy, a parcel of land to protect a prairie dog town." He and his committee were authorized to take steps leading to a purchase.[1] After further review, Symons proposed that "the Society support the Department of Natural Resources in introducing legislation to afford complete protection to all wildlife in all game preserves, including the township-sized Dixon Game Preserve, which should be posted with NO POISONING signs."[2] In 1963, Bob Symons was empowered "to continue negotiations to purchase, or otherwise acquire control of the grassland quarter containing the so-called 'original' prairie dog town."[3] By October 1964 that quarter was in the hands of the Department of Natural Resources.[4] In 1965, a TV show, "Little People

1 Margaret Belcher, 1996. *The Isabel Priestly Legacy: Saskatchewan Natural History Society, 1949-1990.* Special Publication 19, p. 72.

2 Ibid.

3 Belcher, *Legacy, p. 76,*

4 Ibid.

of the Prairie," was video-taped and shown around the province as part of the Society's publicity of the prairie dog.[5] Symons received the SNHS Conservation Award for 1965.[6]

In 1965, the SNHS "made an unusual financial commitment in agreeing to support the publication by the University of Toronto Press of R.D. Symons's *Hours and the Birds*."[7] The U of T Press then proceeded with its plans. The next year, this "new and costly commitment to the publication of R.D. Symons's *Hours and the Birds*" led to "a long series of negotiations . . . carried on between the author, the University of Toronto Press, the Saskatchewan Jubilee and Canada Centennial Corporation and a special committee of the Executive consisting of Margaret Belcher and Bob Nero. The committee proposed that the SNHS pay $9,000 toward publication by the University of Toronto Press, $5,000 of which would be provided by the sponsor of the Centennial Corporation."[8] Symons' book was the only book which was supported by the Centennial Corporation.[9]

In the Memorandum of Agreement signed 15 February 1967, $5,000 was provided to the SNHS by the Saskatchewan Diamond Jubilee and Canada Centennial Corporation; the latter received 200 copies for Saskatchewan school libraries as a centennial project. In total, three thousand books were printed and sold for

5 Belcher, *Legacy*, p. 262, n 3.

6 Belcher, *Legacy*, p. 85.

7 Ibid.

8 Belcher, *Legacy, p. 89*.

9 Ibid.

$12.50.[10] "The book was thus rescued from never being published. . . . To help the Society recover part of its financial contribution, Symons assigned to it all royalties derived from the first edition and gave it all but two of the 17 paintings from which the colour plates were made. Stuart Houston, chairman of the Finance and Promotions Committee for Hours and the Birds . . . energetically promoted sales. . . . An advance copy arrived by air mail for the annual SNHS meeting on 14 October, and Symons, who nearly missed having seen his work in print, attended autographing parties in November in Regina and Saskatoon."[11]

In 1970, Symons was the recipient of an honorary Doctor of Laws at the convocation of the University of Saskatchewan, Regina Campus.[12] He had also been elected Honorary President of the SNHS for 1970-72.[13]

On one occasion in Yorkton in the 1950s, and twice in Saskatoon in the 1960s, our residence served as Symons' "home away from home." He was a delightful, unforgettable guest. Our four children, affectionately called "his little cabbages," were fascinated by the stories he told about the trials of homesteading. Daughter Margaret Houston remembers going to Sunday morning Anglican church communion with him, where the devout R.D. Symons said: "It's a great way to recharge your batteries." Margaret has quoted that Symons statement ever since. On Symons' most prolonged visit in Saskatoon, he also baby-sat pre-school Don for part of each day, because Don was in bed with mumps.

10 Belcher, *Legacy*, p. 94.

11 Ibid.

12 Belcher, *Legacy*, p. 109.

13 Ibid.

Each of our four children has received a Symons watercolour when they were married, and other family members were also given sketches or paintings. One of the family favourites is a rough sketch of cowboys herding cattle, done with coloured markers on a cardboard box. In a few lines, Bob suggested the motion of cattle, horses and humans; you can almost hear the meadowlark singing when you look at it. Wedding presents to our two oldest children in 1975 from their Aunt Margaret Belcher, were Symons paintings. Marg's prize is the Dolgo crabapple tree in bloom, painted by Symons at Belcher's Holkham Farm south of Dilke during one of the occasions when Margaret Belcher took him there from Regina.

"Bob Nero played an important — literally, a life-saving — role" in Bob Symons' life. Symons was "deathly ill in Regina General Hospital, his leukemia complicated by pneumonia. . . . Around midnight Nero managed to sneak into his room, where he found his friend pouring sweat, but grimly reading the last of the proofs of *Hours and the Birds*. Nero asked how he was and Symons gasped that 'I think I'm going to die tonight.'

'Boy,' said Nero, 'that's what I call a deadline.' "

They both laughed so hard that Bob fell asleep. His "temperature dropped, his fever disappeared, and the baffled doctors . . . were able to send him home a few days later."[14]

A deeply religious man, Symons lived another eight years with his leukemia — he felt that God had given him time to write another eight books, two of which won Book-of-the-Month Club awards. Douglas Gibson served as his editor for some.

C. Stuart Houston, OC, SOM, DLitt, DCnL, MD, FRCPC

14. Douglas Gibson, Chap. 3, R.D. Symons, pp. 43-50. In: *Stories about storytellers*. ECW Press, Toronto.

Part I

Friday's Child (1898 –1911)

Monday's child is fair of face,
Tuesday's child is full of grace,
Wednesday's child is loving and giving,
Thursday's child must work for his living,
Friday's child has far to go,
Saturday's child is full of woe,
But the child that is born on the Sabbath day,
Is bonny and blythe and good and gay.

I WAS BORN ON FRIDAY, APRIL 7, 1898, at Yew Tree House, in the village of Mayfield in the English County of Sussex; the seventh son and the eighth child of William Christian Symons, painter and illustrator, and Cecilia Symons (née Davenport), pianist and composer.

The Symons family are widespread in the West country, particularly in the Duchy of Cornwall as suggested by the spelling of the name, the ancient Celtic language of Cornwall being akin to Welsh and Breton.

The family supposedly owes descent from Sir John FitzSimons of Almedros, who received lands from King John, and who died in 1216. From there on they gradually branched out into the Symons-

es of Hatt, Tregarthen, Tremagne, etc. Our branch lived most of the 16th and 17th centuries at Manuels near the village of St. Columb Minor in Cornwall.

Our ancestor in the direct line of (Mark Symons) moved to Trerice Manor at the end of the 17th century, and Trerice remained in the family until the early 19th century. The Manor house still stands. It is a delightful 16th century dwelling which had originally belonged to the Arundels.

My father's second name, Christian, came by way of an early marriage between a Symons and a Miss Christian, allegedly (and lovingly) believed to be a near relative of the infamous Fletcher Christian of the mutiny on the *Bounty*. Other Cornish names which run like a thread through the family tree are White, Martyn, Pascoe, and Julian. The earliest coat of arms is three Trefoils Or, on a Fesse Sable; the crest, an Ermine; and the motto *Cor nobyle, Cor immobile*.

My grandfather moved from Cornwall to London early in the century, and engaged in a printing and engraving business. While most of his antecedents had been well-to-do yeomen farmers and landowners — real countrymen loving their cattle and crops — there seems to have been an artistic strain in the family, and my grandfather certainly showed this. He evidently prospered, for in his later days he was much given to philanthropy, and among other good works built a row of Alms-Houses in Vauxhall.

My father was born at Lambeth in 1846. He studied art in London at the Royal Academy school (of which he was a silver medalist), and later in Paris. "He made his first appearance as an exhibitor at the Royal Academy in 1869 with a portrait of his sister. He also exhibited at the royal society of British Artists and other galleries including the Goupil, and his artistic activities had a wide range

in figure subjects, portraits and landscapes. In his earlier days he occupied himself considerably with designs for stained-glass windows and later in designs for mosaics. Much of the latter work is to be found in the Roman Catholic Cathedral at Westminster, notably the Great Rood, the chapel of the Holy Souls and Crypt of St. Edmund." (Excerpt from *Hampstead and Highgate Express*, 1911, obituary notice, reprinted in *East Sussex Gazette*.)

Much of his work has been engraved and published, in particular his *Queen Margaret and the Robbers*, mentioned by Beatrix Potter in her journal, on the occasion of her viewing the painting at the Royal Academy in 1888; and which has been reproduced by various publishers of history books and encyclopedias.

But father's great love was landscape and the Sussex rural scene. So we find him, after his marriage, removing to the solitude of a small Sussex village to paint what he loved and raise his family in the manner he considered the most healthy and natural. He had married in 1885 (at the age of thirty-nine) Miss Constance Cecilia Davenport, youngest sister of Joseph Davenport, Esquire, of Wilderslow, Derbyshire, she then being nineteen years of age. Her family was descended from the Davenports of Bramall Hall, themselves descended from Ormus de Davenport (1070).

Joseph (my uncle) spent a considerable fortune trying to prove his claim to the estate of Bramall, lost by the breaking of the entail, but without success. The story is too long to tell here, but since the entail was broken (by will) by a marriage of an adopted daughter to a non-Davenport, the whole affair is the subject of a book.

The Davenport coat of arms was printed in gold on all my mother's set of music, which had been grandfather's. The motto is *Pro Des, Pro Rege, et pro Patria.*

"The crest 'a felon's head couped Proper, round the neck a halter

or' indicates the right of arrest and (in certain cases) execution of captured criminals by virtue of the appointment in 1166 of Richard de Davenport to the Master Forestership of Macclesfield, and of his grandson Vivian de Davenport as Master Sergeant of the Hundred of Macclesfield. Several later Davenports in succession held these offices, which included the capturing of outlaws on receipt of writs from the Crown. There is at Capeshorne Hall a still legible roll of the names of master-robbers who were captured and executed by Vivian and his successors, Roger and Thomas de Davenport."

The famous Elizabethan Judge, Sir Humphrey Davenport, was of this family. The Davenports have left their name in South Africa, Australia and North America; "Sir Samuel Davenport K.C.M.G. of Beaumont, near Adelaide, South Australia, has his descent deduced from Ormus de Davenport, living in the time of the Norman conquest. Davenports in the United States have given their names to three towns including Davenport, Iowa." *(They came with the conqueror* [Burke's Peerage.])

The Davenport family, when not engaged in matters of the estate, or as good Church of England adherents contributing sons to the clerical profession, were extremely musical. My mother's elder brother (junior to Joseph) became professor of harmony at the Royal Academy of Music, contributing several books on musical subjects; while mother (born 1866) was a gold medalist of the same institution, where she studied not only piano but 'cello and violin, with harmony and counterpoint and all else that was necessary for the making of a musical composer. And compose she did — all her life, until her death at 81. She had also a gift for poetry and many of her songs were to her own words, including the little songs she made for each of her children, as fast as they were born, for she had nine between 1886 and 1899 when her last, my sister

Elizabeth Anne, arrived.

My mother had all her babies at home, and years later told me, "I really loved those times, your father always engaged a good nurse — usually a sister of charity — and it was always a lovely rest and I could catch up on reading. When you were born I read all through a history of the conquest of Mexico by Cortez — it seemed appropriate somehow!"

My mother herself was one of the youngest of an even larger family, and so when my Uncle Joseph (my maternal grandfather having died and left him as head of the house), became a Roman Catholic while she was yet an infant, he found it not hard to gather his younger brothers and sisters (as well as my grandmother) into this new fold.

It followed that there came to be several of these who chose a religious vocation: my aunt Rose became a teaching nun at a convent in Bexhill; her younger sister Beatrice, also a nun, died quite young at a mission in the Philippines; and my Uncle Louis became a priest.

My Uncle Frank lived (in my young days) in Baker Street. My mother, on her rare trips to London (I being about six or seven) often took me with her. We were always met at Charing Cross by Uncle Frank with a hansom cab, which were still in vogue. At Baker Street I invariably asked Uncle to show me where Sherlock Holmes' chambers might be. The answer was always the same "Sh — sh! Just above me, but his rooms are enclosed in green baize so as to be soundless, and he comes and goes by a secret way; so you must not ask any more!"

For some years before her marriage, mother had "kept house" for Frank, and she used to tell us an amusing story of those days. Frank decided one day to give a small dinner party and asked

mother to arrange the menu with the cook. Some particular dish required brandy as an ingredient, and cook was told to get this with the other necessaries.

Dinner was set for 7:30. At 6 p.m. all smelt well from the kitchen. The housemaid had laid the cloth and my mother had seen to the silver and flowers. She then went to her room to dress. Coming down about 7 o'clock, she was met by cries of distress, the smell of burning and a savage cloud of smoke. Rushing to the kitchen she found an uproar; the joint burnt to a cinder, the vegetables "caught" and two maids fanning cook, who lay prone upon the floor wrapped in an odour of ardent spirits.

Between them all they managed to get cook upstairs and on to her bed. My mother had just time before her brother returned with his friends to send out a note to a catering firm for a dinner to commence at eight.

Next morning she told Frank he must give cook notice. This Frank refused to do — he was mortally afraid of women — so he said: "*No* Cissie! *You* must do that. Extremely good experience, my dear, in case you ever get married!"

So Mother plucked up her five feet one inch of courage and knocked on cook's door. To the mumbled "wazzer matter?" she entered. Cook's red and bulbous nose peeked coyly above the counterpain.

"Cook" said Mother sternly, "do you realize that you were most disgracefully drunk last night, and I shall have to give you notice?"

"Wuzzat Miss?" inquired cook.

"You were *drunk*" Mother repeated.

"*Drunk*, Miss? *Drunk*? *What* a word for a young lady to use!"

How could mother give notice after that?

On those hansom cab rides to Baker Street, usually in the even-

ing in a drizzle of rain with the pavements reflecting the gas-lights of Victorian London, I could fancy that every hurrying footstep was that of Holmes himself, and the damp, cloaked policeman sheltering in that doorway could, I felt sure, know on what errand the great detective was bent.

Shortly after the cook affair, mother met father. He, for his part, finding himself constrained by the traditional narrow code of West Country Methodism in which he had been reared, had in the 1870s become interested in the movement (current in England then) towards Catholicism, and was received in 1877. Bonded together as my parents were by a common interest in the arts, a common love of the rural scene and village life, and above all by a common faith, they were able to transcend the twenty years difference in age, and certainly I have in my lifetime seldom known any couple who seemed more perfectly to have achieved the ideal married state.

Father was firm, kind, and utterly chivalrous to his last days; Mother, gentle, helpful, and always an inspiration to him and nursing him through his last painful illness with love and patience. Father was wise in keeping the peace and avoiding anything making for annoyance. At table we were not allowed to talk about food. Should one of us find a boiled green caterpillar in his cabbage, this was not to be mentioned but quietly put aside. Had one been swallowed by mistake, we were told that it was simply cabbage in another form. So there was never any fussing. Nor was money, or the price of anything ever mentioned, nor were worn spots in the rug or the absence of anything which other people might consider important but which we did not have.

My father was a man of definite ideas. A true Victorian by birth and upbringing, he was yet a heretic in those days of orthodoxy. An artist himself, he followed Whistler into the no-man's land

of those who differed from the hidebound opinions of the Royal Academy Board. Always a poor man, he astounded his acquaintances by referring to himself as the richest man in England.

Just as today we bow with respect to our standard of living, so in my childhood the national household God was "respectability" — a god to whom, however, my bearded male parent refused to make obeisance. Example: respectability in the late '90s had already drawn up a family blueprint of not more than three children, preferably one boy, a girl, and a boy. My father had nine — he would have been as happy with nineteen — and he and my mother between them handled the nine more easily than any modern couple with one.

Of course, no one had heard of "child psychology" in those days. Frustration was an unknown word. Self-expression was a matter to be approached only by artists, poets, and musicians, and then only after they had passed through the hard but necessary schooling whereby they acquired a skeleton upon which to drape the expressive flesh.

For we youngsters it was early rising; bread and milk nursery breakfast; pothooks and timetables in the school room (the same day nursery so called when not used for games or meals); brisk walks; eat exactly what was put before you, or go without. In a thoroughly disciplined and efficiently managed household, why should it not have been easy for our parents to raise us?

Mother and Father did not have to go into a huddle and worry about why Molly was slow in her arithmetic on Tuesdays; or why Stephen looked with disgust at his perfectly good rice pudding on Saturday. It never occurred to them that the slightest word of correction might mysteriously "hurt" Molly for life; or that Stephen was perhaps "allergic" to rice, and forcing him to eat it might give

him a "complex." (Goodness, reading back, I dimly realize how many new words we have cumbered ourselves with since 1914.) What my father did know was that Molly's arithmetic always improved after he tore her paper across and wrote "rotten — feeble — do it again." Likewise, he usually did not need to step into the nursery and roar (yes, he roared like all proper fathers, be they human or animal) for Stephen to wolf his pudding. As often as not, father's step in the passage was quite enough.

He hated cats. Of course it is a very "bad influence" on susceptible little children for their fathers to hate anything, let alone demonstrate that hatred. But, if our old cat (or some of her numerous progeny) happened to invade his studio, down would go his palette and brush, and seizing one of his numerous swords (always to hand) he would chase that cat down the stairs, slashing away and shouting for dear life – but always missing the target of course. I am afraid I cannot say as much for the banisters. We children used to count the notches on them.

Those swords I must explain, because perhaps my readers might imagine they were kept chiefly for this and other disciplinary purposes too horrible to hint at. In point of fact the "collection" of Indian tulwars, cavalry sabres, Turkish scimitars, and a host of others were simply artist's props — very useful during those periods of financial stress when father had to illustrate stories in the *Strand* and *Wide World* "to keep the pot boiling," as he used to say. He did the work with great enthusiasm. We children often had to sit for him (and later for our elder brother) at a penny per hour with a rest every fifteen minutes. Splendid training in sitting still. Pocket money (other than the above salary) was a penny a week to fourteen, then tuppence. Church was compulsory, and likewise family prayers.

You have seen something of the picture, and now do you wonder that we adored our father? What other children had a father who painted jolly pictures, actually paid you for sitting all dressed up like a Turk, Indian chief, or Zulu — and if that were not enough reward, also told you the story he was illustrating in short, vivid sentences fairly dripping with gore? A father who roared like a lion one minute and chuckled like a Cheshire cat the next; who chased Old Nokomis, the cat, with swords; who never gave the slightest leeway when it came to matters of obedience; who smoked a strong pipe, and tickled you with his beard when he kissed you good night.

You will also have gathered this love and adoration was based on a very firm foundation of respect. And, of course, Father was a *father*. Not a pal. He never tried to be a pal — thank God.

Mother played Beethoven, Chopin, List, Frank, Schubert, Mendelssohn, and Grieg. We did not know we were being educated; we just drew in music with our mother's playing. We did not know we were being trained in good manners. We just knew we had to sit still and not interrupt the music by talking. We loved those evenings then. Thanks to them, I love music and know how to listen to it now.

Family prayers followed. We did not know we were being taught religion. We just knew about God in a perfectly natural manner. Then, back to the nursery and bed, after which Mother read from the current book. When very small, of course, we had *Just So Stories* and *Alice* or *Hans Anderson* (I still read *Gerda and Kay*). Thirty years later I found I could tell all the *Just So Stories* to my children by heart in almost the original wording. Later, it was Scott, Dickens, Stevenson, and Cooper. In this way we have gone through *The Antiquary*, the *Last Days of Pompeii*, *David Copperfield*, *Treasure Island*, the *Last of the Mohicans,* and *Handy Andy.*

At seven, we were judged to have come to the "age of reason." It was a great event and heavy duties were laid upon the initiate. Perhaps the most important one was the compulsion to write or illustrate, once monthly, in our family journal, *The Hornbeam Magazine*. The magazine was a monthly one, given to Father and Mother on the third of each month. In mid-December the twelve issues were retrieved from Mother's room and bound in gay red and black (using a brand new coloured frontispiece) as an annual. Thereafter, it took end place in the snug row of its older brothers on a shelf by Mother's bed.

Frontispiece artist was Mark Lancelot, later an artist; the editor was Dom Thomas, later a Benedictine monk, and of course he handled the leading articles as well as musical and ecclesiastical subjects. Bookbinder and printer (copper plate pen and ink) was William Christian Jr., who was also the authority on mechanics and reviewed all new internal combustion equipages. Sister Molly did recipes, holiday poems, and watering places. Authority on angling, bicycling, and kindred subjects was Stephen White, later an engineer. Specialist in mammalogy and painting was James Anthony. John Martyn explained all military matters.

I myself contributed bird lore with extensive and colourful drawings, also essays on how to grow turnips and the points of Wyandotte's poultry.

The youngest of all, Elizabeth Ann, contributed verse and fashion drawings.

There you have us. As we used to sing it, "a rare old, fair old, rickety-rackety crew."

We had a great many duties. As Christmas approached we gathered tons of holly leaves and berries and under Molly's supervision we threaded them into great boas to criss-cross the dining room

ceiling. Night after night we pricked our hands to the steady reading of *Barnaby Rudge* or *Bracebridge Hall.*

Mark also took a shot at Sanskrit and the Indo-Aryan languages. Father was a stickler for proper phraseology and very often pointed out the origin of words (especially old Cornish words which he loved, being himself a Cornishman.) This fired Mark's imagination, and he was forever rushing off to find the meaning of words and trace their "root."

We all painted, more or less. I was allowed a corner in Father's studio to paint my birds. Father did not know an awful lot about birds, but he knew drawing, and if mine did not pass muster he wasted no time in polite comment, nor did he try to find something encouraging to say. "Oh no! What kind of mess is this?" he would thunder and trample the offensive thing under foot just like one of Kipling's elephants. "Use your eye – and your pencil, man," he would add, "like this," at which he would grind his thumb on to his palette (it didn't matter what kind of paint) and with a few strokes — on the floor, on the wall, once on my pinafore — there would appear a bird full of life and zip.

Father had definite ideas as to what was worthwhile and what was not. A true romanticist and a tender husband and father, he loathed sentimentality; he hated falseness; he detested show-offs. He could love a craftsman, a hedger, a ditcher, a wheelwright. I have seen him shake his head over a well-turned furrow or a well-tied sheaf – "By the Lord Harry (his favourite expression), there's art for you." He hated "gentility" and "refinement" – "no gentleman is refined," was one of his sayings. He hated Mammon; money was a forbidden subject. "I don't care a tinker's cuss — we wondered what that was but it sounded exciting — I don't care a tinker's cuss if any of the family make any money or not; it's doing things that

matter and the best things aren't done for filthy lucre."

Don't fear, Father, *none* of us has made any money.

He hated factory made or ready made things. We were not allowed to buy anything we could make. The result was we all learned to use our hands. Not in one way only but in many ways. We all made our own Christmas, Birthday, and Easter Cards (I still do). We all made our cowboy, or Zulu and Indian costumes, and Father saw to it they were made properly. It was not enough for me to make a war bonnet of turkey tail feathers; I had to get down *Catlin's North American Indians* and choose whether I wanted to be a Blackfoot, a Pawnee, an Onondaga, or a Huron.

We did not know we were being educated in attention to detail, in proper handicraft methods, in the knowledge of people in distant lands, but we were.

We had our debating society, which discussed everything from growing peas to the value of machinery to the Central African.

We had our police system: a judge (Mark); prisoner's counsel (Dom Thomas); and executioner (Will); authorized to give us up to six whacks (over six was Dad's job) or deduct fines from pocket money. Having many times been prisoner at the bar, I have no complaint insofar as justice is concerned.

Father believed in getting information from source. Once he had to illustrate a book on ships called *Britain's Bulwarks*. The publishers chose Father because of his knowledge of ships of all centuries and riggings, and suggested that he might consult a certain reference book to refresh his memory. That was not good enough for father. Off to Portsmouth he went for two weeks. I have some of his pencil sketches of block and tackle and hawser eyes today. They are priceless gems of craftsmanship.

Similarly, I wanted to trap moles. Father found me reading

about mole trapping in a boy's outdoor book. "Don't just sit stuffily reading," he roared. "I'll have no dilettante amateur here. Off you go to Old Crittenden and trap moles with him or else you can weed the garden." You will have gathered that we learned to take rebuke without sulking. "Thank you, sir," said I, and was off.

Talking about moles, my mother had left to her by a rich sister a lovely moleskin jacket. One day she said to Father, "Wouldn't a moleskin hat look nice with this – you know, one of those round flat-topped Russian things?" "Oh, Molly can make one," said Dad, and Molly did. I trapped the moles with three traps borrowed from Old Crittenden; John skinned them; Jim tanned the skins; Betty got a pattern from a friend of hers and made up the silk lining; and Molly assembled the whole. It was our birthday present for Mother that year and one and all voted it the most splendid piece of head gear ever turned out by the firm.

So, in this fashion, we found out what we wanted to know. We learned to make contacts. (It wasn't easy to ask Old Crittenden for traps — he was a crusty old boy.) And, above all, we learned to do things for others.

Father never started us on anything. If he helped us at all it was to finish a thing and then chiefly by telling us how to find out the way to finish it. He never tried to save us from difficulties. He blandly saw us get into them and stood on the sidelines. I am sure he felt confident the training he had given us would come to our rescue, and usually it did. If a scheme failed he would say "that's excellent. We build success on failure, you know." Another of his sayings was, "Of course, any decent man has enemies; show me a man today, or in history — a man worth his salt — without enemies."

Neither were we taught good manners – we lived them; nor grammar – we talked it; nor English Literature – we read it.

Sweets were rationed very strictly: more than two chocolates at a sitting made you a "pig." And we never got vitamin pills, orange juice, or crispy crunch, or pop-crackle-snap, or ice cream; and don't think those things didn't exist in those days, but they were considered trash. "Refined" people ate them — the nouveau riche — not people of good family.

My father was rich by virtue of a very old natural law; a law reiterated some two thousand years ago in the words, "give and you shall receive full measure and running over." My father gave. He gave up fame as a painter of well paid "society portraits," as well as popularity, to paint what he felt impelled to paint.

I am glad my father didn't live to see the welfare state, or hear the spokesmen of security. He would have roared, "What the hell do they mean by security? We all have to die, haven't we? Where is the fun in life, where is the adventure, if you know everything is going to be alright next year — which it won't anyway?" Father did better than the state can ever do. He *built* security into each of his children. He taught us the dignity of all and any work. He taught us to work for a pittance if need be and not envy the less capable fellow who was making the fortune. He taught us to rise above circumstances. To "walk with Kings nor lose the common touch." To see our best work destroyed by boorish hands and yet take heart and rebuild. He taught us to forgive and, above all, he taught us to realize that because of God we could be dead yet living, scorned yet loved, poor yet possessing all.

SOON AFTER I WAS BORN the family moved to Robertsbridge, a good deal closer to Hastings. My earliest recollections of that village are the rather ugly, fairly modern house, with its bourgeois vestibule smelling of mackintoshes.

I remember being taken for walks with the other younger children, by our nurse-governess, Miss Power. There was a railway line, and we used to try to get to the crossing as the afternoon train went by so that we could see the gate-arms slowly lower themselves to bar the way, while on either side farmers in gigs and a few pedestrians and bicyclists would come to a standstill. Then along would come the puffing engine with its attendant train, and what a fine sight *that* was.

Beyond the railway the road went between high banks where we would scatter out to pick violets and primroses. Often we searched in the bottom of the hedgerows for coloured snail shells. We like the striped ones best. They looked like bullseyes, our favourite sweet.

In the autumn, when the leaves had fallen, we looked for old birds' nests, and once found what we thought was one but with no apparent entrance hold. We showed it to a passing shepherd who declared we had found a "dormer," and opening the tight little ball of fine grasses showed us the little dormouse fast asleep and actually snoring softly. We took it home to wake it up in the warmth of the nursery, but Father said that was not kind, so we wrapped the creature again in his winter bed and pushed him down among the dead leaves at the base of our own garden hedge.

More often we would find a dried and discarded boot, and for some reason this had always belonged to a mysterious "Gipsy Smith" who seemed to have left his sign all over Sussex.

And once too, I, roaming ahead of the others, came face to face with a brown-skinned young gipsy woman, her full breasts exposed as she suckled her infant. She sat, dappled with light and shadow, her feet in the ditch. Beside her, among the campion and ragged robin and foxgloves, lay couched a lurcher who raised his

head and pricked his ears at my approach. Miss Power took me by the hand and turned me around, tearing my spell-bound gaze from the scene of rustic motherhood.

On Sundays we went in hired cabs to the little Catholic Church at the market town of Battle, a few miles away. The parish priest was Father Wilhelm, a stout man who spoke in German gutturals and who was the kindest and most Christian of men.

He often came for Sunday lunch, and it was on one of these occasions that I, having been sent from the dining room for my afternoon nap, lingered at the foot of the stairs to hear the conversation through the half-open door. I stood near the tall grandfather clock in the hall, and on a sudden impulse I open its front, stepped within and snuggled down. Above my heard were the ropes and lead weight which activated the machinery, and soon the tick-tock of the heavy pendulum lulled me to sleep.

I awoke suddenly to a great hullabaloo, my name being called all over the garden, and footsteps all around. Terrified, I kept still as a mouse. Then suddenly the clock-door was snatched open, and Father's hand had me by the scuff of my jacket. I heard Father Wilhelm's booming laugh and Mother's small cry of, "Don't hurt him, Will."

In 1905 the family moved again, this time to the town of Battle itself. Our home, 22 Upper Lake, was not far from the Abbey built by Duke William on the supposed site of Saxon Harold's death. When taken — we younger fry — for our daily walks, we often voted in favour of a footpath which followed part way along "that dread ditch," the brook called Senlac; where the battle was joined which would forever graft the Norman speech on the blunt Saxon of Sussex, and the outcome of which was to ensure that I should be born in England rather than France.

My education had now started. Thanks to Mother's reading

aloud when we were very young, I could already read with ease at seven and immersed myself in Charles Waterton's travels on the Essequibo and other streams of British Guiana, a study much enhanced by the fact that the grandsons of Charles lived not far away in a house replete with his trophies, including many cases of birds stuffed by himself and ranging from tiny hummingbirds to a large King vulture. To this house we were often invited to tea, at which times I drank in all these tropical beauties.

Our schoolroom was on the lower floor of the Georgian house on Upper Lake, the window facing on the pavement screened with wire mesh for privacy, a mesh which was excellent for sharpening pencils if one could manage that job without detection.

Our eldest sister, Molly, was our chief instructress, and in my recollection maintained discipline very well. At mid-afternoon recess we made toast at the fireplace, using a long toasting fork, and this toast we would liberally spread with that delicacy, beef dripping with a pinch of salt.

Of my elder brothers, Mark, at the Slade School of Art had in this year taken most of the prize money; Philip, having indulged his love of music to the extent of obtaining his Associate of the Royal College of Organists, now went to Downside as a postulant of the monastic life; and Will and Stephen went daily to what we would now call High School at the Servite Brothers' establishment at the other end of the town.

As I have mentioned, ours was a rather lovely three storey Georgian house, and I think Mother really enjoyed her big drawing room where her good Collard and Collard piano stood. The schoolroom piano was not a patch on it; as was easily heard when both were going at once, as they often were.

It was in this drawing room that Mother's evening concerts were

held. And it was in this drawing room, in an alcove, that my prized possession — an ostrich egg given me by Mr. Selous — hung in front of the mirror, which is seen in Father's drawing of Grandmother's room at Church Row, Hampstead.

About the concerts, which were weekly affairs conducted by Mother, Philip (when available) or sometimes Molly, played the piano, Father the flute, Mark the cello, and a young Frenchman (in England to learn the language) the violin. When two violins were required Mother laid aside her baton temporarily, and later Jim took up the clarinet. The young Frenchman's name was André something or other, and we all adored him.

Mother gave a monthly dinner party, usually to artistic friends from London. There would be the singer and music critic William Shakespeare, my poet cousin Arthur, and several painters – John S. Sargent, H. Brabazon, Augustus John, Aubrey Hunt. Sometimes a local lawyer, Mr. Raper, would come, and children greatly admired his great beak of a nose, almost meeting his chin, like De Aquila in *Puck of Pook's Hill*.

We children all met there for half an hour, after our schoolroom "tea" and before their dinner. We were hugged, teased, and made much of. I remember sitting on John Sargent's knee, and being allowed to inspect Mr. Brabazon's gold tooth. Then we were packed off to bed from Jim down the line through John and myself to Betty. How we longed to be allowed to stay up like the older ones!

I would always find it hard to go to sleep on these occasions, and would often creep out of bed to sit in my nightshirt near the top of stairs, from where I could see the doors of both the drawing and dining rooms. The maid, on her frequent calls to the latter, would leave the door open, and I would catch glimpses of the figures around the candle-lit table; my father at the head, his beard neatly

trimmed and his white shirt front gleaming; my mother with her hair beautifully dressed and her shoulders very white against the dark low-cut evening gown; the rest of the company equally handsome and dashing, the conversation sparkling with wit, the full wine glasses glowing like rubies.

Sometimes the maid, seeing my small face pressed against the banisters, would pass up to me a part of a left-over, a chicken wing or perhaps a bit of cake, and say kindly, "There now, master Bobby, be a good boy and go to bed, do."

I could hear chairs moved back, then see the ladies cross the landing to the drawing room, while the smell of cigar smoke and little gusts of laughter would come from the men as they sat over their port, until the time came and they too would rise and cross over.

Soon, from the drawing room would come the music, Mother playing first – *The Moonlight Sonata*, or *The Pastoral Symphony*, and for an encore a waltz or ballad of Chopin's, or perhaps a bit of Grieg.

And then came the tuning of stringed instruments and there would be a trio or even a more ambitious venture. I always hoped for at least one movement of Schumann's *Carnival* and was seldom disappointed. Then would be songs. Father had a fine baritone voice and often sang one of Mother's own compositions such as "The Time of Roses."

And I sitting on the stairs, the smell of varnished banisters acrid in my little nose, would listen and cry, cry and listen, for I was in the seventh heaven and the beauty and longing of the music affected me as it does today, and as many other things do, such as the smell of wild roses on a June evening, or the words of St. John when he writes of the New Jerusalem where there shall enter no

evil thing, nor sorrow, nor pain.

Battle was the habitat of one of the last of the fox-hunting parsons. He was the rural dean, and we often saw him, bearded, bestocked, and be-hatted, riding his fine hunter down Upper Lake on his way to a meet. Before his departure for Downside, Philip had permission from the dean to practice on the organ in Battle church, and we younger ones earned pennies by pumping for him. I well remember one embarrassing occasion when Jim and John came down the nave talking quite loudly and about to put on their caps, at which moment the dean entered and very quietly and courteously reminded them that they were in God's house. We boys blushed with confusion, and I am afraid that the lapse of good manners probably had its origin from our often having heard it said that the Protestants had "stolen" these churches from the Catholics in reformation days, and from that deduced they were no longer proper churches — an expression I heard from my own brother Stephen forty years later. Indeed, Pope John was late a-coming.

I remember, too, the cattle market near the Abbey Square, of which I have a water colour by Father; and of course the annual Fair held on the square or green itself. We children went en masse with Father and (usually) Father Wilhelm, who treated us to cocoanut shies at poor "Aunt Sally" as well as rides on the round-about with its glittering lights, gilded steeds, and clashing Spanish music.

I longed to stray, to lose myself among the rough carters, the shepherds, the cowmen; longed especially to walk and talk with the gypsies in their moleskins, and their gold earrings just glimpsed in the tangle of their dark curling hair. But straying was not permitted, and I must keep with our respectable little upper-class party; and twist my little head around as I would, these people on whom

I feasted my eyes soon moved beyond my vision. Sir Alfred Munnings may not today be considered a very able artist, but I shall bless him forever for his paintings of the Romany people and the Romany horses.

Being always a lover of animals, three recollections of Battle have remained very clear in my mind. One was the annual visit paid to the town by a lithe, dark Italian, complete with hurdy-gurdy and monkey. The little monkey, dressed in a braided jacket and wearing a pill-box hat with a chin strap and feather, would climb right up the house front and present himself at the nursery window holding out his tin cup for pennies. Father liked the hurdy-gurdy and its smiling, mustachio'd owner, although if a more modern barrel-organ came too close to the house, he usually sent a servant with sixpence to persuade it to move on.

Even more exciting (but it only happened once) was the appearance of a huge bearded man, lacking one arm and dressed in a Russian soldier's greatcoat (of the type we saw in illustrations of the Russo-Japanese War then in progress) who came leading a large brown bear on a chain. This man had some sort of a stringed instrument slung before him, to which the bear, having been prodded with an iron-tipped staff, danced on his hind legs in slow circles, looking supremely bored. This may have been the last of the dancing bears as depicted by Hogarth, which were such a common feature at fairs in the 18th and early 19th centuries.

Lastly, when taken to a travelling menagerie, we boys, while admiring the somnolent "Nubian Lion" (probably from Kenya), noticed some village boys trying to rouse him by throwing sawdust at his eyes.

After taking this in patience for awhile, the lion slowly rose, reared up facing the crowd with his great paws against the bars,

and solemnly voided an evil-smelling stream which struck directly on its tormentors amid the plaudits of the more fortunate; after which the King of Beasts settled once more to his repose.

About this time Father commenced his work at Westminster Cathedral, and had to make many trips to "town." Very handsome and King Edwardish we children thought him as he left by cab for the station resplendent in glossy silk hat and well-brushed morning coat.

That same top hat once became the cause of another childish downfall. Father had left his hat and cane and gloves on the heavy oak chest which stood in the hall while he went upstairs for some final words with Mother. It so happened that I was lingering idly in close proximity to temptation. The maid, who had been "doing" the hall fireplace, had been summoned by bell to the kitchen and had left her black lead and her brushes behind. On a sudden impulse to improve the hat's gloss I seized those brushes and the blacking and went to work on my father's crowning glory.

Once more I seem to hear Mother's plea not to hurt him! Father entered the cab wearing a bowler.

Sometimes, when Father was away for a week or more, Mother would take me (or some other child) to visit him at his studio, and on these occasions we invariably stayed with my godparents, Robert and Agnes Le Brasseur. Agnes was an old school friend of Mother, they having both attended a convent in Dieppe.

Robert Le Brasseur was a solicitor and connoisseur of the arts. He owned probably the largest and finest collection of Father's work. The family lived at 63 Belsize Avenue, Hampstead, a big brownstone house of innumerable rooms.

It was a great joy and a treat to stay with these charming people.

The eldest son, Jim, was reading law, and we did not see much of him, but Raymond was about my age. There were also Marjorie (who my brother Stephen later married) and Helen, who became a Carmelite.

Their broad staircase, as well as the hallway and library, were hung with fine paintings, and objects d'art adorned the drawing room, which looked immense and airy. At Christmastime my godmother always sent us a large hamper of good things from Buzzard's emporium, which included pain d'epice, marrons glacé, French nougat, Chinese ginger in syrup (we kept the delightful little pots) and candied fruits of all kinds. I sometimes received from her similar hampers (they were of wickerwork) when in Canada, and to a homesteader this was heaven indeed, though my young bachelor neighbours made sad havoc among the delicacies!

The Le Brasseurs were Channel Islanders on both sides. There was something very elegant and French about their ménage, including delicious food prepared by her Swiss cook. Indeed, most of her servants were Swiss Catholic girls with whom Godmother spoke in easy French; for of course, this was another Catholic family, but rather of the continental persuasion than the more intense English-turned-Roman.

Like so many women of her class and day, Agnes Le Brasseur sparkled with wit and talent, while at the same time being almost completely ignorant of the business world. A story going the rounds of the family at this time will illustrate this. It seems that my godfather, tired of being asked so often for money, called his wife to him and addressed her as follows: "Agnes, you seem to have little head for money. I think you will be able to keep your accounts more accurately if I were to give you a reasonable allowance for your expenditures over and above the monthly bills.

"Now, I know you have refused this in the past, since you find it easier to come to me — often at the most inconvenient moments — and obtain your requirements in cash. However, I have — today, it being your birthday — deposited such and such a sum to credit at the Bank; and a like sum will be deposited monthly hereafter.

"So here is your cheque book and your bank book, and I want you to pay for your personal purchases by cheque only. Fill in the blanks, showing date, amount, and details of each purchase. In this way I hope you may learn to keep your needs within a fixed budget. Do you understand, my dear?"

"Why, of *course*, Robert, that will be *so* convenient and easy! I'll go shopping this afternoon!"

"Humph," said Robert.

At the end of the month Robert called Agnes to the library. "My dear" he said, "the bank informs me that you have overdrawn your account, and I have to make it good. *Really*, you must be more careful or the whole object of your allowance will be meaningless. Please be more careful in the future."

Agnes thought silence was best, so she gave him a kiss for an answer.

Another month went by. Once again Agnes was overdrawn and her husband spoke severely.

"Oh, but Robert," replied Godmother, "I know I haven't overdrawn and I can prove it."

"My dear," reproved Robert, "banks can't afford to make mistakes. No, the fault is yours, and you will have to be more careful."

Agnes rummaged in her big purse, then, "Wait, Robert," she cried, "here! Here's my cheque book and – see? – why there are two, three, five cheques still left!"

THAT MY GODMOTHER WAS EVERY INCH A FRENCHWOMAN may be seen by another incident which happened some years later. My father was lying seriously ill and Agnes had come from town to help Mother. She arrived by cab from Rye Station in her usual flurry of silks and heavy furs all scented from the bunch of sweet violets she always wore, and surrounded with baskets, boxes, and portmanteaus. She gave me a big hug, nearly smothering me in her black fox muff, then pushing me away and folding back her veil, produced a large florist's box full of gorgeous tulips. "Come along Bobby" she cried gaily, "*you* are to help me with the flowers. Bring your mother's big bowl, the one with Chinese dragons."

I fetched the bowl and some water and watched Godmother arrange the blooms. With her long beautiful fingers she coaxed them to her satisfaction, straightening one here, inserting another there, the sunshine through the window flashing tulip red from her rings.

I said, "*Aren't* they beautiful tulips!" and Godmother replied "yes indeed *mon enfant,* but you might have been more chivalrous. You *could* have said the tulips are nice but not half so beautiful as *your* two lips!"

Godmother's house was the scene of many a gay and delightful party. All sorts of young people gathered there, as well as many interesting personalities in the world of the arts and the state. I remember Du Mauriers (George's family, I think) and Warwick Deeping the novelist, and several of the Mandys (Godmother's family), one of whom had been with Cecil Rhodes and delighted us with stories of the Transvaal and the unfortunate Jameson raid; although we never quite knew whether he had been a participant in that action or not.

Mr. Le Brasseur was a member of the Zoological society, and

this meant he could take us to the Zoo free of charge on Sundays. Here I began to get acquainted with tropical birds, African crowned cranes and the various parrots, cockatoos, and macaws which sat on their perches in the open air, screeching shrilly as I attempted to draw them.

I did not like monkeys; their eyes were too sad, as if they could almost reason, but not quite.

Seeing all these first made me long to wander far afield and see strange things. Africa was first on my list then; and strong fuel was added to this burning urge by listening to the yarns of that doughty hunter Frederick Selous, who would visit with family between his safaris on African game trails.

How those early memories crowd forward and demand to be told!

The lights of London town! The wet pavements, the rumble of four-wheelers and the lighter whine of a hansom cab, the driver like a ship's captain on his bridge, water streaming from his hat and whip a-tremble!

Pantomime! Puss in Boots! Cinderella! Laughter! Little girls in curls and sashes! Too much cake. Ices on frosty plates. A gleam of sunshine at St. James. The Horse Guards. A flower woman, all be-shawled at Piccadilly Circus. Crying her wares on a pale April day. You could smell them. Primroses! Fresh from country lanes, sent before dawn on the milk-train! In bunches. Even a child felt a heart-tug at the leaf-mould smell – Sussex smell, it was. The tightness of an Eton jacket. Cold fingers re-fastening the collar you had loosened, for your throat was pinched.

There goes the Portuguese Ambassador! Senhor something-or-other. Glossy horses, their hoof beats dull on the wood-block street. Liveried and powdered coachman. The coat of arms of our

oldest ally done in gold and black and red on the closed carriage.

We looked for suffragettes tied to railing and were disappointed to find none. Sitting by the serpentine, watching the ducks and the great white swans. Nannies flirting with red jacketed guardsmen or tall policemen.

The Bandstand hung with Union Jacks; the band blaring forth "For He is an Englishman," or "Every Step with Caution Taking."

Little did we know that in less than a decade all this would pass away and the Edwardian age perish as a tale that is told.

AND SO BACK TO UPPER LAKE, Battle, and back to the schoolroom.

In August our quiet market town usually suffered an invasion of "trippers" come to see the Abbey. Many of these people were Jewish, mostly young girls, in parties which I suppose were given the trip by some society, and the balance of the year presumably saw them in London's East End, and perhaps they were not all Jews, but were so-called by the servants; and to we children reared among the flaxen-haired South Saxons these girls, with their bright clothes, dark liquid eyes, and curling tresses were as foreign and romantic as if they came from the South Seas.

Once Father heard us say "Jew girls" as a laughing little group passed by the house.

He did not rebuke us directly, but quietly sat down and gave us a brief history of the Jewish people, and how they were still God's chosen, and how Our Lord had been of their race; and so, without giving orders, he left something with us which never permitted us to speak loosely again of another people.

We were now much closer to Church, and Mother was asked by Father Wilhelm to take charge of the music and the choir. Mother had composed several masses, and on Easter Sunday, 1908, one

of these was first sung. Anyone who has done this sort of work will appreciate the amount of tact required to deal with aspiring members of a choir. There was one young lady who out-sang all others in a high tremolo shriek — like a peacock's — and she quite exhausted Mother's patience. It led to a minor spat. My mother felt quite conscience-stricken, and suffering from scruples, endeavoured to confess her sin of allowing duty to music to interfere with Christian charity.

Father Wilhelm always heard confessions for half an hour before mass, but very often found himself hard put to accommodate all the penitents in so short a time. He therefore, when Mother presented herself, told her to omit the "Confitior" and "get on with it."

Mother began to tell her little sins, but the good priest cut her short with a question of his own. "Do you take good care of your children?" he asked.

"Of *course*" said Mother.

"Do you take good care of your husband?" the priest went on.

"Why, of *course* I do" she replied, this time quite indignantly.

"Go in peace, daughter, and pray for me," said Father Wilhelm, who quite obviously knew her voice.

"Thereafter," said Mother, telling the story years later, "I remembered to avoid scruples and if any choir member didn't come up to scratch I knew what to do."

My mother was of necessity a woman of many parts. Although immensely dedicated to her music — she practiced at least two hours a day and composed in the evenings — she had to supervise a large household, and this included a good deal of dressmaking. Each spring and autumn several days were given over to this passion. First, the draper would arrive with samples of cloth, in par-

ticular black material for the maid's afternoon uniform and pink or blue print for mornings, for in those days servants were dressed at the expense of their employers, although expected to help in the actual cutting-out and sewing, and Mother had to show these (usually) raw Irish girls how to baste and stitch. So the sewing-room would hum with activity, my mother usually on her knees at her dress-form (known as Mrs. Grundy) with her mouth full of pins, and a tape measure draped over her shoulders.

Mother was also a good nurse, who could whip up a mustard plaster in short order. Father, toward his latter days, had several illnesses, and as a consequence Mother was much at his side. During the South African war he contracted pneumonia, and a Sister of Charity came to nurse him. This woman, of Dutch origin, was on the side of Boers, and would greet Father in the morning with some news of British reverses. Once it was "the Boers haff had a great victory, and General Bullar iss kilt!" These remarks, Father said later, encouraged his will to live, if only to get strong enough to answer the sister in kind!

I myself was given to bronchitis, and it was Mother who sat up with me at nights. I would wake up trying to cough, with my chest so painful, and see her start from her chair, trim the night-light, and then her arms would be about me, and she would lift me to let me sip a glass of barleywater poured from the big glass jug in which half lemons bobbed like abandoned boats. The room would smell of camphorated oil, for a flannel soaked in this healing unguent would be taped to my throat and chest.

When a serious illness struck a household, it was customary for the County Council to spread tan (the residue of oak bark from a tannery) on the street in front of the afflicted house. I well remember this being laid down when my father was ill. People had

enough sense in those days to understand that an ill person wants, above all, as much quiet as possible, and the tan — or sometimes straw — muffled the sound of horse traffic very effectively.

People were very generous, and on such occasions many delicacies to nourish the indisposed would arrive: a nice piece of venison from Mrs. Woodcock in Scotland, or a brace of grouse; jellied chicken from Mrs. Wallace; or hot-house grapes from Lord Ashburnham.

That fine old gentleman was a Catholic and the chief patron of the little chapel at Battle. He engaged Father to paint his portrait, which meant that Father must go to Ashburnham Place once a week for sittings. The old lord would put his coachman and carriage at Father's disposal on these days, and I was sometimes taken, very much in awe (at first) of the grand coachman with his mutton-chop whiskers and top-hat. At lunch a footman would attend — equally grand — and after the meal, while Father painted, this splendid personage would be directed to take me into the grounds. He would take off his coat, fold it carefully before laying it down, and play catch ball with me in his striped waistcoat.

The grounds were lovely, with acres of smooth, rolling lawns dotted with trees, mostly single specimens like the great monkey-puzzle tree from South America, as well as Canadian maples and American sycamores, while here and there were great clumps of rhododendrons and beds of hydrangeas.

I have one of Father's water colours of a garden party at the place, done about 1907, which shows a delightful variety of ladies' hats, such as I have never seen since, except in such films as *My Fair Lady*. Many of these were trimmed with stuffed birds of paradise, or several tiny humming-birds, as well as ostrich plumes and flowers of every variety, set off by long feather boas and trailing gowns. How gracefully did the women of those days grasp their

skirts by the side and lift them as they moved from group to group, chatting, smiling, twirling their fringed parasols.

But it was the stuffed birds which fascinated me, and once, caught staring at Lady Webster's hat and being corrected, I said quite loudly, "Oh, it was the lovely bird I was looking at."

I suspect Father had a good many lady admirers among people whose portraits he had painted. One was the Baroness Von Rhomer whom Mother liked immensely, but of the others — especially one titled society person — she had but a poor opinion. That particular lady was, Mother thought, "common," and that, for Mother, was stern condemnation. She did not care for the aristocracy, and later on blamed Edward the Eighth's defection on "common, fashionable people with too much money and no purpose in life."

In 1909 the family moved again, this time to a large rambling farmhouse in the village of Udimore, on the road from Rye to Hastings; only a bare three miles from that famous old port long since abandoned by the sea and visited only by fishing-boats. The local legend concerning the village's name is that when the church was being built it was first located on the marshes of Brede valley below the ridge upon which it now stands. But each morning the workmen found their previous day's efforts torn down and the stones scattered. One night a watch was kept, and what presumed to be heavenly voices called out "O'er the mere! O'er the mere!" Taking the hint, the builders carted the material up to the ridge, and here the church was built without molestation. Since then the valley has been under flood a good many times.

It was many years later that I realized that the move to Udimore was made chiefly for financial reasons. With the rise of photography for portraits, scenes and illustrations — these latter being a major source of income — artists were having a hard time of it,

and Father's earnings suffered accordingly. He still painted some portraits but exhibited less, for showing cost money. The artist whose work passed the selection committee of the Academy had to go up to town for "varnishing day," and railway fares and hotel bills took ready cash, while perhaps the picture remained unsold.

In addition, Father's long bouts of illness were a drain on resources, while at the same time the growing family required more and more expenditures for clothing, food, and education. Years afterward, when she was 80, Mother told me something of this and of how, when leaving Battle, Father had barely enough cash to finance the move and none left to pay off some of the heavy bills for doctor's fees and stores.

But apparently, not having an ounce of false pride, Father arranged a group of paintings in the drawing room and invited his creditors to come and take payment by choosing from the selection, and it speaks volumes for the respect and liking in which he was held that the butcher, the grocer, and several professional men met together and, while Mother bravely served afternoon tea and played for them, they made their selections and relieved Father from the shame of debt.

Artists had done this before. One calls to mind the story of Whistler, who having replied to his tailors' demands for payment by offering them a painting, was informed by them that they did not ask for a *Symphony in Blue* or a *Nocturne in Silver*, but for a settlement in black and white.

So the great horse-vans came to 22 Upper Lake and all the fine old furniture, now showing wear and tear; the big four-poster bed (on the back board of which Father had painted a scene); the rugs which were showing worn spots but were still far better than more modern ones; these and much more loaded up, the carters called

"Gee-hup — *way*" and "come'ee *over!*" the horses leaned into their collars, and the heavy wagons took the long road lying white and dusty in the heat of summer. We children watched them go, carrying all our dear household goods away to a strange country. Each of us had in turn been born in that great bed, each of us had knelt before that carefully-packed crucifix, each of had practiced our scales on that old schoolroom piano; and we had to follow.

Will and Stephen had made friends with a family called Kemp, who owned a gypsum mine not far from Battle. The manager was Harry Kemp, and the supervising engineer was his brother Louis. Harry was married, and they lived together in the firm's modern bungalow among the healthy larch woods in which the mine was situated.

These very up-to-date people owned one of the new motor-cars, a Renault, done in bright red, and of the typical double-seated open top style of those days. Harry Kemp kindly offered to drive our parents, Father being far from well, to Udimore in time to be there to supervise the unloading. The other members of the family had already gone ahead on bicycles when the handsome motor drew up to take Father, Mother, Emily, and myself to our new home. Emily was the one servant now retained, a spinster of sharp tongue, golden heart, and doubtful age.

The men of the party wore heavy coats, peaked caps, and goggles, and the women (Mrs. Kemp included, who "came for the drive") were wound about with veils and mufflers which streamed behind them as the motor came to the open road and dashed furiously along at a good twenty miles per hour, sending fowls screaming into the ditches and carters to their horses' heads. I sat in the back between Mother and Emily, clutching my precious ostrich egg, well boxed and wrapped, while Emily held the canary in its cage on her lap.

The dust was great and I tried in vain to peer through it to see the whitethroats and chaffinches perched on the brambly hedges, and I decided I did not like motor-cars. And I never really have ever since, and quite understand why Father called them "inventions of the devil," although no doubt glad to make use of one that day. Or had he (very sensibly) accepted the Kemp's offer to avoid hurting their feelings? Certainly some of my brothers did not share my feelings, and Stephen (and later John) could talk about motors for hours, and call out the make and horsepower of a passing machine with the same sort of intense interest and accuracy with which I could identify any given species of bird.

Louis Kemp had been in Western Canada, and his description of the prairies was my first introduction to those distant plains.

When we got to Stocks House, for that was the name of our new home, we found the early birds had looked to most of the unloading. The movers' heavy cart horses were standing in loose traces in the dappled shadows of the back-door shrubbery. Alas! One of them took to browsing on a laurel bush and was seized with colic, rolling on the ground and groaning as if about to die. Fortunately, the owner of the farm was at the stables and his ploughman came with a drench of oil and turpentine which brought the beast around.

Father finally paid off the carters and each man was given a glass of whiskey to keep out the dust on their homeward journey.

The family was much smaller now. Mark had his own studio at 10 Beaufort Street, Chelsea, curiously enough a house owned and occupied by two ladies who had been as girls the models for John Sargent's painting, *Carnation Lily, Lily Rose*. Philip had left for Rome and was at Montecassino. Molly was studying in London for her matriculation. Will had left the previous year to work

in the offices of the Grace Steamship Line in New York, and now Stephen, in his turn, took ship for the same destination and work. Will stayed with the firm all his life, having married an American girl. Stephen, who had always wanted to be an engineer, studied at night school, and having got his training eventually returned to a business of his own in England.

The head of the firm of Grace and Co. of Hanover Square, New York, was a fine old gentleman who often visited Battle, for he had bought the abbey itself from the previous owners, as many other rich Americans had bought property in England. He commissioned Father for his portrait, and it was because he took a liking to my two brothers that he offered them employment.

So with Betty at the convent of the Holy Child in Bexhill (where my Aunt Rose was an instructress) there were left at Stocks only Jim, John and my small self. We three now took our schooling from the vicar of Udimore, the Rev. Fred Sargeant, a former Master of Shrewsbury, a veteran of some years in Australia, now a widower whose eldest daughter, Marjorie, kept house for him.

The vicarage was just across the way from Stocks and we would report sharp at nine to gather in the vicar's study where under his sharp eye we toiled with Latin and History, grammar and composition.

Mother had now more free time and besides indulging in her beloved gardening, with shrug and old gloves, trowel and bars for tying large herbaceous clumps; she was able to get around on her bicycle to visit old houses and churches, for she loved the brush as Father did.

I had my own sketch book and paint-box. One of the very first things I learnt was never to use the camel hair brushes provided with the box. Father said "no matter how poor a worker you

are, no one can develop without good tools," and would give me a couple of sables. I never developed the sense of simplicity and airiness which was so much a part of his technique, but then he was a genuine post-impressionist, and I was held back from his looseness by my love of natural history, always tempted to show the smallest detail.

I can see Father now, squinting at his subject, his strong spatulate fingers manipulating the large brushes he used so rapidly and with such apparent ease. In summer he always wore white linen suits made by Mother, and a white, floppy linen hat. One summer, however, the American artist Aubrey Hunt arrived from a visit to the States (otherwise he preferred to reside either in France or Algeria), wearing a fawn coloured sombrero and carrying another which he had brought for Father. They were of the stiff-brimmed Stetson type in use, even now, by the Royal Canadian Mounted Police. It was from Aubrey Hunt that I first heard of that famous Montana cowboy-artist, Charlie Russell, whom I was to meet some years later at Medicine Hat, Alberta.

Sometimes these sketching trips brought us close to the "Plough" inn, and before coming home Father often stopped for a rest on the bench in front, talking with the carters, shepherds and labourers — men he always liked — and sipping a glass of good ale with them.

MOLLY, HOME FOR THE WEEKEND, helped Emily in the kitchen. It was she who bought the turbot as a treat, for Father loved a turbot as only a connoisseur can. It was his one weakness where food was concerned.

Mother went to dress — apparently she still had a rag or two. I dusted the dining room and set the cloth, and John began to

get out the silver. A mad dash was made to the garden for some fresh roses, and lo and behold the rickety-rackety household became sedate, smoothly run, and as if accustomed to distinguished visitors as a matter of course.

So we sat down to a delightful meal. Mother looked divine, with just that little flush from hurried dressing which so became her. Father was at his wittiest, Shakespeare trying to outdo him with his booming laugh, and wine flowed golden and freely as the two men toasted their "charming hostess," the "young lady who cooked the turbot," and finally "the noble turbot" itself.

Father's linen suits remind me that the whole family were given, in summer, to wearing brown Holland, an excellent material we do not seem to see now. Mother wore a dress of this for gardening and bicycling, and she made short pants and jackets of the same for us boys.

We had bicycles, too, and as Jim soon went to London to study at the Royal Academy School, John and I were thrown very much into each other's company and rode all over the countryside in the evenings and on Saturdays. John became quite keen on collecting butterflies and lepidoptera, while I concerned myself more with birds. Many a tall oak did I climb to search out the secrets of hawks and owls, although already I was beginning to have a greater "feel" for the open lands than for the great woods of oak and beech, and I especially loved the sheep-dotted marshes of the Tillingham and the Brede, not to mention Romney Marsh, of which these were mere fingers. Those first two marshes lay on either side of the east-west ridge upon which Udimore was set. So in the long summer holidays we pedaled all over the lovely rolling country following the narrow lanes and the woodsmen's cart tracks.

Sometimes we visited friends for tea. Once we drove up the

drive of Wallace's farm near Beckly, for we had been invited to that pleasant meal. Bees were swarming, and soon we were both covered with the insects which crawled around our ears and neck and over our hands. I knew something of bees, for our miller kept a few hives and had told me how you had to "tell the bees" when there was a wedding or a death in the family, but above all he had warned that one must never, *never* get cross with them. So I said to John, "Whatever you do, don't panic or slap at them," but I was too late. Already he had brushed the bees off one hand and was slapping at his face and neck. At once their hum changed to an angry high-pitched buzzing and before we got to the house door my brother had been stung over twenty times. I got off with one sting through my shirt. Quickly we went through the door and John collapsed in the hall. The Wallace family all stood making suggestions while Mrs. Wallace, having brought John to, dabbed at him with a rag soaked in dissolved baking soda, but Mr. Wallace had already sent for the doctor. While we waited I sketched the great horned ram's head mounted in the hall. I was very disappointed when I asked Mr. Wallace what species it was to be told it was a Highland Black-face, for I had thought it was a Rocky Mountain ram at least, if not a Marco Polo sheep. I should of course have noticed the various ribbons the beast had won, in life, pinned below the head.

While the doctor worked on John we all had tea and muffins with gooseberry jam. John, somewhat revived, was on his feet but pale, and Mr. Wallace immediately ordered his dogcart and drove him home while I followed with the two bicycles. I pedaled slowly across Tillingham Marsh in the cool of the evening while the lapwings rose and fell, circling and crying mournfully and turning in flight to show now white underparts and now glossy dark backs.

Indeed, I haunted those marshes, which being well drained by

dykes, were not really swampy, and provided the finest grazing for the red Sussex bullocks put there for fattening, and for the great flocks of our Romney Marsh sheep which are such a feature of the landscape; for they were seldom out of sight or sound. In early summer the baa-ing of the flocks would increase as they were brought in for shearing, and the clip-clip of the blades would be heard in every farmyard as well as in many field pens. Old Butchers, the Holme's shepherd, used to let me help, and I would hold the tar pot and notice how he applied the black stuff to minor cuts and wounds. On cold misty autumn nights the coughing of an old marsh ewe away off in the gloom held nothing frightening, but was as familiar as the hooting of an owl on hunting bent.

The Tillingham is a tiny brook, but with steep banks, and I have often taken a crook and helped a lamb from a watery end, while the old ewe stood by and stamped her foot for me to hurry. I can never smell wet wool today but I am on the marsh with the pewits running among the lambs. The stream was hedged in places with great reeds, within whose restless and rustling fastnesses the reed warblers built their pendant nests, and from which teal or even mallards could often be flushed.

There were trout in the Tillingham, but they were small of size and very wary. The largest spotted beauty ever caught there in my day was the one taken by my brother Stephen when on a visit from New York just before my father's death. This brother of mine was a most ardent angler.

With Philip in Rome, editorship of the *Hornbeam* magazine now fell to Molly, who worked at it in her holidays, and sad to say, the annual became slimmer and slimmer, although I now began to contribute more, with articles on birds and natural history subjects all illustrated.

I GREW UP IN HEARING OF THE SLOW, country speech of the people of Sussex. Only occasionally have I heard it over the past fifty and more years, for most of the English immigrants to the prairies came from the industrial areas of the Midlands and North of England. After all, why should the Sussex folk have emigrated? They had a moderate south-coast climate and were not crowded into slums and tenements. The grass of the Southdowns was green and turfey, smelling of wild thyme. The shepherd, the ploughman and the waggoner could all see the blue waters of the channel, and, beyond, the fair coast of France, from whence, in earlier days at least, came smuggled treats. The men of the Weald, out of sight of the sea, could still smell her, could still feel the soft air blown inland by the southwest gales. The oak woods between the fields of turnips and corn held a magic which worked in their bones, as it had worked in the bones of the South Saxons since first their forebears ventured across the grey North Sea.

The men of the hop-gardens, the men of the Pevensey marshes, all had pleasant work. Work which could satisfy both the hands and the minds of these slow-moving, slow-speaking folk. There was room to swing a cat. There were blossomed lanes in which courting sweethearts could linger. There could be a tasty rabbit for supper after a day at the plough-tail and a lunch eaten under a brier-grown hedge and yellowhammers piping for "a little bit of bread and no cheese," scorning the chunk the ploughman held with his artful thumb atop the heel of a crusty loaf, while his muddied horses blew into the nose-bags which held their noon-day corn.

Why emigrate?

For me it was different. My family followed arts and letters. They were Celtic-Norman; even if I (at least) was Sussex-born. We had no farm, although we lived in a farmhouse. Nor would a farm

ever be possible for me in this tidy land of few, if productive, acres, for my father only sold enough pictures to keep at bay the butcher and the baker and to provide an education for seven sons and two daughters. So how could the seventh hope for a birthright in either cash or land?

Stocks House had stood behind a set of sturdy oaken stocks up to the late 1700s. The name remained. The identity of the various smugglers and assorted rogues who had once been confined in the stocks may long since have been forgotten. They were quite possible Coopers and Crittendons and Eldridges and Beanys (but let us not study the Parish Register too closely). The house was a typical East Sussex building of four hundred years ago, built in what is commonly called the Kentish style, with brick-floored kitchen, scullery and "wash-up," as well as a bricked yard. The usual great yew tree stood before it, for this was the site of an earlier building, of the time when all yeomen's and country gentlemen's residences (as well as most churchyards) could boast one or more yews in their grounds.

These had not, however, been planted for adornment, but rather to afford a supply of tough yew-wood to make the bows which had upheld the honour of England at Crécy and Poitiers. The oak woods, too, had been left from the wild primeval weald-forest for a purpose. Sussex has always had one eye to the plough and one to the sea, so the trees were carefully harvested in bygone years, for oak built Britain's bulwarks — the wooden walls from which Drake harassed the dons and which later had bellowed at Trafalgar. Nor were oak and yew all the fee offered by Silly Sussex to the kings; for there had been iron-works too, famous in their time, and these made ash and beech, willow and chestnut and "apse" (aspen) of value to the grimy-faced charcoal burners who earned

their bread by supplying the smelters.

In my childhood oak was chiefly bid on by furniture makers, although at Rye a few small wooden ships were still being built by a dying race of craftsmen. The iron-works were only remembered in the andirons and firebacks and chimney-cranes within the wide bricked open fireplaces. As for the yew-trees, they were known to be poisonous to horses, so no waggoner would rest his beasts in their shade.

Most of the big farmhouses had an orchard in attendance which, like the kitchen-garden, "went with the house," so in spite of the fact that our landlord farmed the land we were not without the fruits of harvest. Nor did we lack for wine, because on either side of the kitchen door, as well as above the opening of the drain, had been planted strong, tall elderberry bushes, yielding a dark and juicy fruit.

The drain itself was an old-fashioned affair laid under-ground, heaven knows when, from the kitchen sink and the big clothes "coppers" of the wash-up, and opening at the foot of a bank beyond which lay the horse-pond, the cattle yards, the horse stables, and the wonderful old timbered barn. This, at its west end, became twin oast houses (flues for roasting hops), each topped by a white-painted cowl with snake-like weather-tongue. How they creaked, these cowls, when the south-west gales blew! Swinging with every vagary of the air currents, always pointing those carved tongues away from the wind, sheltering beyond the cone-shaped, semi-circular draught regulators.

As a boy, the drain was one of my favourite play places. Soapy water from the coppers would gush and gurgle on a Monday noon, sending the ducks away in quacking protest. For the ducks loved this damp spot. Seven white Aylesbury ducks there were, with a Rouen drake resplendent as a Saskatchewan mallard, with green

and glossy head, a white neck-ring, and two beautifully up-curled tail feathers.

At the mouth of the drain grew grass both green and tall, over-hanging the oozy outlet, and itself, like the ooze, a breeding place for countless beetles, worms, and snails. Here the farmer's ducks would puddle and probe, gabbling the latest news amongst themselves. You would have thought their plumage and their handsome, restless, yellow bills would have become soiled, but not so. They were as immaculate as the enameled dragonflies which darted overhead.

Beyond the grass grew nettles, rank and tough and ready to sting a bare knee or arm, but things are never far from their opposites, and always there was a large, drooping dock leaf, all rusty on the underside, to pluck and press against the bumps which rose white against red, to soothe the pain and witch it away. The nettle-beds were beloved by the whitethroats, or nettle-creepers as the country people called them. These were not our Canadian whitethroats (which are sparrows), but smaller, fussier, warbler-like creatures with delicate bills and large, bright eyes.

And in the overhanging elderberry bushes which kept this spot so shady, so secluded, so dankly wet, the blackbirds nested year by year. I knew, I saw, and I kept my peace, for our washerwoman's son would rob a blackbird nest and feel proud that he had saved a few raspberries or strawberries.

After watching ducks, after being stung by nettles, after wetting my boots, I liked to trot over to the horse pond. If it was evening the carters would be watering their feather-footed Shire horses, and I would stand and watch the water gulping down their throats, and their ears flickering back and forth with each swallow, while the "soft spots" over their boney eye-structures would contract and expand like bellows.

And so to the cart-shed below the threshing–floor of the barn.

Here carts stood down-tilted on their red shafts. Here were the blue-painted wagons with "R. KENWARD" scrolled on their sides; wagons which had taken sacked corn (as all grain is called in Sussex) to Rye, and returned with linseed cake for the fattening bullocks, which stood knee deep in straw. Many a time had I seen these high-wheeled wains loaded high, the big horses scrabbling up Cadboro' Hill, the carter, on foot, giving directions with his pointed whip and slow, hearty voice -- "Whoo-a! Comee over, Varmer! Wey over there, do-ee, Cap'n!"

Now, while these same horses munched hay in the brick stable, while Edwin sat to his cows, sending twin streams to thump in his pail, I would creep over and under the turnip carts and the wagons, scattering speckled Sussex hens which had been dusting themselves on the dry, chaffy floor, or pecking about in the wagon beds for scraps of cake, or running to glossy Chanticler as he tuck-tucked over a new-found morsel.

The sun would be down and the bats fluttering and squeaking in the gloaming by the time Edwin took himself and his pails homeward and I turned towards the lighted window of Stocks House, with something tight in my chest from all the beauty I had seen and felt.

My bedroom faced on the rutted cart-track which led from the Hastings road to the farmyard. I always woke just before seven o'clock — or, rather, I was woken by the tramp of hob-nailed boots as the men came from their scattered cottages to their daily work. I would hear, "Marnin', Willum, it do be a fine day," and the reply, "Marnin, Garge. Yes, it be, 'less them clouds be holding thunder-plump." And — "Boy! Where's that boy? I dunnamny time I do tell-ee muck out Cap'n *fust*!" Or — "'Ave-ee slop' t'old sow, Edwin? She be main squealing'! Oah! Liddle 'uns already, be it?"

And I'd creep to the window to look down between the curtains upon the sturdy men with the strings holding up their corduroy trousers below their knees. And somehow envy them too, who had not to sit making maps of the world or declining Latin verbs. But never — no, never — did I hear from them an ugly oath or a besmirching word.

In summer we often walked over the fields — that is, by footpaths and stiles — to the seashore at Winchelsea, which was barely three miles away. We took a picnic hamper. We were supposed to spend a lot of time swimming while Mother, after a brief dip, would read, comfortably ensconced against a break-water. I was never agreeably disposed to watery sports, although a good swimmer.

Whenever possible, I would break away inland and there, among the warm dunes, admire the yellow-horn poppies and search for wheatears' nests in the rabbit burrows. My reaction to water was really, I suppose, nature's warning, for no matter how hot the day I came out with chattering teeth and a greeney-yallery complexion, suffering pains in the arms and legs, which were put down by my unfeeling brothers as "growing pains." It was years later that doctors told me never to go naked into water, or indeed live too close to that delightful element. I had been born with a caul [a piece of membrane that can cover a newborn's head and face], which Mother's nurse had carefully preserved, and that was supposed to be a life-long protection against drowning, and perhaps my dislike of water was the doings of that scrap of dead tissue!

This, combined with my being the seventh son and born on a Friday, was known to Emily, our Irish maid, who used to hint that there was something special about me. Somehow, this became known to some gypsies who camped annually near the village, and

one aged seeress begged Mother for a look at my palm. But Mother, as a good Catholic, could not countenance such a thing, in view of the catechism's injunction to pay no heed to "signs, portents, witchcraft and such-like vanities."

When I was a boy, the coming of the gypsies to our village was an event to be looked for twice a year at least. They were real nomads then, and the first thin wisp of their cooking smoke was a sure sign of spring as the mistle thrush's clarion voice from the cherry orchard. Lord's Wood — that mysterious blur of budding sallows and interlaced oak boughs that crouched itself to the west of Dumb Woman's Lane — was a favourite camping spot for these colourful people. In all East Sussex, they said, there was no spot so well favoured, so quietly tucked away within an arm's length of food, water, and abundant firing. Nor was there a more kindly man than "Mus' Holmes," the owner, who would turn his face away, like a gentleman should, from wisps of rabbit fur, or even a pheasant's bright feather, if such should happen to float his way borne by the fragrant breezes of early dusk.

There were few who passed by Lord's Wood. Sometimes the shepherds took a short cut, following the rutted tracks of timber-wains, or some village boys bent on plundering the nests of magpies or jays — but not when the gypsies camped there. One glimpse of those dirty brown tents, one whiff of alder smoke, was enough to send them scampering away. They had no desire to stand face to face with those mysterious brown people in their shabby clothes bedecked with garish and alien colours "near enough to make a Christian come all over weak-like." The village folk "couldn't abide" them.

Then, one day, up to the village the Gypsies would come. Perhaps two men, to grind scissors and such; or two or three women — usually with an ancient one in command — carrying their bas-

kets of clothes pegs, or perhaps a stack of sallow baskets for sale, carrying them with the same Greek-like dignity that we recognize in Arabs and American Indians. Their wares had been made in the wood. By day the thickets had been explored for material; by night around ruddy fire the work had been done. The women talked and laughed at their task, while perhaps a fiddle played. Quick gusts of laughter were answered by the tap-tapping of the men as they mended pots and pans. And all the while the big pot would simmer and bubble, releasing tantalizing odours, while nearby the firm-pressed earth kept secret the source — rabbit, perhaps, or chicken, or even something more epicurean — and guarded from prying eyes the tell-tale claws and feathers.

For some reason I had no fear of Gypsies. They were, to me, people, and interesting people. Perhaps that is because I am the only dark-skinned one in a family of seven boys and two girls, and that only by comparison between my creamy colouring and their pinkness. Of this I was extraordinarily proud — for had not my mother told me many times, with a merry laugh, that I was not *her* boy, but a changeling? — and "Taffy" my father called me, and was not Tafai a Gypsy name as well as Cornish for David?

"Tell me about being a changeling," I would say to my mother, and she would invent a story of how when her last little boy had been born the Gypsies were camping in Lord's Wood, and of how, when I was still tiny, she left me in my crib beneath the yew tree whose feathery branches tapped impatiently at the drawing room window as if they had a right, and of how, as she sat at her piano playing a Hungarian Rhapsody (which everyone knows is Gypsy music) she thought the branches' tapping became more than usually insistent, and she heard me cry. She ran out, she said, and picked me up, but dusk was falling in the shadow of the great

yew, and it was not until next morning that she knew I had been changed. And then she remembered that the Gypsy women were wont to sit by the wall outside the garden whenever they heard her playing through the open windows.

Thereafter, she said, it became a regular thing for her to open the windows wide; and I remember so well how these chattering women and tawny girls, and perhaps a velveteened man or two, would drift in from the lanes and meadows to sit so silently and drink in the wonder of Beethoven and Bach and Liszt. Once a young man brought a fiddle, and, when Mother had finished a piece, quickly played something very like it, only more wild and tumultuous, and my mother leant from the window and said "thank you" into the heavy scented dusk. "Good-night, Missus," they replied, and drifted silently away. I sat under the yew tree and watched them go, my thoughts tramping with them. The evening breeze laid itself down, and a great moon rose behind Rye Hill to see that all was well. Then a tiny point of fire flared for an instant and, from the Gypsy camp, there floated the high sweet notes of the fiddle once more. Long I gazed toward the dark woods, my heart tight, I knew not why.

At golden harvest time, or just before, the Gypsies came our way again. There were hops to pick, pots and pans to mend again, more baskets and things were needed, and there would be a juicy harvest of blackberries to pick and cry from door to door, or tiny white gnomes of mushrooms to be gathered from the sheep-dotted marshes. Old Cruttenden at the oasts would let them bake their filched potatoes on the coal fires which sent their sulphur-scented reek drifting from the great squeaking cowls so far above.

When the leaves fell and the moorhens left the tiny ponds, the Gypsies moved again. I know not where they went. They never

told us and we never asked them. Their caravans loaded, they took the road. In the gay tilts sat the women with their gay scarves and tinkling ornaments. Behind came the men, riding, leading, or driving the nondescript collection of skinny horses or shaggy colts which were their stock in trade. As the villagers said, "Them pesky Egyptians ha' gone 'thereabouts', and a Christian and his fowls can sleep again." And I — I would think that something that belonged to Sussex and me was gone, and only grey winter was ahead.

Perhaps a modern psychologist would say that my mother was wrong to tell me her laughing tales. They might say that under this influence I might develop unsocially, without a proper love and regard for my parents. They would be so utterly wrong. But I always preferred the woods to the cricket field, the far-flung places to the ordered city; and perhaps that is why I, the seventh son, at the early age of sixteen, left "Silly Sussex as ever was" behind me and came to the West. And perhaps that is why I like the Indians — as people, not specimens — and why I love to hear soft Cree voices in the twilight as I love the rise and fall of the Romany tongue. And when old Nokum Katcheech of the Salteaux once placed her wrinkled hands on my shoulders, and peered into my face with her bird's eyes, I remember how the old Gypsy women had sometimes done the same. "Gorgio," they had said, and smiled and shook their heads ever so slightly, one to another.

Be that as it may, it was when I was 10 that I first began to be aware that I could arrive at many explanations and conclusions more easily by *not* trying to rationalize and think them out mathematically; and my dislike of and indifferent performance in the field of arithmetic perhaps stemmed from that. I disliked metal in any form, why I cannot tell. The touch, the feeling, the smell — to me metal smells strongly — all set my teeth on edge. I felt differ-

ent, uneasy, when surrounded by it. My brothers got to know this, and "shut your eyes" they would say, and then hold out some small object. "Where is it?" they'd say. "Next to my right ear." "What is it?" they would ask. "A piece of wood," there would be no discomfort, no acrid smell, and I was at ease. But if it was metal, I knew at once and would start to squirm. Worst of all would be a table knife held pointed toward the bridge of my nose. One foot away was uncomfortable. Three inches away was almost agony. In any case, I knew metal at once, for not only did I smell it but it caused a tingling feeling which would sometimes travel all over my body. Wood, wool, leather — these were comforting. Celluloid was quite neutral and hard to tell for sure. And the worst metals of all were steel and cold iron.

This dislike has lasted all my life. It probably explains why I would rather lay my hand on a horse than a motor car; why I always detested anything mechanical, and the noises made by mechanical things. I hardly remembered what a motor-bicycle looked like once it had passed; yet I could from memory draw a set of harness, or the leaves of different trees, or the pattern on a willow basket or some other non-metal object I had looked at for perhaps a minute or two. I don't ever remember, as a boy, or later, ever drawing a motor car or steamer, although I loved wagons and sailing ships. This was in marked contrast to my brothers, who could recognize any late model motor or battleship at once. Oil, too, repulsed me. I mean mineral oil, and while I felt more than comfortable with a shepherd or cowman smelling faintly of their animals, or a Gypsy smelling (like our Canadian Indians) of wood smoke, yet the look, the smell, the feel of fuel oil (or gasoline for that matter) nauseated me, and to this day I can hardly bear the close proximity of a grease-stained mechanic.

This I find very hard to put into words for I suppose they are

instinctual feelings which cannot be rationalized, and when one names them they at once become *things*. Is that why we say, "he has a *thing* about such and such?"

All I know is that I could (and can) find my way in the dark as easily as in daylight, that I seemed to always know my direction, was aware of danger by way of hidden holes and so forth. Yet I could not rationalize these things or think them out ahead. I just knew, and if ever I doubted that I knew and tried to think I was usually at a loss.

Undoubtedly the schoolroom submerged a good deal of this, though perhaps less than today's more formal system of teaching with its insistence on mathematics and science. It came back to me much more strongly when later in life I lived so much in the Canadian wilderness. I never, as a matter of fact, really attempted to rationalize my more and more ardent desire to go to Canada. I just knew I had to, and it was because of this that I spoke to no one about it.

By now, at 12, I had become not only an avid, but a really accomplished reader, having evolved a system I use to this day. Taking a new book, I would first skim over it very rapidly, gulping it by paragraphs rather than words. If it "scanned" to my liking, and I felt I needed its information or story, I would read it again slowly and reflectively, often going back to read a paragraph for the second or third time. So does a youngster in meeting a new grown-up — first he stares (which is rude!), then he begins to listen, and if the grown-up is for you, then you must ply him with question on question.

Those books! They were all I wanted for birthday and Christmas presents, and many were given me, some by Father and Mother, some by friends like Dr. Austin who was home after forty years

as a medical doctor working for the Dutch colonial government in Sumatra and Java. This kindly, bearded man was loved by all the village. The pockets of his shabby overcoat bulged with sweets for the young and pills for poor, for he had a small dispensary in his cousin's farmhouse and treated many ailments for no pay. By him I was given two priceless volumes (albeit old-fashioned), *The Complete Grazier*, and *Farm Management*.

Rex Holmes, our village squire's brother, told me of flowery prairies in the Canadian Northwest, and explained that the beautifully beaded moccasins he so often wore had been sewn by the squaw of his dark, silent Indian guide. The Indian, who was a friend as well as a hired guide, had led him over the frozen muskeg in search of the bull moose whose skin now trod an English carpet. It was he who gave me Captain Butler's book, *The Great Lone Land*. Du Chaillu's travels in West Africa and his discovery of the gorilla was perhaps my greatest pleasure; and I followed his quest of the 'Ncheego 'Mbooba and the Kooloo Kamba till my knees were cramped in bed and I hear the peremptory order, "Put out your candle."

Livingston's *Journal*, Stanley's *Darkest Africa*, Seton Thompson's *Wild Animals I Have Known* all teemed with birds and animals and strange plants, and I pored for hours over the *Harmsworth History of the World* (which I still have) and Seebohm's *Birds of Europe*. Next to them in my regard came such fiction as Kipling's *Captains Courageous*, *Kim*, and the *The Jungle Books*. The lighter adventure stories were not lacking, especially those in which "natives" (black, red, or yellow) and wild animals figured; such as Ballantyne's *Young Fur Traders*, Henty's *Out on the Pampas* or *The Dingo Boys*. I loved the *Leatherstocking* tales of Fenimore Cooper, not only for his accounts of Indians, but for his wonderful descriptions of forest and

prairie, and while it was said that Cooper romanticized overmuch, I was to discover later how closely he had captured the nature and disposition of the unfortunate Indian characters he had depicted.

It amused me also to try my hand at illustrating these books, thus fixing more firmly in my mind various details of animals, peoples, and places. I was encouraged by Frederick Selous who was taken with my drawings (from his descriptions) of lions, zebras, impala, and flat-topped acacias. I drew Berber tribesmen camped in the desert from hearing Aubrey Hunt's yarns, and after reading Speke's account of how Mutesa the King of Buganda force fed his numerous wives on milk to fatten them, I came up with a drawing I have today!

My thoughts had been very much on Africa until I met Rex Holmes, but gradually Canada began to appear as my El Dorado. Rex had joined the group known as the "Barr Colonists" who went as a group to Saskatchewan in 1904, settling near the present town of Lloydminster, which indeed they founded. He had returned to England in 1910, and at the outbreak of the 1914 War joined the French Army in some "top secret" capacity. He went later to an administrative post in Tanganyika, where he died. He was a good ornithologist and contributed considerably to the museum at Nairobi. When in Udimore he stayed with our squire, his brother Alfred, and in that house — Cross House — had several fine cases of Canadian birds which he had sent from Canada to Roland Wards, the famous London taxidermist, to be mounted.

On the higher ground west of Stocks stood the mill, which then ground its corn twice a week as it had done, if not "ever since domesday," at least for uncounted years. The miller's house, low and slate-roofed, stood nearby; and since I bought my feedstuffs for the growing flock at his mill, I had many a chat, and sometimes

a cup of tea, with the kindly white-bearded old gentleman and his rosy-cheeked wife. But Weston, who worked the mill for him, was even more interesting to me. I would sit and watch him dress the "French Stone," which really did come from France and was of a terra-cotta pink, and he would explain his art (for all craft is art) to me. One day I noticed some bags of corn (wheat) stacked up against the wall. They were marked in big, red letters MANITOBA HARD WHEAT. Weston explained that this wheat, rich in gluten, was used to mix with our softer English product, and this, he said, resulted in a better loaf. He opened a sack and I took some in my hand. The colour was more rich than ours, a fine amber-red. Taken in the mouth, it was as hard as gravel. Weston said he had a nephew who grew wheat in Manitoba, at Portage La Prairie.

Portage La Prairie! The romance of the name thrilled me. Portage La Prairie! I thought of couriers de bois and the voyageurs! And I trotted home repeating to myself, "Portage La Prairie, Portage La Prairie" in time to my own feet ringing staccato on the metalled road.

One backward glance I gave, looking west as the twilight fell and rooks winged homeward to the churchyard elms standing so dark against the last glow, and I thought that soon the sun would rise over those distant wheatlands and O! If I were there to see it!

Now I began to take notice of world affairs, for they were discussed constantly. We younger members still had a "schoolroom" type breakfast, which went in heavily for porridge, toast and marmalade. Father did not rise till about 9 o'clock, after we went to our studies, and he breakfasted with Mother on bacon and eggs. Mother always read the paper to him, and in the holidays and on Saturdays we boys would listen to the news and the discussions.

I remember when the Union of South Africa was being formed and men like Botha and Smuts were to the fore, and that Father said, "Briton and Boer! It sounds all very well and it is not the first time such a partnership has taken place. In Canada the French and English seem to get on. Indeed, I think a lot of the Quebec clergy feel grateful to the fortunes of war which kept the French revolution and the 'age of (atheistic) reason' at a distance. But I think the case of South Africa is different. The two races have little in common. The British are too liberal and too forgiving, while the Boers are a stubborn stiff-necked race who have a narrow, Calvinistic belief that they are 'chosen.' I am very much afraid that, in spite of men like Smuts, it will take only fifty years before we are back where we started, all the sacrifices of the war will be for nothing." (This turned out to be a prophecy fulfilled.)

Kier Hardy, the socialist, had been elected to Parliament, and he shocked the staid House of Commons by presenting himself complete with labourer's boots, corduroy trousers, red neckerchief and workman's cap. "A real case of invented snobbery," snorted Father. Our whole village was a little dubious of Lloyd George, that remarkable and brilliant statesman of whom it was said that in moments of stress he played "wild Welsh hymns" on the harmonium. His promise of "five acres and a cow" did not look very realistic to our Sussex labourers, who had their cottages rent free, with leave to keep a cow or a pig and a flock of poultry. Our village was nothing if not conservative!

Then good King Edward died, followed by the accession of his sailor son, George V, who was to see his father's and his grandmother's way of life pass away. Edward's greatest contribution to the Empire was undoubtedly his framing and practicing of the "Entente Cordiale" with the French Republic; and this was to bear

fruit in the year following his death, during the "Agadir Incident." The Kaiser had to draw in his horns, but he set about enlarging his fleet and perfecting his already efficient army in preparation for *Der Tag*. The anti-clerical French government of the day cracked down on the religious orders, many of which sought refuge in Protestant England, as so many persecuted people of all faiths and nations had always done. Houses were found for them and money collected to help them, but *La Patrie* was only too glad to recall them later, to nurse and minister to the war wounded.

The Sun of Yat Sen (if I may pun!) was rising in China, and the Imperial throne tottered; while at the same time a famine was wracking the land. Nuns from the China missions used to come in demure twos to beg for relief money, and they were not refused.

Headlines began to appear about Turkish massacres in Armenia and already Abdul Hamid II was being spoken of as "the sick man of Europe," and the signs in the stars bespoke the Balkan wars which would break out in just over two years.

In Canada, Sir Wilfred Laurier was telling the world that the 20th Century belonged to that great Dominion, while the controversy on reciprocity raged from Halifax to Vancouver. The Royal Canadian Navy had a small beginning in a few vessels given by Britain, and before a few years were out Canadians would no longer see the Royal Navy's "guardian prows" based at Halifax and Esquimault. Nevertheless, a large section of the British public still based their ideas of Canada on Robert Service's *Songs of a Sourdough*, and the "Klondyke" was still a word to conjure with, though it had passed its zenith.

In India, the Congress Party was becoming more and more powerful, and we were hearing strange and terrifying rumours from the Belgian Congo, and considerable criticism of King Leopold.

The United States had begun to engage in the colossal task of building the Panama Canal. In spite of yellow fever, many young Englishmen were flocking there, but many more were emigrating to Australia, New Zealand, South Africa, and Canada. Some were still being indentured to the great trading companies: the Hudson's Bay and the East African Co.

To a man (or boy) they felt a sense of dedication to the Empire, to the *pax Brittanica*, and to duty, by giving themselves completely to whatever job was in hand, either just the ruling of native peoples or by fair accounting to the mercantile companies. Many joined the North West Mounted Police.

Altogether, the world was a good place. All seemed well, in spite of Kipling's "Recessional" warning, my father's fear of socialism, the Kaiser's almost obvious plans, and the Japanese penetration of our markets. For that nation, flushed and arrogant after their recent victories at Port Arthur and Tsushima, and realizing the full significance of the first occasion in modern times of an Asiatic nation soundly drubbing a western one, was taking full advantage of the added prestige.

The *Strand* magazine was running Conan Doyle's *Tragedy of the Korosko*, but it was the *Wide World* which I found more to my liking. The amount we all learned from this magazine! If we didn't actually "take tea with the giddy Masai," we at least felt on speaking terms with them. The British were then building the railway from Mombasa westward to Uganda, and some of the stories of man-eating lions almost putting a stop to this enterprise were in the *Wide World*, well illustrated with photographs of Masai herdsmen with their great shields.

There was a description of an Australian aboriginal corroboree as seen (quite accidentally) by an English governess on a cattle sta-

tion in the back-blocks. Miss Beatrice Grimshaw published her travels on the wilds of Papua, with her own photographs of head hunters with great boar's tusks through the cartilage of their noses.

We read Teddy Roosevelt's accounts of his adventures among the Gauchos and Indians of the Matto Grosso and El Gran Chaco; somebody's "brush with Idaho horse thieves"; somebody else's close call with a tea caravan in Sinkiang.

But above all, the deceitful Louis de Rougemont filled the front pages with his long serial of fictitious adventures in Australia's "never, never" land and the islands of the coral seas. When the editors discovered the hoax, they announced to the public that because of their reader's enthusiasm for the series, they would continue to print them, but that during its run they would alter their proud motto of "truth is stranger than fiction" by adding, "but De Rougemont is stranger than both."

All this and more I remember so well that I must have read some of the stories a good many times. All these and more fed my urge for travel and adventures. Geography became my favourite subject, though history gradually supplanted it.

The Coronation of King George [22 June 1911] was the occasion for a great celebration at Udimore, with masses of cake and ices for the children between their songs and recitations, speeches from grown-ups and more patriotic songs — one being a composition of Mother's, ending with God Save the King and lowering of the Union Jack which had fluttered all day from the top of a marquee (hired from Rye) which had been set up in the Glebe field behind the vicarage, a high piece of land from which one could see across the Channel to the blue coast of France.

The *Illustrated London News* carried many pages of pictures of the coronation, and I saw my first Royal North West Mounted Po-

lice in them.[1] A contingent had been sent from Canada, and King George was as pleased with them as his father had been that he bestowed on them the title of "Royal" about the time of his coronation.

1 Their title of "Royal" had been given them by King Edward VII in 1904 to recognize their service in the South African War; they were objects of great interest and admiration as they sat on their horses, borrowed from the Life Guards. One paper said "The Mounted Police from Canada were the equal of any cavalry in the world." It was to be my good fortune to meet at least one of the members of this small party some years later. He was Constable Bert Mosses – an Englishman – who was later my opposite number as a Field Officer of the Saskatchewan Department of Natural Resources.

Part II

Dream in the West (1911 – 1916)

In September 1911 my father died, in the bed he had shared so long with Mother, the bed in which we had each seen the light of day. The funeral was at Udimore, and was conducted ecumenically by Father Bonaventura, the little Franciscan from Rye, and our vicar.

Father had been a very broad Catholic, and I expect this was at his request. He always loved the Bible, and had made a frieze in the dining room of texts from the Psalms in the Latin, and worked in illuminated script. Where Mother would be apt to say "the Church tells us to do so and so," Father would have said, "God requires such and such." He would have welcomed good Pope John. And when Mother got impatient with Protestants for being so stiff-necked, Father had need only to look at her in a certain way for her to say, "although I am sure many of them are very *worthy*."

Soon after the funeral, Mother left for a holiday she badly needed. She sailed for New York and spent six weeks with Will and Stephen, returning much improved in health and spirits. Always a good story teller, she amused us with various adventures, one of which I remember well.

Mother went to Atlantic City with her sons. Shades of Queen Victoria! The two sexes could not bathe together, but must use separate beaches. Mother swam out to a large raft moored off-shore,

and my brothers likewise swam out, and the three of them sat chatting and swinging their legs over the side, when a motor boat drew alongside and a policeman said, "lady, you can't sit with gentlemen here, the ladies' raft is over there." Mother excused herself and prepared to leave when the official caught sight of her bathing suit and also saw she wore no stockings. He lectured her on this, for the law required that the nether limbs be fully covered. In England (old fashioned England) one-piece bathing suits and bare legs were quite accepted by this time, as mixed bathing had been for years!

Shortly after Mother's return from the States, Mr. Marchant of the Goupil Galleries arranged a memorial exhibition of Father's paintings in their London salon. It was well attended and many pictures sold.

We younger boys were excused lessons for a few weeks and were invited to stay with old friends of Mother's, Captain and Mrs. Huth, who lived in a big house near Wadhurst called Riverhall. It stood in handsome grounds, and was all polished oak staircases and floors, furnished in old oak, too, and you had to be careful lest any of the small rugs slipped on the glossy surface. Captain and Mrs. Huth rarely met except at the luncheon table or at dinner. They were very correct and polite to each other but said little. Neither one ever asked the other what they would be doing that day.

They had separate stables and separate grooms for their separate horses. Mrs. Huth's establishment being in every way apart from her husband's, he apparently never intruding on them nor she on his farmyard. Even their dogs owed quite separate allegiance. He had a couple of terriers and a retriever; she had four great Borzoi — Russian wolfhounds — with snaky heads and beautiful silky coats. We used to exercise these huge beasts, and how sore my arm would be after a long tramp with two of them pulling at their

leashes, their heads down and tongues lolling. It was not uncommon at table for you to find a long wolf-like head thrust under your arm, and a narrow snout laid alongside your plate!

I remember asking Mrs. Huth where Captain Huth was, for I was more given to men's company. She replied coolly that she hadn't any idea. I felt embarrassed and never asked such a question again. We didn't see much of the Captain.

Every morning at ten her groom led a tall, snorting hunter up to the brick mounting-block by the front drive, and she would mount and settle her linen habit, adjust the veil of her bowler hat, and ride off at a canter followed by her loping hounds. I admired her horsemanship and determined that I would one day ride like that, but not of course, in a side saddle, which was still the vogue for most ladies, although a few of the younger set were adopting the astride posture in the hunting field.

Captain Huth took me on one rare occasion on an otter hunt. I stood in shallow water with the rest of the field, keeping my pole moving to prevent the otter from going to its hole, and was in at the death when hounds surrounded the poor beautiful creature. A paw was cut off, and the master dabbed me on the cheeks with the bloody stump. "Well done!" cried several tweedy gentlemen as I was "bloodied." The paw was given to me and I sent it to a taxidermist at Hastings to be mounted in silver and suitably superscribed. I gave it to Mother, and have not seen it since.

Captain Huth also came once to Lord's Wood at Udimore to "draw" a badger. He had a couple of other sportsmen with him, and they were all dressed in blue coats and black velvet caps. Captain Huth carried a hunting horn in a leather case. Alfred Holmes, the owner of Lord's Wood, was also there, and had invited me. Several labourers with spades stood by to dig. The first two terriers

disappeared into the sett (the badger's den) with alacrity. We heard a scuffle, a thump and a terrier's sharp yelp. Out came a terrier dreadfully gashed, soon to be followed by the other, scratched on the muzzle. Two more terriers were loosed. Another scuffle and dead silence. "Dig here, men!" called the Captain and the men went to work with a will.

They had got down some four feet when we saw the rumps of two terriers, side by side and straining backward. Captain Huth waved the men aside, jumped down into the excavation and taking hold of the terriers pulled with all his might. This was more than old Brock could stand, for terriers had their teeth firmly clamped on his nose. Slowly the badger was "drawn" and one of the other sportsmen quickly seized him by the tail and raised his hind parts from the ground. At this the two grinning terriers let go and began to paw the clay from their eyes, while the man now lifted the squirming quarry on high, still by the tail. The beast was fat and heavy. Captain Huth blew a few fine blasts on his horn and the badger was then dispatched with a blow from a spade. I had very mixed feelings, mostly on the side of poor old Brock, who grinned in death as if *he* had won. Perhaps in the end he had. To the best of my remembrance the terriers were rough-coated and short of leg — Sealyhams, I suppose. In older days the badger would not have been killed, but kept alive to be "drawn" again, from a long wooden box in which the terriers were loosed, and sporting gentlemen would lay heavy bets on their particular fancy among the assembled terriers. But that had long since been frowned upon, together with bull baiting and cock fighting, with the advent of a more humane point of view.

ALFRED HOLMES, BROTHER TO THE EX-CANADIAN REX, would in an earlier day have been called the Squire of Udimore, for the "living" was in his family. He lived at Cross House, just across from Parsonage Farm with its big house. Although he farmed the land and used the farm barns, cattle sheds and oast house, he (being then a bachelor of about 30) preferred to rent the big house to two ladies who operated a training school of gardening for young women. A very large garden went with the house, with greenhouses to boot, so those damsels had plenty to practice on. They were mostly in their teens and were called by the village folk "the lady gardeners." They dressed in brown calico jumpers with shoulder straps, pretty short in the skirt for those days, and wore brown stockings and stout boots.

They were often to be seen walking up the village two by two, there being six or eight at one time in training. We got to know them all eventually, and two at least attended the weekly meeting of Mother's Choral Society, and tried their voices at *Orpheus with His Lute* and other part songs, accompanied by the strong baritones of Reg Eldridge (who brought our water) and several other village swains, as well as some village girls including May Butchers, the belle (and she *was* pretty) of Udimore and daughter to Alfred Holmes's foreman. Marjorie Sargent, John and myself pretty well completed the singers, who met in our drawing room.

The gardening school was operated by two charming maiden ladies: Miss Peake (dark, handsome, flashing), and Miss Ridley (slim, red haired), both experts in horticulture as well as in other arts. Miss Peake's father was manager of Jay's in Regent Street, where Betty was later employed as a fashion artist.

I reached the age of fourteen and longed for the day I would see a more distant land, but I knew I would have to wait, and so

I settled down the more seriously to my studies, fairly eating my way through *De Bello Gallico* and starting on Virgil and Horace. My French was improving, and I was to find a use for this later, for many of the Métis and Indian people of Canada's Northland spoke a form of that language, albeit mixed with Cree and English words, but still recognizable. I had worked though *Hernani* [Victor Hugo] and was wallowing in *Les Trappeurs de l'Arkansas*, which was a factual account of French-Canadian adventurers on the great plains of the American West in the days before the Louisiana Purchase.

The Rev. Fred Sargeant was, I believe, a good tutor, and when he found how little aptitude I had for mathematics, did not force me in that direction, but rather encouraged me in language and history. It was John who excelled in the exactitudes of algebra and logarithms, and he far outstripped me. It is no wonder he chose to be a gunnery officer when the war came.

Mr. Sargeant certainly did not ask us to memorize *facts*, which he said had little to do with understanding. Facts, he pointed out, could be looked up in any encyclopedia or text book. But facts had to be understood, the mere knowledge of them was useless, and memorizing them simply clogged the brain which could therefore have no room left to wider thoughts, or personal appraisal.

He spent a good deal of his time gardening and improving the vicarage grounds, which had been sadly neglected by his predecessor. He would set us our lessons and disappear to his spading and planting, visiting us only at half-hour intervals to set a new lesson. Being a thorough gentleman, he always entered noisily. On the hall table outside our study he kept a large China Humidor of tobacco. Before entering, he invariably loaded up his pipe with a great clatter, giving us time to straighten up and appear to be absorbed in our studies. He would then look over our work, emitting

clouds of smoke from his pipe, give us praise or blame as occasion demanded, walking up and down as he did so, jabbing the air with a strong, blunt finger (indeed those two adjectives describe the whole man) emphasizing a point, and usually ending his harangue with a quotation from St. Paul — and very much to the point those quotations usually were.

"*Not as one beating the air,*" he might say, or "*furthermore, think on those things which are of good repute,*" and so on.

"Parlous" was a favourite word of his. "How did you get your book in such a *parlous* state?" he would say. And his antipathy for saying "bean" for been was something to hear. "The enemy having *bin* routed" he would enunciate so vigorously that one wondered he did not break the stem of his tightly clenched pipe.

I have always preferred drawing to writing, and I made profuse illustrations in the back pages of whatever book I was translating. Although often lectured about this "parlous" propensity, I was incurable, and after a while "the old Boy" (as we called him privately) only grunted when he came across Caesar's camps or Canadians with long rifles and swinging sashes. Once, at a scribble of Greek soldiers, he snorted "wrong helmets," and drew his pencil across my effort.

He certainly was a remarkable man to whom I owe more than I can repay. I know I was a sore trial to him, but the worst he ever said was "Bobby, Bobby, Bobby! — what a *tiresome* boy you are," accompanied by a tweak at my ear. And once he said, "At least, Bobby, you will never drown!"

But I already knew that. And fervently hoped I wouldn't be hanged, either.

Behind the vicarage lay the glebe field (the site of the Coronation festivities), rented at this time by a man curiously named

Parsons, who lived in a small, thatched house which was the old parsonage, and the first; for the big parsonage was the Holmes's house of the lady gardeners. This had some two generations before been purchased by the Holmes family, who then built the vicarage again on the glebe land.

Parsons was the local carrier, and his covered cart, drawn by one horse, went twice a week to Rye on errands, taking garden stuff, eggs and the like to market, and returning with yards of cloth or a bicycle pump or other odds and ends of stuff for the villagers. He used to bring me boards, nails, tar paper, and chicken wire for my poultry industry, and all for a very small carrying charge. His cart would usually be festooned at the back with rabbits, caught by the ferreters and destined for the butchers at Rye, or perhaps private customers. They hung by the hind legs, one leg being put through the Achilles cord of the other and any number threaded on one small pole, and bumping and swaying head downwards as the cart jogged along. We boys often went ferreting with Butchers, who showed us how to set the nets at the mouths of the burrows, and how to handle the vicious little stoat-like creatures which would be put down one hole to chase the rabbit to its netted bolt-hole.

Or sometimes, as I got older and had been given a .410 shotgun by Alfred Holmes, a bolt-hole would be left unnetted and I could try my hand at hitting a running target before it vanished from sight in the brambles. "*Born an' bred in a brier patch*" as Uncle Remus said, these animals of the woodland warrens were not an easy target.

To return to the village, Parsons's daughter, Daisy, used to deliver our milk and cream, for they kept several cows whose cream was yellow as a buttercup. This village damsel used to play the piano — atrociously — and nearly drive Mother mad on a summers' day

when all windows would be open and the thumped strains of some sentimental piece would resound from across the way. The same young lady held court every Sunday afternoon in summer, sitting in gorgeous pink within a rose-grown bower a few feet from the white latch gate which opened on the street, and many were the sunburnt swains in Sunday best who leant on that gate or sat on the grassy bank.

JOHN AND I NOW HAD THE BIG TWIN ATTIC ROOMS for our personal use, over and above the bedroom we shared. Each of these was larger than the average modern sitting room, with big dormer windows. Mine held a varied collection of rather badly stuffed birds — though I was improving with practice — as well as my now quite extensive collection of books, leaning heavily to history, travel and natural history. I had Cassel's big book on anatomy which was priceless to me. Then there were my agricultural books, and almost a whole set of Kipling.

Finally, there were my many single and two large "flight cages" and two breeding cages for my canaries and the goldfinches I sometimes mated them with, as well as a big indoor aviary cage (given me by Alfred Holmes) in which I kept my budgerigars and a pair of African love-birds. Luckily, Mother could not, from her rooms, hear the assorted songs, screeches, and chattering of this menagerie, but I was not allowed to keep Jack, my pet magpie, there for he really was too noisy and had to be kept in the wash-up. I did have a partridge with a broken wing who called out "kaa-rick" at intervals.

Here then, I drew, I read, and I wrote. In 1913 I sold my first manuscript for half a crown. It was an illustrated article on home-breeding of budgerigars and it was taken by *Cage Birds*, a monthly

periodical for bird fanciers. I also took *Poultry Life* and due course sold them an article on Houdans, a crested French breed.

Mother had been reading *The Garden of Allah* by Robert Hitchins, and I later took it up to my attic, for I was attracted by the fact that part of it was laid in North Africa. I was quite struck with the story. I thought the ex-monk made quite the wrong decision in the eyes of God, to give up his wife and child to return to a monasticism which he had never, in the first place, voluntarily embraced with full knowledge of the consequences. He certainly, I thought, owed more to his family than to his only half-understood vows; and noble though the action might have been, it was a selfish one, and I felt disappointed that he had made his decision on narrow orthodox lines, and had he braved society and the wilderness to do what was his closest and most obvious duty, he need surely not have separated himself from the love of God.

But books and my water colours aside, my growing body demanded action, and I had the whole countryside to roam. Most of my walks were through the woods and fields; making small sketches of birds and beasts and flowers; sitting by a dyke to watch the water-boatmen (beetle-like insects) row their clever way between the clumps of water ranunculus; or listening to the sound of wind and noticing its change of tone in oaks, in reeds, or over grass.

And always in all this wonder and beauty of leaf and flower, of hill and marsh and bowered greenery of woodlands, I seemed constantly on the point of reaching up and grasping something — some elusive *tertium quid* [middle course] — which hovered between the seen and the felt, between the scientific explanation of *how* and the spiritual *why*. Something which would join the material world of nature with the instincts, the waves of the eternal (sometimes so strongly felt) with the beaches of the now, the yes-

terday and today, with the tomorrow. What was the mind of man, I thought, that one could project oneself into the future and actually *see* oneself in a certain situation; or fly in mind to a foreign land and be at home; or go backward in time and march with Caesar's legions? Were those situations of the past — and the future — actually going on all at once? I had not then heard of the fourth dimension, but I certainly did feel the vibrations of something unseen and untouchable going on behind the façade of the Today. I often knew before I saw such and such a bird that I would find that bird's nest. I would sense the presence of a fox before I could see or smell the animal. And I did not care to mention any of these things to a soul, for I was afraid I would be told to stop dreaming and get to work at something.

I was still a little concerned about religion and read and re-read *Newman's Faith of Our Fathers*, which so logically proved the claims of the Roman Catholic Church. But I was still not convinced. Not that I really worried myself; I was too full of life and joy to do that, and simply believed that one day the seeker would find, and the flame within me would meet and recognize what it was.

My eldest brother, Mark, often came to stay. He had extremely broad views — often too broad for Mother, who feared for the faith of her younger boys. Mark was a fluent and interesting talker, and at the breakfast table his conversation sometimes irritated Mother, who fumed "would that you were hot or cold."

One morning Mark was speaking of the splendid work of the Salvation Army in the poorer districts of London. Mother finally said, "Well, of course I suppose they are worthy people, but are they not spreading error?"

"No, Mother," Mark replied, "they are spreading *love*."

He himself was a devout Catholic and at one time wanted to be

a priest, but he was not considered sufficiently robust, and he went on with his painting.

The people I met on my rambles were of equal interest. Of course I knew all the shepherds and ploughmen and hedge-cutters, and I learnt something of their crafts, for such men are slow and patient and will answer questions and let you try their hedge sickle or their crook or invite you to hold the plough handles, or lead the heavy footed team.

I often met Alfred Holmes "walking" his large farm. (For if the master's eye fattens the bullock, so are his footsteps the best fertilizer.) Gradually he invited me to walk with him. He gave me a "spud" to jab the thistles with. We didn't talk a great deal. Our company was enough. But sometimes he would ask me how Julius Caesar was coming along, or some other of my lessons.

He was himself a Cambridge "Blue" and had studied law, but preferred the farm. He would explain something of the culture of the horse-beans or how to assist a cast sheep. These walks usually ended up at Cross House about tea-time, and we would tidy up and he would put on a Gilbert and Sullivan record and his stout housekeeper would bring in a pot of tea and bread and butter, with jam. We never ate these together at home. Father had been keen on self discipline, and if we had butter on bread we didn't have jam, and vice-versa. So I felt just a little guilty of piling on apricot jam.

Alfred was at once a companion, a teacher, a brother, and a father to me. He never "jawed" or sermonized, yet his whole way of life steadied and disciplined me and helped me to grow up without any feeling that it was difficult to do so.

HALF A MILE EAST OF STOCKS, on the highest point of the ridge, stood Knellstone farm. Here, in a large, rambling house, lived

Mr. and Mrs. Austin, whose fields, orchards, and hop gardens lay below, merging southward into the marsh pastures where cattle and sheep grazed though the long, bee-loud summers.

The Austins were getting old. Two (then) unmarried daughters lived with them, as well as the good doctor, their cousin, whom I have already mentioned. The eldest daughter played the organ at the village church, while the younger had been taught by "Cousin Henry" in the arts of the dispenser, and could usually be found in the morning among bottles, phials, and pills.

John and I would often be invited to tea at Knellstone. The sitting-room window commanded one of the finest views in Sussex. You could see the hop-fields below, then the Pett levels which took the eye to Winchelsea and the dark blue channel, while southwest the heights of Fairlight Ridge stood up clear and blue with Icklesham windmill turning blandly in the middle distance. Only when the sou'west gales blew up a beating rain was this view obscured, and even then you could sense the flat expanse of the marsh land, or between gusts catch the glimpse of leaden water in the mathematically straight drainage dykes.

White sheep crawled like ants on these grass lands, and when the windows were open the constant deep baa's of ewes and the shrill answers of lambs would provide a constant background to the rattle of cups and saucers. You could also follow the twisting course of Dumb Woman's Lane, that old, narrow, hedge-in smuggler's track immortalized by Kipling in *Dymchurch Flit*. My father once did a delightful watercolour (after rain) of the path which led from this lane to the back of Knellstone buildings.

Old Mr. Austin told me that, in his father's time, the big woodpile was stacked against the wall by this path, and the smugglers would leave little casks and rolls among the faggots. So it was

"*watch the wall my darling while the gentlemen go by.*" Whether the parson got his brandy or the clerk his 'baccy I do not know, but I expect they did, as I expect many a weary packhorse once munched sweet marsh hay in the old oak-beamed stables. Father gave his watercolour to the eldest Miss Austin, but how it comes to hang in my house in Saskatchewan today does not belong here.

The spacious sitting-room at Knellstone was flagged with square tiles kept "redded" by the small plump maidservant. In those days the "redding" (red ochre) man still drove his cart and sold his goods to the country folk for renewing the bright colour of bricks and tiles, as well as for marking sheep. The word sheep, I see, occurs often in these reminiscences, but I cannot avoid that. As Kipling put it: "*the Downs*" (he might have added "and the marshes") "*are sheep, the Weald is corn: thank God you be Sussex born.*"

This sitting room also held an enormous open fireplace with a carved oak beam across the front. Here, in winter, a high wood fire blazed among the andirons and reflected its glow from the heavy iron fireback. These were genuine Sussex craft-ware. On either side, in identical Windsor chairs would sit, at tea-time, Old Mr. Austin fresh (in spite of his nearly 80 years) from "walking" his fields, and his little apple-cheeked wife, so shy and so kindly. He was a gaunt, tall man who must have been a giant in his youth. His fine big nose and red cheeks were framed in what was once called a "Newgate fringe"; white as snow. Apart from this style of beard, his face and chin and upper lip were cleanly shaved. The marsh vapours are cold and clammy when the sun is low in winter, and surely this "fringe" must have been a good protection to the throat.

The plump maid, as shy and apple cheeked as her mistress, her cap slightly askew and her blue Saxon eyes alight with the love of service, would wheel up the tea-table and bring tea, and home-

baked bread; and butter in rolls, as yellow as marsh marigolds, and jams from the Knellstone orchards.

And old Mr. Austin would tell of floods when two shepherds gave their lives for their sheep; and of famous Kent rams which had won prizes at Ashford, and point in confirmation to their photographs above the mantel, festooned with the ribbons of long ago, now dry and dusty.

So the November dusk would begin to fall and we'd say goodbye and thank you, and as we left the old couple's heads would be nodding a little closer to each other, and his white beard would gleam in the dusk like his wife's coquettish little lace fichu, and except for his great size and his boots and gaiters you would hardly know who was who. The gale could blow, the windows rattle, the great fir trees groan, they knew it not; as they heard not the soft step of the little maid as she whisked away the tea-things.

Yeomen of England, and yeoman's wives — what do we not owe you?

IT WAS NOT OFTEN THAT JOHN ACCOMPANIED ME on my rural explorations. His interest was more along the lines of engineering and mathematics, and he studied for long hours; though he never neglected the piano as I did. While my room was untidy, his was meticulously neat. My idea was, "why on earth bother putting away coats or boots you are going to wear tomorrow?" After all, untidiness, like beauty, is in the eye of the beholder! We would briefly visit each other's sanctums, but we both carefully refrained from comments on the obvious or picking up each other's things. What is more irritating than having someone ask what you are *trying* to do when you are doing it?

Mother wisely kept out of our attic rooms and Emily, who was

a lover of the broom and duster, learned not to brighten my birds or move John's tools or wires. He soon installed an electric bell for the front door, and being asked by our Landlord, Mr. Kenward, whether it would be possible have a telephone from his house to his bailiff's at Church Gate (a distance nearly half a mile) John answered "of course," and installed it in jig time.

So for John, the fixed mathematical formula, from the possibly soulless effects of which his deep religious faith and his love of music saved him; while for me the easy-fitting garment of a loose orthodoxy (although always aware of the fundamentals, which are strong pillars), the instincts — "hunches," if you like — and that easy intercourse with all kinds of people which was to stand me in good stead later, when forced to mix with Indians, poachers, and pioneers.

John was tall, nearly six feet at seventeen and topping that figure later. He was also red haired, freckled, and shy. I was short and remained forever at the five feet five inches I achieved at fifteen, and I was brown haired and far more confident. In spite of our differences in temperament, the bond of brotherhood was strong. I owe a lot to his example of steady self-control.

We used to walk the three miles to Rye every Sunday, to attend eight o'clock mass — fasting of course. We had to go to confession before Holy Communion, and I always felt slightly sick on those occasions, for I was tired and hungry and kneeling in the dark confessional I wondered what I had done wrong during the last week. It seemed so inadequate to mention petty quarrels or laziness at lessons or "impure thoughts" (which are nature) even though I had put those from me and already told God I was sorry about the other things. Just the same, I liked and respected the little Maltese priest in his Franciscan habit, who always after mass

invited us to the presbytery for a breakfast of eggs and toast laid out by a beaming and inarticulate lay brother who had no English.

But if John was usually busy with his own affairs, and although I was usually (as I am today) pretty well satisfied with my own company, I was not ever anti-social, nor was I without companionship of my own age, for a young relation of Alfred Holmes used to visit Udimore in the holidays. He often stayed with his Uncle Robert Kenward, and we soon got to be firm friends, and I think Mother really loved this boy who had lost his own Mother some years before. Jack (or "Jackie") Stevens was about a year older than me, and went to school at Marlbough, but during term time we corresponded and planned for the holidays. We sometimes went to Itchen Abbas in Hampshire where his two uncles farmed in a fine old property called Barlydown, and where his father (a brigadier general with the army in India) would come on his occasional leaves to England. We used to try fishing in that lovely stream, the Itchen. But mostly we foregathered at Udimore and went rabbit or wood pigeon shooting together.

Jack served in the Royal Artillery in the war, later with the British forces which landed in Archangel to help the white Russians, and he died untimely in the late 1920s, which was a sore loss for me, for the bond between us was very strong, despite the fact that we had different backgrounds — he the typical scion of his hunting-shooting country family, and myself reared in the more classical atmosphere of art and poetry. I think we both recognized that we were complementary one to the other, and if he led me in shooting and fishing, I introduced him to worthwhile reading.

WEDNESDAY WAS MARKET DAY AT RYE, and promptly at ninethirty we would hear the clatter of a dog-cart and our landlord,

Mr. Kenward, who farmed Stocks fields as well as many more wide acres of arable and pasture land, would pass by to buy or sell at the marketplace. His little brown mare fairly made the sparks fly from the crushed-rock road, and his whip would stream behind like a banner as he sat, rugged and upright, clenching a cigar like Churchill, his white stock showing up his square ruddy face.

I met him often as he walked his land, for he allowed me the run of his farm, knowing from shepherds and Alfred Holmes (who was his cousin) that I knew better than to frighten stock or do mischief. So I crossed fields, stared at sheep, watched cattle drinking, or explored a new-sown field of turnips to see how the seeds were germinating.

Mr. Kenward, seeing me, would sometimes wait, leaning on a gate as only a farmer can. When I approached he would remove his cigar, and ask me a pertinent question or two — had any ewes lambed in such a field; was there still water for the bullocks in another; had I found a partridge nest, and if so had I marked it so that the keeper would collect the eggs for safer incubation.

Yet it was still Alfred Homes who taught me the most. It was he who explained the value of good muck, why the yarded bullocks must be bedded in deep straw, the depth to sow field-peas, how to know a good tilth and read the "heart" of the land, how to read an approaching storm, or help a ewe to lamb. All these and more he spoke of in his kind, slightly stuttering voice.

And joy of joys, he taught me to ride, and let me exercise his hunter, Dick. This animal, on meeting a motor in a narrow lane, invariably jumped the hedge into the nearest field, and I am afraid I rather showed off on these occasions. Once, coming across country from Peasmarsh, and passing Broomfield's (the keeper's) cottage, I set Dick at a five-barred gate. He cleared it, but to my shame,

when we landed, my arms were about my steed's neck and I was hard put to regain my seat; but worst of all I saw Broomfield watching me and my face must have been scarlet.

But trust the taciturn gamekeeper not to say a word — or if he did tell "Mus' 'Olmes," that good friend kept it to himself.

Sometimes I was sent on an errand to Rye, and I would ride through the Land Gate very pleased with my breeches and leggings, and put up Dick at the mews behind the feed store. I thought of all the riders who had clip-clopped over the cobbles on the King's business; who had been met (like me) by an ostler with his braces down and a dandy-brush in his hand. And I would go to the feed store and order half-a-ton of cotton-seed cake and a dozen bags of Sussex-ground oats and say the wagon would be there on such a date, to load, and feel very grown up and responsible.

In the autumn, Alfred's brothers came for the shooting. They would all pile into a high, yellow-wheeled dogcart with pork pies and bottled beer under the seat and retriever dogs in the back and start out for big Park wood, stopping at Stocks to pick me up. The morning shoot would be there, and I would stay near one of the guns and help pick up stray pheasants while Broomfield alternated between the guns and the beaters who sat feet-in-ditch to munch their bread and cheese and mild onions and boiled bacon.

Then came the afternoon shoot at the Sheep-Dip wood with its high-flying pheasants and a few woodcock in the deep, wet parts, or perhaps a long-legged hare coming from nowhere in particular. And so to Peasmarsh ridge and Brommfield's parlour, with stout Mrs. B. gasping in with a great game-pie with crust an inch thick, and bottles of mustard and more beer, and the men with their damp tweeds smelling of Hebredian sheep and retriever dogs.

The men would toast the day, their country faces glowing be-

hind the wisps of blue cigar smoke; while a sleepy boy drank it in and loved it and thought he'd go to Canada but only long enough to make his fortune so that he might return to Silly Sussex and have a few bullocks and some Kentish ewes (with a few South-downs for winter folding) and a rough shoot with some pheasants and perhaps a woodcock or two for a damp October homecoming at dusk.

I did not know then — though perhaps I sensed it — that I would be wooed and won and be in love forever with prairies and fleet antelope and sunsets so big that you hardly could believe them, and that I would never regret that Sussex farm but rather cherish the thought of it, as a man cherishes the memory of his mother after he has put his life in the keeping of the woman he loves. For when the shooting season was over and guns silent I thought again of Canada and ranch horses and cattle in great herds.

THIS ACCOUNT OF MY BOYHOOD would be far from complete if I did not explain that my interest in cage birds and poultry stemmed from two absorbing interests: natural history and animal husbandry. Hobbies they were, but they had far wider implications, for what I learned has proved a basis for all my later studies on these two inter-related subjects. I did not just breed canaries; I selected a breed — the Norwich — which most nearly resembled a wild bird, and these I crossed (successfully) with goldfinches and (unsuccessfully) with bullfinches and greenfinches. I offered them different types of nesting material and observed the results. I learned the value and effects of different kinds of bird seeds, soon learning to avoid hemp seed, so greedily eaten and with such bad effects on plumage. I experimented with different types of cage, which I made myself.

It was the same with poultry. I had a choice of the Mediterranean breeds, Anconas, Leghorns, Minorcas, the "show" breeds; laced Hamburgs and Game, the heavy breeds; Buff Orpingtons, Langshans, and the Crosses, the dual-purpose; Wyandottes, Rhode Island Reds, and Sussex. It was only after careful study I voted for the latter, our country breed, then little known abroad but now (1968) one of the most popular in Canada and Australia. I studied a book on *Mendel's Theory*, as well as my Cassells' *Anatomy*. From that book and *Poultry Life* I taught myself to caponize young cockerels — a very simple operation. A little more difficult was operating on crop-bound hens. The birds, when on open range, would sometimes pull long grasses which tangled up with the food in the crop and cause this often fatal condition. I learnt how to tie such birds down, part the lower neck feathers, cut through the outer skin and clamp it back, then make an incision in the crop itself, remove the hardened mass, and sew up first the crop and then the outer skin. A few days isolation on soft food did the trick. For disinfectant I used a few crystals of permanganate of potash in boiled water. All this experience stood me in good stead later, for as a rancher I was not afraid of using the knife as occasion required.

My attempts at "stuffing" birds (taxidermists today hate that expression!) was also helped considerably by my opportunities to study postures and actions in small birds and poultry; and watching such behaviourism as we call today "the pecking order," gave me many good clues to their social life.

If in my later nature writings I have (as an amateur biologist only) refrained from using Latin names for species and for anatomical parts, it is not that I did not long ago commit them to memory; and I am sure I bored poor John with references to *tibias* and *femurs* and *(pyloric) cassia*; as he did me with *armature* and *volt*.

Thinking of "stuffing" birds reminds me that I used a deadly poison which parents today would fear for a twelve year old to possess. This was corrosive sublimate in alcohol; which (for all its skull and crossbones) I obtained without trouble from the chemist in Rye. I doubt that my mother realized its potentialities, any more than she realized the possibilities of John electrocuting himself! But then we followed our text books to the letters and did not fool around.

One day, in *The Farmer and Stock Breeder*, I saw an advertisement from somewhere in the south of France, for setting eggs of a breed I had seen only in pictures — Houdans. These birds were handsome, with tiny walnut combs just above the beak, topped by great crests, shaggy in the cocks and as round as a chrysanthemum in the hens. So I went to Rye, obtained an international money order, and enclosed it in a letter written rather laboriously in French. I then waited in high expectancy.

I had a speckled Sussex hen all nice and broody and I had my coop ready to receive the baker's dozen of precious eggs. But the very day the carrier brought the parcel from Rye, the confounded hen gave up her maternal pretensions and decided to go walkabout. So I consulted my good friend and informant on village matters, Mrs. Beany, who was our washerwoman.

"Gates farm," she said. "Coopers. I 'ear they 'as a mort o' cluckers. You just go douain to Gates, they'll oblige ye, master Bobby."

So to Gates farm by the Tillingham I went.

I knew Mrs. Cooper well; she was a famous hen-wife. "Uz folk do be knowing 'bout them furrin birds you be gettin'," she said by way of answer to my inquiry. " 'Taint likely they'll be much good" (with a sniff) "but there! You be allus a–trying summat, and I 'ave some old cluckers. Take your pick for 'alf-a-crown." I had a cup of tea with her and laid the half-crown on the table where she could

see it but pretended not, and out I went to the hen-yard to choose a red Sussex hen whose comb still had enough red in it to tell me she had not been broody very long, and with the bird under my arm walked the two miles home.

I went to bed happy that night. Thirteen French eggs would take only twenty-one days to give me my flock of five-toed Houdans.

Before I went to sleep I re-read the kind note in French wishing me good luck.

Mrs. Beany was of gypsy blood, they said, and indeed she was no buxom, fair-haired Saxon, but as dark skinned as any Chippewa, with lank hair, now grizzled, and black eyes sunk in deep sockets. Her lean hands were corded and strong. I think she was about sixty.

She came once a week from her little cottage "up the street" and superintended the weekly laundry in the Stock's "wash-up." My pet magpie — the keeper had wing-shot the bird — used to live in the little brick building, and Mrs. Beany hated "that dratted bird" with its hoarse cry of "Jack? Jack?" and its way of flying past her head. She would thresh at it with a towel, saying she'd beat its brains out, all the use o' *he* was to steal from the cat's dish.

This, then, was my liaison officer for the village, and whether I wanted a setting hen or a man to give me a day in my garden, or the higgler to call to discuss the sale of eggs or surplus cockerels, it was Mrs. Beany who spread the word. And helped me bargain with the higgler, too, till he sullenly paid the price and took himself and his old horse down the road to Rye, the high-stacked crates only held by the ropes which bound them, and the young cockerels and old hens shrieking through the bars, their necks out-thrust for one last look at home.

Sometimes John and I met a couple of the young "lady gardeners" on our rambles. Once it was at Winchelsea beach, and after a swim (there were huts for undressing, marked "Ladies and Gents") we would come back across the fields together.

On such an occasion we boys (almost young men now) carefully observed the law of good manners which then required that when a style or locked gate was to be maneuvered, the males must go first and just keep walking slowly with eyes to the front till the ladies caught up (just as one was to go upstairs ahead of a female.)

This may sound devilish prudish, but I believe that by not having curiosity aroused at the sight of calves or petticoats, we were probably the more carefree and natural, in fact happier in our companionship. For fifteen and sixteen is an age at which a boy can very easily be coaxed by circumstances (and fashions in dress are one) into thoughts and feelings which are only frustrating and disturbing. The image of woman can be too easily vulgarized in youth, and it may be better to keep that image as such. We never dallied, we never kissed, we barely used first names, for all our minds were on the walk, the conversation, and the bright and lovely world around.

Mother now thought about enrolling me in the Royal Academy School of Art as soon as I was sixteen. That would, I know now, have been made possible by the Artist's Orphan Fund. The A.O.F. was for the assistance of artists' widows and children. I think Mr. Ouliss (the artist) was the secretary or something of that sort, for he came at least once a year and would be closeted with Mother, while Mr. Sargeant invariably joined them, presumably to report on our scholarly aptitudes.

So I think, but am not sure, that it was the same fund which paid our tuition; for Father's savings must have largely disappeared

over his long illness. I believe my father had subscribed to the fund all his life, but I often wonder whether those responsible for its disbursement were ever properly thanked by the Symons family. I try to thank them today by giving what little I can spare from time to time to the Writers Fund here in Canada.

However, to forestall any plans for me to be a professional painter, I asked Mother for permission to leave for Canada as soon as I reached my sixteenth year. I told her that Rex Holmes said I would find no difficulty in finding work on a farm or ranch, and had coached me in how to go about it.

She said, "Why Bobby, you can't *possibly* go so far away!" But I got Mark on my side and he said, "Let him go — he'll come to no harm." So permission was finally given.

Before I left I had to dispose of my cage birds and poultry. I gave two Houdan hens to Mrs. Beany, but all the rest of the poultry were disposed of to the higgler, and the runs and henhouses to Parsons. From these sales I had enough money to buy some extra warm clothes, including good wool flannel shirts, with enough left over for incidental expenses on the way and keep me if I did not get work at once. Mother and my brother Mark were able to supply passage money.

The canaries I sold for a couple of pounds with their cage, but the budgerigars I also gave to Mrs. Beany, together with their aviary cage, which she set among her hollyhocks. It is interesting to add that in the scramble and the higgler's hurry to load, a few bantam hens got away. With the removal of their dwelling they strayed down to Stock's wood, where they crossed (as I was to find out) with a cock pheasant. Most of the increase were shot the next autumn, and if any survived they are long since dead, for these hybrids, though not uncommon, are known to be sterile.

I was to start off just after my birthday. I would sail to New York on the American Line S.S. St. Louis. Two of my brothers were in New York then, and I was to spend a few days with them before continuing my journey. I had a steamer trunk, my tickets and meals prepaid, and twenty pounds in my pocketbook.

My destination was Maple Creek, a town in the cattle country of Southwest Saskatchewan. It was Rex Holmes — of the beaded moccasins — who had suggested this, for he knew that part of Saskatchewan, and he said any young Englishman would have no difficulty getting a job there. But he warned me not to expect much pay at the start, and further gave me the names of acquaintances in Medicine Hat and Lloydminster to whom I might turn as a last resort.

The squire drove me to Rye in his high yellow dogcart. Since my father's death, this man had been indeed a guide and friend. He had persuaded "Old Butchers" the cowman to teach me to milk cows. He had taught me to take a glass of beer and call that enough. He had lectured me when I needed it. And on this April morning at the Railway Station he had said, with that slight impediment of his, "Well, Cheerio! B'Bobby," and slipped a five pound note in my pocket.

Although a country boy, I was not altogether a stranger to London. I stayed with an aunt, did some last minute shopping, and went to *Cyrano de Bergerac* at His Majesty's theatre. After goodbyes to many more aunts and cousins, I was seen off on the boat train for Southampton.

As the S.S. St. Louis took to the open sea, I left behind a way of life that I have not seen since. The war was to strip away much that was gracious and traditional. No doubt it also stripped away a certain complacency and selfishness. This was my first experience of

shipboard, and I had a great deal of difficulty in cataloguing most of the nice but peculiar people with whom I lived in close contact for seven days. I had not yet learned that Americans cannot be catalogued. Those who seemed to be veritable mines of knowledge used the most impossible grammar. Many who appeared to be wealthy apparently had nothing except their wealth.

It was on this ship that I was to meet the first of a species now become quite common. I refer to the starry-eyed do-gooder, who so often does harm because he labours under the delusion that if all people would do as he does, live as he does, and think as he does, they would be perfectly happy; and that sin and war would vanish.

His name was Jack Corcoran, an Irish-American who had been visiting England with his wife. I don't quite know what he did, but I think it was something to do with the Knights of Columbus or else some youth movement. Had I done as he did, I would have asked complete strangers for their intimate history, and pointed out to them where their thinking had taken a wrong turn. Had I lived as he did, I would have smoked a nauseous crimp-cut called Prince Albert, which passed for tobacco, and eaten ice cream for breakfast. Had I thought as he did, I would have hated England and wanted to make it a Republic. Jack Corcoran possessed a tremendous acreage of gleaming teeth, and very dark eyebrows, like bits of moleskin pasted on. He spotted me in all my pink-faced innocence, as a country boy, looking with kindly indulgence at my tweeds and heavy boots. He gathered me into his coterie, which included other various young gentlemen, all on their way to New York to work in offices. His wife was gracious and charming, except for a hideous voice, and this good couple constituted themselves our guides, philosophers, and friends. Jack — "Just call me

Jack" — would gather us for a round-the-deck walk, the while he lectured us on wine, women, and various frightful and anti-social maladies. I think I may have understood ten percent of his subject matter.

There was an extremely nice German couple, whose company I really enjoyed. The good Herr had been in Tanganyika, and could talk about it.

The night before we docked, the usual shipboard concert was held. Being asked to sing, and being far too shy to attempt any of the current love songs — "Two Eyes of Grey," and "Because we're a la mode" — I fell back on a good old English song, "The Roast Beef of Old England." I felt defiant that night toward Jack Corcoran, who sang a warning to heavy drinkers: "There's a Red Light on the Track for Boozer Brown."

Next day I was with my brothers in New York. They took endless trouble in showing me around, but bricks and mortar didn't seem too interesting to one intent on seeing the prairies. The vision from the top of the Singer building is no doubt wonderful, but I was wishing to see the real mountains.

What I enjoyed most was a dispute as to right-of-way between an Italian garbage man and an Irish brewery driver. It took place on the East Side, and after the first exchanges of bottles and dead cats, the crowd began to take sides on a national scale, and the uproar was terrific. All the while a city policeman chewed gum and gently twirled his nightstick as he supported the corner of a tall building. Most New York policemen can claim descent from the Old Sod but here at least was a neutral.

As a parting gift my brothers gave me a most splendid pair of boots from a Fifth Avenue store. They were knee high, laced, and of a glossy tan — very superior "surveyor boots," of the kind worn by

the upper stratum of oilmen and hunters. These were considered, by the owner of the store, "Vurry appropriate wear for Canada."

My journey from New York to Chicago was lightened by the interest of two yellow-faced Americans of that uncertain age so commonly observed in the United States. They were from Arizona, and I now suspect they had something to do with real estate. Like so many of their countrymen, they were both inquisitive and kind. They usually occupied the window seats in the glossy smoking room, with its polished brass cuspidors.

They were dressed alike in panama hats and seersucker suits without waistcoats. Their jowls were shaved to a gloss, and so were the backs of their necks. They both wore rings. One smoked Pittsburg stogies from a tall tin. The other chewed from a plug of Peiper Hiedsick, which he extended to me. My refusal did not disturb him. He had broken the ice.

"Where was you raised, Bub?" he asked.

I told him.

"Where are you headin' for?"

I told him that, too.

The gentlemen exchanged glances.

"You're makin' a mistake, Bub," said the first. "That there country won't never amount to a hill er beans. It's all snow." I said I was not going to the Arctic part, but to a part where they raised cattle.

"Well, Bub, if it's cattle you want, you go to Arizony — Arizony with a big A; and it's the ranchinist country on this yere univers. Ain't that right, Tex?"

Tex said he was Godam right. "A young feller like you," he added, "don't want to go to Canady. It's mostly wheat farmers, and they're a triflin' lot. I know. I been to Winnipeg. Nice little town, Winnipeg, but why freeze up there when you could be a baskin' in Phoenix, or

Yuma? You turn your ticket around, Bub, an' head for Arizony."

About this time a white-clad Negro announced "*Fust* call for dinnah in the dining car."

We adjourned.

The most interesting thing about Chicago was riding in a street car drawn by mules with fly nets swinging at their side, a huge sun hat on their heads. I had heard my parents speak of horse-drawn tramcars but had never thought to ride in one. And I had been led to believe that the United States was so far in advance of sleepy old England.

At St. Paul there was a ten-hour wait for the train which was to take me into Saskatchewan via the Soo line and North Portal. I saw the sights, and strolled across a bridge to the Minneapolis side. I leaned my elbows on the parapet and watched the Father of Waters rolling on south, and my mind went with it. I was almost at New Orleans when a strong gust of wind took my English felt hat from my head and flung it into the tide below, where, like my thoughts of a moment before, it tranquilly bobbed its way south. I was more glad than sorry. People were always staring at this hat. I went into one of the stores and picked out a wider brimmed felt in a neutral colour. After that people did not stare so much.

The C.P.R. train from Moose Jaw got into Maple Creek at midnight. All across the North Dakota plains my eyes had been glued to the great spreading scene outside. It was mostly vast wheat farms, but I had expected that. It was getting dark as I changed from the Soo line to the main line at Moose Jaw, but I could still firmly see the flatness and sense the distance to the horizon that lay under the twinkling stars.

I was the only passenger for Maple Creek that night. The only other person on the platform was a tall man in boots and spurs with

a broad brimmed hat. I guessed he was a Mounted Policemen, and later learnt that a member of the force met every train. I asked him where I could get a room and he said, "I'll show you." With my heavy suitcase banging against my leg, I tried to keep step with his jingling stride, but when he saw my predicament he eased up. We crossed a dusty street, and he pointed with his riding crop to a building with a light over the door, and the sign "Cypress Hotel."

"You'll be all right there boy. Goodnight." And he jingled away.

OF MY LIFE IN THE FOLLOWING TWO YEARS I shall only say that I got that ranch job, and since much has been told in *Many Trails* and *Where the Wagon Led*, I shall quote from those to show something of the cattle country of those days.

"How much further?" I inquired for the fifth time. My companion flicked his whiplash at a gopher scurrying across the trail. "A ways, laddie." He said, as he had said four times before.

So I relapsed into silence again, following the advice of the livery man at Maple Creek. He had got me the job with Scotty, the grizzled Orkneyman who had left his native island so long before to join the Mounted Police at Fort Walsh — who now owned a ranch in the Cypress Hills as well as the livery barn at Maple Creek. I meant to keep this job if I could, and if the man's advice to keep my mouth shut and my ears open would help, why then I'd take it.

I hadn't much money when I hit Maple Creek — then, as now, a dry, dusty cow-town — but then, with its outline unrelieved by trees and shrubbery, the wooden sidewalks ending abruptly at the edge of the prairie beyond which the blue ridge of the Cypress Hills made a back-drop to the neat police barracks, over which the familiar old flag of my boyhood waved so bravely. No, I hadn't much money; and life, the prairie, those distant blue hills called

me, and I wanted to see it all. And now with a job already in hand I felt I was well on my way.

We had been traversing the brown prairie since early breakfast, and now the sun was already hanging low over a great blue hill which I was to know as Eagle Butte. The monotony of the journey, and by monotony I don't mean boredom, but rather a drowsy sameness all quite delightful, had been broken at Fish Creek where we had made a noon camp to rest the horses and boil some coffee.

And the journey had been briefly broken on two other occasions. Once when a rider in woolly chaps had stopped to parley, and once when we passed a sheep outfit on the move. Each time Scotty had brought the team to a halt and hailed them. In each case the procedure had been the same — "Hi there, are you frae Aberdeen?" Scotty had roared, and each case the question seemed to be familiar, for the answer had been "Sure" in a pleasing drawl from the cowboy, and "You betcha" from the Basque sheepherder. Whereat Scotty leaned back over the democrat seat and lugged up the big jug of rye which reposed among ropes and blankets and sides of salt pork. And each in turn had taken a pull, holding the jug by a forefinger over the crook of the arm, Swedish style; after which the jug was tucked away and we drove on.

As we neared the hills the country became more and more rolling and the trail wound in and out following the draws. The creaking democrat splashed through shallow creeks and rattled over pebbly washouts, until finally we climbed out of a coulee onto level high prairie where the air was cool and sweet after the dust and heat we had trotted through all day.

My boss, a heavy, hearty man with a handle-bar moustache, handed me the reins. "Take the lines, Charlie," he said. (Most English greenhorns are called "Charlie" in the cow country.) With his

Stetson well over his eyes, he lolled back his head upon the hard upholstery, braced his feet against the dash, and fell asleep.

I took the lines, but did no more. The team — wiry, small-hoofed cayuses — had never swerved all day from the two tracks which made the trail; and I thought they were doing all right. So I simply held the lines away from their swishing long tails and let them alone.

Kip, on the right, was a strawberry roan with white legs and a broad blaze. His mate Bunco was a blue roan with some white patches, that made him almost a pinto. Like all western horses they had long manes, tails, and foretops, and although not over fourteen hands they had cheerfully eaten up over thirty miles of trail already.

As the sun began to slide down behind the hill, Kip and Bunco quite suddenly wheeled into a trail which met ours at a sharp angle and in another minute stopped before a barbed-wire gate with high posts, beyond which a group of weathered log buildings formed a sort of shapeless blur. Scotty woke up. "Open the gate" he said, and took the lines. "We're home."

Putting the team away by lantern light with old Sandy, the collie, frisking at their head, I saw for the first time a watering trough made from one solid cottonwood log, opened for the first time a swinging pole corral gate, and smelt for the first time the sweet herby scent of prairie hay as it was forked down from the loft above the log stable. I stood for a little while looking across the shadowy corrals where vague forms of horses moved, until I could see the bulky black shoulder of the butte against the starry sky.

Scotty touched me on the shoulder. "Supper," he said. "Come on or Ma won't like it." I followed in a sort of trance which we soon dispelled by the bright light of the oil lamp in the kitchen. The boss's wife, neat in a checked apron, was taking hot biscuits

out of the oven of the Home Comfort. Coffee bubbled in a granite pot; on the well scrubbed cabinet big, brown loaves steamed, belly upward, cheek by jowl with fragrant pies. On the table was a platter of smoking beef.

Scotty was already toweling himself, puffing noisily through his moustache, by the time I had taken all this in, and been greeted. He indicated the wash bowl and I dowsed my head and slicked my hair quickly, for I was hungry. "Make out your supper," said the boss. I did.

Soon I was riding with the foreman for stray horses in the Cypress Hills of Saskatchewan. He was a taciturn fellow, and on one occasion, after a sixty mile ride, he directed me to a place where I was to wait for him.

Shortly, the trail forked — one branch to the east, the other to the south.

"I'll be leavin' you here" said my companion. "You keep a-ridin' that way" — he pointed east — "and in about a mile and a half you'll come to Giesner's store. Tell him I sent you, and I'll be there about noon tomorrow. The hosses should be south here somewhere, but if I'm not back when I said, you just stay put."

With that he touched his horse with the spur and loped away across the bench.

I felt very much alone.

Here was an enormous stretch of country. If I got lost I doubted if I could find my way home. However, if there was a store only about a mile away, there must be some people about. Had I known it, there were several ranches, including McGregor's, which we had passed on the ride.

Well, I thought, this is the life I wanted, and I might as well like it.

In half an hour the trail started down a coulee where, among poplar and pines, stood a low log building with a sign STORE crudely painted on a crooked board. Some sheds and corrals showed through the trees behind.

Simon Geisner, the proprietor of this backwoods store, was a strange figure; quite old —probably sixty — he was the most bent and shriveled gnome of a man I had ever seen. His nose was almost flat to his face; his eyes burnt in deep sockets over-shadowed by unkempt brows; his face was seamed with dirty creases. Great tufts of coarse grey hairs protruded from his wide, dirty ears. He wore shabby old bib overalls and a faded blue shirt which may once have been clean. He met me at the door of the store, stared very hard at me and in an unpleasant, rasping voice, asked what the hell I wanted. I told him Jake had sent me and I was to wait here for him.

"Well," he said — reluctantly, I thought — "guess you kin stay. Put your hoss in the corral thar, but I warn you, there ain't much to eat, an' by grab I ain't going to bother cookin' nothin' for a saddle tramp."

So I turned my horse in, and made him comfortable; then went to a door at the far end of the shack which I guessed must be the living quarters — for he had locked the store door as he addressed me, and then disappeared through this other. I knocked but no one answered, so I entered. Geisner was taking some stuff from a corner cupboard. A can of sardines. A handful of homemade biscuits. A greasy looking plate with a dab of butter on it. These he arranged on a rickety pine table, brushing the crumbs and dead flies of an earlier meal to the floor with his sleeve. Having put down two plates, two mugs and some cutlery, he appeared satisfied and spoke two words.

"Sit in."

The sardines were good, but I could have eaten two cans myself. The butter was rancid. The biscuits had been made a week and they were burnt black. I longed for some tea. As if reading my thoughts, Geisner said, "Ain't got no use for tea or coffee or any ev that bellywash. There's water in the pail." I filled my mug, but noticed that while I did so he adroitly slid a small bottle from his dirty clothes, and tipped some into his mug, before following me to the water pail.

I was hoping he might speak. Ask more about the horses or where Jake was or something. I found the silence uncanny and frightening. As I watched his dirty, claw-like fingers scratching up biscuit crumbs I thought of Ebenezer Balfour of Shaws and wondered if my second name — David — was an unfortunate one.

After supper he told me I could sleep in the hay loft above the stable — "and mind you don't smoke." So I said goodnight and turned to go. He did not reply but busied himself putting the remains of the meal back in the cupboard, slamming and locking the door.

I went out thinking that here must be a real miser. It was not quite dark so I strolled up the hill behind the corrals, and out onto the bench. A horned owl hooted. The nighthawks were twanging their bowstrings and peeping as they swept overhead. The bench grass was wet with dew. Overhead the stars, which were later to be my friends and guides on many a lonely night watch, twinkled and shone.

How peaceful, how enchanting was this new country. Yet how grim and foreboding to be a stranger here, unable as yet to judge the motives and characters of a people of whom, some at least, seemed incapable of any gesture toward friendliness. I thought of

how Du Chaillu's West African savages invariably met him with presents of chickens and fruit. I was not to know that into this free and peaceful country had from time to time come some of the most unscrupulous people in North America — fugitives from scenes of former crimes, offscourings of earlier frontiers. Nor was I to know that this man Geisner was hated and feared for many miles — if not for any known criminal act, at least for his miserliness, his bad temper, his suspected connection with horse and cattle thieves — in fact, to use an expression of the country, his all-round "orneriness." The store was more of a blind than anything else, though I didn't know it then. He raised a few horses, a few cows. But in no sense was this place a ranch. It was, rather, a "roost."

IT TURNED OUT THAT THE FOREMAN WAS IN LEAGUE with some Montana horse thieves and had been robbing his employer, who took his problem to the Mounted Police at Maple Creek.

The police did their best, but the odds were against them. The patrol that went out to Scotty's Ranch was too late. Jake had departed. Probably he wanted me to go with him that last morning so that he could pump me. Scotty must have made some pretty pointed remarks, and when he held me back Jake must have realized that trouble was on the way. Not only was Jake gone, but his saddle and spare clothes — and the sorrel saddle horse which was Scotty's property, the horse we called Fox. For this last theft a warrant was sworn out for Jake. The police rode many miles on their investigations, but it was as though the earth had swallowed Jake, horse and all.

The patrol to Kealy Springs was as unsuccessful. The police could get nothing out of Geisner; and Coyote Bill and the other men had had three days to decamp, and get their "hot" horses over

the line. Communications were not so speedy then as now. The various detachments here were not linked up by telephone, and in any case the N.C.O. in charge was apt to be out on patrol. A wire to the Sheriffs in Montana, at Chinook, Havre, Plentywood, or Malta had to be sent by way of Moose Jaw and Minot, North Dakota, and sometimes was many hours in reaching its destination.

Apparently the authorities south of the border took this matter very seriously, as later events were to prove. It is a big, wide country from the Canadian border to the Great Northern Railway line in the States — badlands and buttes and semi-desert — a country where a man can travel many miles and still keep out of sight. The stolen horses were probably branded (with a brand registered under an assumed name somewhere south of the border) and very likely herded in some quiet, grassy valley till the brands "haired over" and lost their new look. A few weeks after branding the scab lifts and leaves a vivid pink scar, which takes some months to tone down and "hair over" again. Thereafter that brand will show, either because the new hair may be a different colour, or grizzled, or because of the set of the hair.

It was quite probable that the thieves had intended to brand this bunch of young stuff at Geisner's before moving them. My presence may have made them a bit nervous so they pulled out right after Jake and I left, for according to signs which the police found, a bunch of nags had been held for some hours in a brush corral in Cow Coulee, on the south side of the bench. The men wanted them away from Geisner's, evidently, but held them till nightfall before attempting to cross the open country toward the border.

I was learning a lot of things.

As for the police and the U.S. sheriffs, they renewed a vigilance along the border which had dropped off in the last few years. It was

to be not long before this vigilance was rewarded.

Just before we left, Staff-Sargeant Flint called us both to his office. He told us what he could of the above happenings, and ended up with some words of advice to us both.

To Scotty he said, "Old timer, I joined the force about the time you left it. You are the old-fashioned, out-of-date rancher whose word is as good as his bond, and you think everybody else is the same. It is a good way to be. But it is expensive. If people were all as straight as you think I would be out of a job today! I know that at one time you had a lot of faith in Jake Meldrum. You told me so yourself. You had no sons, you said, and here was a likely fellow, and if he'd do right by you, well, he'd probably get a share in the spread someday. Jake might have been alright once. But you see, you were too easy and too trusting, and your 'likely man' couldn't wait for 'his share.' Human nature is often like that.

"So you get yourself a good ramrod, Scotty — a man with references, not just a saddle tramp from God knows where who will try to 'work you' like Jake. You don't need to mind asking for a reference and the right man will be glad to give it. Then see that he does his work. Oh, I know you're getting old and can't ride — but first off have a round-up to gather all your horses in. Put on enough men to be sure you make a clean sweep. Then brand everything that's 'slick' — provided you know they're off your own mares. See that all the young studs are taken care of. Then get a brand new tally book and enter up the lot, that'll give you a fresh start. And after that let us know right away when anything looks suspicious. Darn it! The police can't help you fellows if you leave your stuff all over the place and unbranded. Just trusting to people's honesty!

"What's that? You hate writing? No hand with a pen? Well, get Charlie here, or someone, to do that — but get those nags *tallied*

and branded and *keep 'em* tallied and branded, for your own sake — else you'll go broke — and for our sake so's we don't do a lot of work for nothing.

"Now, so long Scotty! And no hard feelings, eh?"

"Man, no!" laughed Scotty. "I ken well 'tis my own fault — trusting to luck and honesty like you said! But I got to tell you I believe I *can* get the right kind o' man. Do ye ken Lee Blackwell? Him that used to break horses for the 'Q'?"

"I sure do," replied the Sergeant. "He's a good enough rider, I know — and honest, I am sure. We had him riding the rough string at Regina when I was at Depot coupla years back. Inspector Fowell — 'Turkey' — thought a lot of him and I believe he tried to enlist him in the force, but Lee said he'd done enough soldering and saluting in South Africa. But what makes you think you can get him?"

"Eh! — but I'm pretty certain! The wagon boss of the '76' was in town last e'en and he was telling me Lee had been with the Matador outfit but they were closing out some of their lease at Swift Current so he was at a loose end, and he was spearing for a job with the '76.' But Galbraith says the're near through with the round-up so they don't need him. I sent word back wi' him to tell Lee to ride over to Graburn and see me."

"Good — good!" the policeman ejaculated. "You'll be in luck if you get him. Maybe I lectured you too soon! Looks like you mean business, anyway."

He turned to me. "Now, my boy," he said, "you've been a help to your employer. Go on being. You're young and you're green, but I bet you know right from wrong, and don't forget it. If you ever need help, come to us! And don't forget to write home!" he added with a smile."

In due course we had a new foreman named Lee. He was a fine companion and a good teacher. Under Lee's tutelage I broke out a four-year-old gelding to add to my "string." The pony did not buck much when I first rode him in the corral, but I thought it was bad enough. He was very nervous, but Lee said something I never forgot: "You think you are scared! Don't worry — that hoss is a damn sight scareder!"

Next time Lee snubbed up the colt to his saddle horn, and I crawled on somehow. The sorrel couldn't do much, and after about a mile Lee passed me the halter-shank, and said in that easy way of his which horses like, "Take it easy. He don't know he's free yet. Sit tight but relax. He'll follow Cap (Lee's own mount) anywhere now, so don't bother to try to rein him till he gets used to packing you."

Next day we left the colt (which I called Red) saddled and bridled, with one rein tied to a stirrup. He was in a big corral and had freedom to move about, but always the rein brought him around in a big circle. We went about other work — we had some foals to brand — and at noon, after he'd had his hay, Red was turned loose again, this time with the opposite line tied back. It wasn't long before his mouth began to toughen up enough to bear reining on, and he knew what a slight tug meant.

Next time I rode him he went pretty well. Lee said — we were getting near a small band of horses — "See if you can work Red around to the left and bring in that there grey mare and foal." Red didn't want to leave Cap. He seemed to think his life depended on following exactly in his tracks, with some difficulty, for he kept trying to rear and throw his head, I worked the colt partly around in the right direction when he got stubborn and started to back up. Lee said quietly, "Don't let him put it over you. Tighten your grip and then use your quirt — leave his head free or he'll start to

buck around." I obeyed. With the first crack of the quirt [a short-handled riding whip] he bucked, but I had my seat. Lee saw I was uncertain and called, "Hit 'im again — hit 'im every time he bucks — don't stop till he goes the way you want."

If you are green, and a horse starts to argue with you, you quite naturally think of his size and strength and you think you can't win. But when you get to know, you realize a horse can't think of two things at once. If you can change his thought you are master in no time.

So I quirted that pony a couple more times, and he didn't like it and I thought, *here's where I get piled* — but just then he lunged in the right direction, straightened up and loped toward the old mare. She ran to join the bunch and Red, right behind her, realized he had done it and was quite pleased.

In an almost incredibly short time — about a week — that colt which was not even halter-broke when we first caught him up was driving stock, if not quite like a veteran, at least very well. It was interesting to see how he gradually gained confidence and got to know his job. Lee said, "All this fancy breaking and lunging may be OK, but for my money take a green horse and put him to work with stock right away — that way he don't have time to think about monkey pranks."

Red was always hard to catch. He had to be corralled and roped each time. But he remembered lunging and fighting against the hard-twist lariat when I had halter broke him, and after that, no matter how fast he was dashing along the corral bars, he'd stop dead the minute the noose settled over his head. Of course, while a young stock horse was put to work right away, it was not to be compared with eight or ten hours on a plough. You were constantly on and off for one reason or another, and the companion-

ship with your horse was close and intimate. You would go a few miles at a job. Then a gate to open. Then perhaps a short rest by a creek for a drink and a graze while you sat on a knoll with a cigarette searching the landscape for the sight of some stock, so as to save miles of riding. Then away again to look through a bunch of horses. Nothing wanted there — so an easy trot over low hills to explore up draws or around water holes. Always doing something, always looking for something, but never hurrying. At noon, saddle and bridle off, and either hobbled or picketed to graze; although with one old wise horse along, the green ones could often be turned loose with just the halter shank dragging. Young horses are like young people. They like to appear brave and dashing, but not often will they break ties altogether with their elders, and few young horses would make a dash for home on their own hook.

A young horse, perhaps the third time out, hardly knows what to do when unsaddled and hobbled. He seems afraid to move, let alone get down for a roll or start grazing. He thinks he is still under discipline.

Another thing which helped in breaking a horse — he was always in and out of strange places, and seeing strange sights. A lumbering wagon or a high top buggy might scare him the first time, but not again. Barking dogs, chickens or geese in a strange corral would make him snort; but as soon as he got his hay, good appetite soon overcame fright. Mostly our saddle horses lived by grazing, and none of them knew what oats were; but the odd overnight or noon feed of hay at a ranch was something they really enjoyed.

We never put a horse to gallop except when chasing something and were forced to. By riding at a slow trot — *troto sereno* Lee called it (he had been in Mexico) — our horses were always cool. Then if we spied a bunch of real "spooky" horses, led by some old

ridge-running mare, we had plenty of reserve in our mounts and could usually head them the way we wanted. Those old leaders — the matriarch mares — were up to all the tricks of the trade. We thought we could "read" the country pretty well, but what those old sisters knew about it made us feel pretty green sometimes.

We would start a band down a coulee which led to level ground. They'd trot along and turn a corner perhaps; and the next thing we'd know they would be clattering away up above us, headed for the broken country again. The old leader knew there was a side coulee up which she could dodge. Once in a while we would lose a bunch like that because dusk was coming early. And of course next time the old girl could be depended on to pull the same trick again. Only this time one of us would not go down the coulee at all but slip back and around to the head of the bolt hole and outwit the old devil. They usually knew when they were outmaneuvered, though, and after that they'd string out for the home corral. I remembered the same sort of thing happening when riding with Jake, and he didn't seem to mind them getting away. It was clear to me now that this was what he wanted. It made them wild and foxy, which suited his purpose.

Not only did I learn a lot of horse nature, but I was able to see any amount of wild life on these rides. Flocks of pipits and long-spurs would rise out of the dry grass and sweep away like wind-blown leaves. They were migrating southward from their Arctic breeding grounds. Geese and ducks were gathering on the lakes preparatory for departure, and we would hear the sharp whit-whit of mallards wings above as we rode home in the dark. The grating cries of southbound cranes filled the air for days.

Once in a while one of us would pack a scatter-gun and get a brace or two of prairie chicken (sharp-tailed grouse) which Lee

showed me how to skin and spit above a fire of *Bois de Vache*, the plainsman's fuel, which was always handy.

These buffalo chips, to use an old term, were really just that in the days of the Red River carts and hunting Indians. This had been a great bison pasture once, and the beasts' old wallows were everywhere — shallow depressions perhaps a foot deep in the centre and six to eight feet in circumference — now grassed over. Also there were the great buffalo stones here and there, where bison were once wont to rub and scratch, till they had worn a deep trench all around and polished the rock till it shone. And quite often we rode by bleached old bison skulls which had met death here perhaps forty years ago. Indians, in pursuit of the herds, had camped frequently in this area; we often saw the stone rings marking the sites of their tipis.

One such camp, judging by the rings, must have contained about one hundred and fifty lodges. Some of the oldest camps would have been those of the Gros Ventres, but most of them were Cree or Blackfoot, for here was a meeting place of the two nations. Though "meeting place" ill describes that no-man's-land in which these old enemies both hunted, and which the tide of mastery swayed back and forth till recently.

Sometimes we saw pronghorn antelope, but this heavily grassed foothills country was not their favoured habitat. They preferred the sagebrush and soapweed flats further south, where the grass was short and the wind never ceased to blow, for antelope are creatures of the wind and the empty places.

It is in the fall, too, that the eagles come here from the mountains for their winter hunting. Mostly golden eagles, but sometimes one of the bald kind. We could usually tell when we were approaching the carcass of a dead animal, for these birds, gorged and sluggish,

would rise and sail slowly away on their great pinions.

In late winter I was to see my first — perhaps worst — blizzard, in which hundreds of cattle died. The storm blew with ever increasing ferocity for several days, during which it was nip and tuck getting from the bunkhouse to the barn and back. We fixed up a rope by tying several lariats together, but even then the wind couldn't be faced, and going out to feed the horses we went backwards. On the third day — the worst — we couldn't get feed to the calves, but they had a shed for a windbreak and a couple of days starvation wouldn't hurt them, we knew. After that the wind dropped and it warmed up a bit, but continued to snow, only this time it was large wet flakes, and sometimes cold rain. We managed to get my load of hay unladed at the calf corral that day.

Lee decided that next day we would ride out and see what we could find, but that night the wind came out of the northwest with greater fury than ever. Next morning it took us till noon to dig out the bunkhouse and stables, for the snow had drifted right to the top of the doors on the lee side, and it was packed so hard we shoveled it in chunks. About noon the wind dropped and the sun came out, and by evening the prairies lay peacefully smothered by a great snow blanket, all rippled and carved and sculpted by the wind. The sun set red behind Eagle Butte, and as the full moon rose, northern lights — always a good sign — flickered and wavered across the sky.

The next day we thought, now we can ride. But we hadn't gone far before our horses were played out and bleeding above the fetlocks from the sharp edges of the crusted snow. "This doesn't look too good," said Lee, as we turned our weary mounts about. "It's got to soften up some before we can do much."

And so another anxious day passed before the sun finally made

travel possible. And that morning a rider from the East and West Ranch made through to us by following the edge of the timber where the snow was not so packed. Even so, both he and his horse were weary, and he was glad to throw himself on a bunk.

He told us that about eight hundred of their cattle had drifted through the hills by way of Graburn Gap — three miles west of us — and would be scattered over the open country south. Pete and George wanted our riders to lend them a hand to locate them. They were short of help, but young Mitchell (our visitor and informer) would stay over and go with us, while the brothers would join us somewhere below the gap. Mitchell added that they thought Scotty's cattle would have all made the winter camp. Lee explained the situation to Scotty.

The boss thought a while, then true to his salt, he said, "Aweel, laddie, 'twill be easier going like though the Gap, and if the boys want help we'd better give it. Forebye, any of our cattle that have lived through the storm must have gone through the Six Mile, and if they follow the Havre trail there'll be no guessing where they'll be. However, the Oxheart riders and Badger men will be out, I'm thinking. So we'll let the folk east take care o' ours, and we'll gie help closest to home where it'll do the most good. Take Charlie and Chuck wi' ye. Banjo can stay at the camp, and I guess I can tend the calves for a couple days."

That afternoon we set out with Mitchell, through the Graburn Gap. We saw some cattle sign, but the wind had obliterated most of it. There were no horse tracks, so we knew we were ahead of the boys, as the proprietors of the East and West were commonly called. At one place we found a cow standing upright in a snow-drift frozen solid; she stared at us with great eyes which were as hard and glassy as marbles.

It was the warm day between the storms which had done the damage. The tiny ice particles of the first snow had penetrated through the hair to the hide, until the animals' coats were plugged full. It had started to melt on their backs that mild day. Then when it suddenly turned cold again it froze solid and became a heavy mass of ice, built up by the second snow.

Now the heat of the sun was thawing the ice loose — that's why we could see the cow's eyes — and as we looked at the poor dead critter, a mass of ice which must have weighed fifty pounds suddenly sloughed off her hips, taking hair and hide with it.

"Good Gosh," said Lee, "if there's many more like that it'll be a real die-off. Anything still alive won't hardly be worth saving if the snow goes quick. If it don't, well, holler-gut (starvation) will finish 'em. Let's go."

And as we came out onto the plain beyond and topped the first rise, what a ghastly scene presented itself. It was a Dante's Inferno — the rolling plains, the Milk River Ridge a blue knife-edge on the southwest horizon, the sky blue and clear, the sun hot. The glare of the snowfield stinging one's eyes. And looking, we suddenly saw — here — there — along that coulee edge — in the lee of that patch of brush — at the edge of that wash — dark, deformed bits and pieces of shape. All that was left of eight hundred cattle! Not all together, of course. We could see perhaps twenty-five from this low ridge, but we knew the scene would be repeated and repeated. Sometimes a humped-up back, and a bit of a head. Sometimes only a leg protruding from a drift, or part of a horn. These were dead cattle. But worse than the dead were the living. Poor beasts! Stuck fast in the drifts, or trying to rise from shallower snow as we rode up, feebly making a gesture of defiance, trying to give a toss of the heads at the approaching horsemen, that ultimate standing at bay

which is instinctive to creatures about to die.

Many of them were practically — if not totally — blind, their eyeballs frozen. Great chunks of ice welded together ears, horns, and forehead. Hair, hide, and meat was stripped in chunks from the backs and ribs. Their tails were frozen like broom-handles. Most of them had been hock-frozen, and when they tried to move their joints creaked like rusty hinges. We looked for a minute or two. The East and West rider said softly, "Them could be any of us." Lee slowly pulled his Winchester from under his stirrup and levered in a shell. "I'm mighty sorry, old gel," he said to a brockle-faced cow which stared at him with her sightless eyes. "I'm mighty sorry," and you felt he meant it.

Bang!

"We finished off several more, then went over the next ridge. We heard a couple of shots from our west and partly behind us. "That'll be the boys," said Lee.

"It was dark when we turned into Bill MacRae's horse ranch near Egg Lake. But we had another long day ahead of the same kind, before we finished, "helping the neighbours."

But miracles happen, too. There's a big spring surrounded by a thicket of Buffalo thorns at the head of a coulee leading west from Battle Creek. Lee and I went to investigate and found four or five big steers safe and sound, only a bit "ganted," as Lee put it. They must have been among the first to drift here, and they had found good cover. Naturally, steers could live where a cow would die. At this season cows are heavy in calf. Over in another coulee we thought we saw a drift move. We picked our way between some dead critters and Lee kicked into the drift with his foot. His horse reared back as through the opening in the heavy crust a two-year-old heifer pushed an angry head.

We dug around a bit and helped her out. When she was free she promptly charged the East and West man who just made it to his horse in time. Then, looking thoroughly pleased with herself, she turned back to the snow cave and uttered a low note. What should stagger out, bright eyed and licked dry, but a newborn calf. "I allers say," Chuck spoke gravely above the cigarette he was rolling, "I allers say it takes a storm to start the calves a-coming."

After many days of pushing a tired horse through heavy snowdrifts in an endeavour to save as many beasts as possible, after many days of enduring the glare of the fast-northing sun reflected from the white snow, it was good to get back to the bunkhouse and bathe our sore eyes. The bunkhouse was our only home, though a mere log shack at that.

In describing the sparse furniture of the bunkhouse I may have given the impression of a bare and empty sort of cabin. Such was far from the case. There were always saddles hanging on pegs or lying on the floor in process of repair. Cans of Neat's Foot oil lay in a corner with cleaning rags. On the numerous spikes driven into the log walls hung a varied assortment of gear, all smelling strongly of horse. Bridles, bits, spurs, hackamores [bridles without a bit], odd bits of rope, hanks of leather for repairs. Chaps, heavy checked shirts, Stetson hats of every hue and age, from Chuck's new pale fawn to Lee's battered black "four gallon." Fur hats, mitts, sheepskin jackets for winter use, hung near the stove to dry out and warm up. Oilskin slickers were hung out of the way till next summer, and in their pockets mice might nest.

The long winter evenings were spent playing cards, reading, repairing gear, or perhaps making a hackamore or braiding bridle lines. All cowboys excelled at some such hobby. On a typical evening Chuck was cleaning his beloved thirty-thirty Winches-

ter, lovingly wiping away excess oil and polishing the stock. Banjo was braiding a bosal — a nose band. Lee replacing the stirrups of his saddle. My hobby being natural history, I was skinning out an antelope head with a good set of horns which had recently fallen a victim to the aforesaid thirty-thirty. There was much disgust when I boiled the skull. They called me "gut-eater" and threw boots at me. But when I finally sewed up the skull, fitted the eyes I had sent to Chicago for, and mounted the finished product on the wall, their praise made me blush. I had also tanned the skin of a bobcat with the head fully mounted in a vicious snarl. His Latin name was *Lynx rufus*, but when an Indian said they called it *pah-pah-kao-pisoo,* or spotted cat, I thought that much the better name.

Once I packed a big old buffalo skull back on my saddle. They said "What in tarnation do you want that thing for?" I didn't quite know myself. But it was a beauty. In between times I used to make sketches — birds and animals mostly, but quite often of some little incident on the range. The boys were kind about them and said I was as good as Charlie Russell, but I knew I never could be.

And as our fingers worked with oil or leather or brush the talk invariably turned to horses and cattle, grass and gear. The merits of Hambley and Co's Ellensburg tree would be totted up against the Visalia or the Cripple Creek. Frazier of Pueblo, Riley and Mc-Cormick of Calgary, Adams or Great West were names that could start an argument.

Cowboys love a fine saddle. Good craftsmanship and durability comes first, of course. Many a man has owed his life to the faithful hidden work of a good saddle maker. Only the best seasoned oak must go into the tree, to be covered with heavy green hide sewed on wet. Then the saddle leather proper — best

California oak-tanned. Having got your basic saddle, high in the cantle and with an adequate horn in front to hold the dally of your rope, you could then have your choice of a fork or any of the more up-to-date swells. You could have a plain or a roll cantle. One fellow always said, "Give me a Cheyenne roll — one had on that one of the horn an' they really *got* ter buck." Horns could be squat and broad, Mexican style, or high and slim. They could be rawhide braided, rawhide wrapped, leather covered, or just plain shiny nickel or bronze. The latter were cold in winter. Skirts could be square or round. Rigging — what holds the saddle to the horse — could be double, three-quarter, or centre-fire. Cinches could be mohair, fish cord, or cotton. Latigos did not vary much and were of two-inch oil tanned. They were not buckled but tied to the cinch rings. Neither were the stirrups leathers buckled. They were laced to the rider's fit; much safer with no danger of a buckle tongue tearing out.

Stirrups could be Oxbow (round bottoms) or Cheyenne (flat). Mostly they were of oak, either brass bound or covered with rawhide, but some of the boys favoured a simple metal ring about six inches in diameter. Finally, the saddle could be perfectly plain, or "basket stamped" or (final glory) decoratively hand-tooled into a design which might embody prairie roses, bucking horses or lovely girls, or all three.

Saddle blankets came into the discussions, too. One fellow would say he favoured a genuine Navaho, thick and with an Indian design, from New Mexico. But they were expensive. We looked at them in the States catalogues and wondered could we spare twenty, thirty dollars when our old wool blanket seemed to suit the horse alright. These catalogues were thumbed and re-thumbed during those discussions.

"See what I mean?" Chuck would say, "Frazier's a-puttin' out a new tree with a low cantle — that may be jake for a flat country, but if you wanted to get to the top of ole' Eagle Butte you'd be a-slippin' off your hoss's rump."

Quirts and hackamores (Spanish *jaquima*) and such braided stuff was often home-made, but it was a tricky matter to draw too much attention to a man's technique in this regard. It smelt of Deer Lodge, for prisoners in the Montana State Penitentiary were taught this work and earned their pocket money by supplying the big saddler firms with their handiwork. A horseman's gear seems to be one thing where hand work is essential, and as long as cattle run on the range the saddler will be at his bench.

Banjo was telling us about the English officer who was buying cavalry remounts in town. "We were all down at the stockyards and this here Officer says, 'Let's go, boys. I'm in a hurry.' So we all got ready. There was a nester kid from up hear the Sandhills with only one hoss — a pretty good-looking one, too. So we let him go in first. He led that cayuse in on a halter and just stood there. The officer walked around him. The old hoss just stood hipshot an' easy; a-whiskin' his tail — though there weren't no flies — and with his eyes half shut. 'Do you want I should ride him?' asked the farmer, 'but I ain't got no saddle.' 'No,' roared the officer, 'take him out! You are just wasting me time. I want to see some *horses*!' After a bit the kid, he gets talking with Frenchy — that Oxheart fellow — said he needed the money bad and wished he could sell the hoss. The Oxheart man looks the hoss over. It carried Q and that's a top brand. 'Tell you what,' says Frenchy, 'for five bucks I'll sell that hoss for you.' 'Done,' says the kid, 'if you can, that is.' Frenchy waits his chance, then when he sees an opening he jumps on the Q with just the halter, neckreins him into the ring walk, trot, canter, then pulls up short.

"The officer took it all in. Horses was supposed to be led into the ring first off, ridden later; and the officer barks away at Frenchy, but that boy's got a nice grin, an' sitting so easy like with the hoss's head up and ears well pricked, he just talks sort of apologetic and soft and says, 'I know, mister. But Kitchener yere he like to ramp on my feet — not mean, you know, but he's got lots o' gimp, so I . . .' 'Never mind,' says the officer, and walks around the horse. "Now boy,' he says, 'take him around again. I want these gentlemen to see what I see. That's the kind of hoss we're looking for. Don't waste my time with nothing else.' Then to the cowboy: 'Take him over to the vet's corner and soon as he's passed you'll get your cheque.' "

Talk would drift off. We'd crawl into our beds one by one. Someone would say, "Dowse the glim," and with darkness came sleep.

BUT THERE WAS A LIGHTER SIDE TO LIFE in that country of pioneer ranchers. One girl who was doing well as a secretary in Winnipeg came back for a holiday bringing in tow her beau, a young bank clerk. Both were attired in the latest city finery. The young man was introduced and they sat down to dinner. The old folks didn't say much. For daughter's sake they were on their best behaviour. When they'd finished eating the young fellow produced a packet of "tailor made" smokes and offered one to the old man. "No thanks, no thanks. Roll my own," said the rancher, and producing a sack of Durham deftly rolled his cigarette, naturally enough scattering some of the weed down his front and on the tablecloth. He struck a match where he always did — on his pants — ignoring the new fangled lighter held out to him; and puffing away, went to the open door. One of the hands was just going by and the old man called out, "Say, Bud, take the team and haul that load of manure out to the garden, will ye?" Father and boyfriend then adjourned to the

porch while Mamie helped her mother with the dishes. Daughter was silent for a while. Finally she spoke. "Mother," she said, "can't you stop Dad from rolling those awful untidy cigarettes of his? I was *so* mortified." Mother paused with her hands in the hot suds. "Why, Mamie," she said "it took me years to *get* him to smoke cigarettes instead o' chawin' terbeker and spitting half the time, what's wrong with him makin' his own?" "Oh, Mother," said Mamie desperately, "you don't understand! And then I was downright ashamed at what he said — and in front of Arthur, too."

"What did he say wrong, girl?" Mother looked puzzled.

"About manure! Can't you teach him to say fertilizer?"

"No, I can't, and I don't intend to try. It took me over twenty years to teach him to say manure."

Mrs. Manser, a Scotswoman, kept the local post office on her husband's ranch at McKay Creek, about seven miles downstream from Gow's ranch. Mrs. Gow, who came years ago from Scotland, had brought with her a voluminous petticoat of black silk. Mrs. Gow liked to have a few geese around; never more than one pair, which annually raised a few fat goslings on the creek.

One winter's day a coyote carried off her gander, which had had the temerity to leave the goose house on a warm January day. Mrs. Gow was at her wit's end. She was not the kind of woman to spend good money on another bird, so she bethought herself of the petticoat. She took me into her confidence — not, of course, to the extent of letting me see the garment. But she assured me it was of the finest silk — "and it has'na been worn, no, never since I spent good siller on it in the Edinbro' ship," and did I think Mrs. Manser, who had lots of geese, would trade her a gander for it? It would makeover into a lovely dress. Next time I went for the mail I put it up to Mrs. Manser.

"Laddie," she said, "if that garment is as good as Mistress Gow says, tell her I'll take it and gie' her a bonny young gander."

Mrs. Gow was pleased. Riding for the mail again the next week I carried the garment, well wrapped in brown paper and tied behind the saddle. I presented the parcel to Mrs. Manser, who dodged quickly into the bedroom with it. When she re-appeared she said, "I'll trade whateffer," and came with me to the chicken coop to pick out the gander. This creature was put in a gunny sack, and I had to take the heavy squirming thing across my lap, which put Buck in a bad humour. However, I got it safely home and into the goose house, a low log hut on the creek bank.

Mrs. Gow donned mitts and a heavy shawl and came out for inspection. She looked for all the world like some seeress peering into a cauldron. "Aye," she said at last, "'tis a bonny bird, a grand bird, and I'm that grateful to Mistress Manser belike I'll gie her a fat gosling in the fa'."

Shortly the old goose began to lay. I was supposed to get her egg every day for fear it would freeze — it was only March — and soon almost a full clutch lay in a big bowl on the kitchen sideboard. Then came the day I found two eggs in the nest. When I brought them in Mrs. Gow said "Losh, laddie, did ye no look yesterday?" I said I had, but added, "I'm afraid that gander Mrs. Manser sent you is a goose."

"That did it. Mistress Manser, so Mrs. Gow declared, was a bad woman. "Might the Lord forgive her, for she couldna." A deceiving body, that's what Mistress Manser was, a light Quean [an ill-behaved woman]. Och aye, Mrs. Gow didna care sae much for actual loss, but to be made a fu' of — and she thocht Mistress Manser was her friend. But if she — Gow's wife — had been made a gowk of, she could still hauld her tongue and gie nae kind o' satisfaction to That Woman.

When not out on the range, it was my job to take Mrs. Gow to those occasional services at Mansers. So this Sunday morning I harnessed the driving team and went to tell Mrs. Gow it was time to go. "And ye hae nae need to tell me, laddie," she said. "I ken the day and the hour. But ye can put the team awa'. I'm no for the sairvice the day."

The climax came with the Rev. Mr. MacWhinnie's next visit. That gentleman was a devoted minister of the Presbyterian Church. A dour lanky Scot, he made his headquarters at Medicine Hat, from where he periodically visited the scattered ranches of a parish as big as an English county. He drove a team of shaggy ponies hitched to a top buggy. Sometimes his team would stop on the trail, pushing sideways to crop the grass, while the good man read one of the theological books in which he could almost be said to live. Looking up, he would see the sun getting low, pick up his loose lines, seize his whip and drive like Jehu to his stopping place for that night. A rare and loveable type was the Rev. James Hector MacWhinnie.

It was the Sunday before Easter, his invariable date for his spring visit to this part of his parish. He usually got to Manser's on a Saturday night, held a service and Sunday School for the Manser children on Sunday morning, and in the afternoon drove down to Gow's where he had supper, held prayers, and slept before continuing across the bench to Faulkner's and the wild horse country.

All through supper the minister was very quiet. Finally, when the meal was over, he pushed back his chair, slowly and deliberately took a pinch of snuff, passed the snuff-box to Mrs. Gow and said, "And noo, Mistress Gow, why were ye no to the sairvice the day?"

"I didnae care to gae, thank ye."

"Didnae care? Losh, woman, tis not matter o' carin'. If ye were no ill, what ailed ye that ye wouldna go to the hoose o' God?"

Mrs. Gow sat very straight and looked the minister in the eye. "I'm a God-fearing woman, sir, and I ken me duty. I *wad* gang to the hoose o' God sir — but I'll no gang to the hoose o' Manser!"

During my second winter the news from Europe was bad. My brother John was in France with his battery. Jim was with his regiment in the trenches, Stephen flying a "kite" with the Royal Flying corps. I was old enough now. I had been turned down once for age and height.

A friend wrote me, "They have lowered the height standard to five foot six. Reckon you can stretch half an inch?"

Within forty-eight hours I became regimental number 276119 and a member of the Canadian Expeditionary Force.

-

Part III

Soldiering (1916 – 1919)

THE 217TH BATTALION, WHICH I JOINED AT MOOSOMIN, went under canvas that summer at Camp Hughes, Manitoba. The camp area was one of rolling sand hills with clumps of poplar and a few spruce, standing singly.

The total number of troops at this camp was in excess of 15,000 — infantry, cavalry, and artillery. It was something to hear the bugles and trumpets blowing Last Post at sunset, each unit in turn, so that the sound came muffled from the farther ones, like an echo of those close to us.

I still remember the thrill of being reviewed by the handsome, aging Duke of Connaught, who was then our Governor General; and the massed bands, as they thundered out "God Save the King," followed by "O Canada," were something to stiffen both the back and the resolve. It was hot, and the wind blew sand in our faces, but at the end we sent up cheer after cheer in spite of dry throats, and perhaps a few gritty eyes.

November came with a foot of snow and zero weather, and we were hard put to keep warm in the bell tents; but after a week of that we entrained for winter quarters at Regina, then a city of about 10,000. There we were billeted in the old Winter Fair Building, sleeping on the draughty bleachers and drilling on the big central show-ring space. This big old building squatted by Wascana Creek

hard by the Mounted Police barracks over a mile from the city proper. In those days there was no building on Dewdney Avenue west of Government House (the residence of our Lieutenant Governor) until you came to the Police Barracks. A street car ran down Dewdney, but the last car had to be caught about ll:30 p.m. up town. Quite often, on a late Saturday pass we would miss that car, a group of us, and have to hoof it in the cold wind. We certainly got to know the street names, for we warmed ourselves by singing a bit of doggerel made up by the wit of my platoon —

"Albert, Angus, Rae, Retallack —
March you son-of-a-bitch!"

And so on for the other cross streets.

Among the people I got to know in Regina were the Sheldon-Williams sisters, Dorothea and Cecilia, and their brother Inglis, the artist. This came about through a letter from England suggesting I look them up, as my father had known Inglis when the latter was studying art in Europe.

Dorothea was a secretary to Sir Frederick Haultain, while Cecilia was teaching. She subsequently started the Outpost Correspondence School in the old Normal School building on College Avenue.

The Sheldon-Williams had originally come from England to the Cannington Manor settlement, and when that venture folded up they gravitated to Regina. They occupied a large suite in Cornwall Court — then a new and up-to-date apartment building, and many a fine musical evening I had with them, and many a fine discussion on painting and other activities. It was a wonderful change from the austerity of barrack life.

It was they who one evening invited me to hear a talk on prairie birds and wildlife to be given by the Chief Game Guardian, Mr. Fred Bradshaw, a lean lank Yorkshireman who, it was plain to see, was dedicated to his work of conservation. Bradshaw had commenced the nucleus of a Natural History Museum, of which the few cases of specimens were housed then (and for many years after) in the corridors of the Normal School.

I listened entranced to his discourse, and plucked up my courage afterwards to meet and talk with him. From this meeting I later (after the war) became a regular correspondent of the museum.

If a monument were needed to commemorate Fred Bradshaw, it is in the fine modern Museum which today graces the corner of College Avenue and Albert Street in Regina. Although Fred himself never lived to see it, and it was Fred Bard who brought it to completion.

And the Sheldon-Williams are not forgotten either. Inglis for the paintings he left; one of which, now the property of the Norman McKenzie Art Gallery, shows horses in a prairie blizzard seeking shelter at a straw stack. A fine reminder of pioneer days. Inglis later died in Italy. Cecilia is remembered in the fine Sheldon-Williams High School. Another brother, Ralph, was overseas with the Canadian Machine-Gun Corps, and was later killed in action. He was no mean poet and I still have a small book of his war verses given to me in 1916 by his sister.

Regina looked more truly the Queen City of the plains in those days, for one could almost always catch a glimpse of the flat prairie from a second or third story window, or compressed between the buildings at the end of many streets. Now one sees less, for the trees which were mere saplings then have flourished and grown and spread their tops so as to conceal the vast surroundings, over

which the new developments now march like regiments.

In March of the next year we got our sailing orders and boarded the troop train for an unknown Eastern port. We stood in long lines in the deep snow of the station platform and said goodbye to the city which had been so good to us; and for some it was goodbye to sweethearts and mothers and sisters, while the band played "Tipperary" and "Keep the Home Fires Burning." Then, amid the hiss and fog of steam and clanging of the locomotive bell, we entrained to leave Regina behind as darkness closed down over the mute and featureless landscape.

And that is why I now choose to live near the plains city by the Pile of Bones, for it is good to see a friend after an absence of year. *Floreat Regina!* And may she long keep her home-town atmosphere.

BEFORE MY REGIMENT WENT OVERSEAS I was to hear that my brother Jim had been killed at Bouzancourt, on the Somme.

Our troop train — made up of "colony" cars with wood-slatted seats — had to lay over for twelve hours at the city of Trois Rivières. We were locked in, and blinds were drawn. As we whiled away the dull hours with sleep and cards we could hear a small crowd outside spitting on the windows, smearing the coaches with chalked insults, and the shouted words "*Maudit Anglais!*" and "*a bas la guerre!*" excited no doubt by the anti-conscription speeches of M. Henri Bourassa. Our Military Police looked cranky and tired when our train finally pulled out. However, once we had seen the gallant Van Doos in action we began to forget this incident.

We had a six-weeks delay at St. John, N.B. (due to an outbreak of measles) before we finally put to sea in the *Olympic* (a sister ship to the ill-fated *Titanic*), which had been converted to a trooper. The

people of New Brunswick greeted us with open arms. It was in this maritime province that I first met with the farmer-fisherman folk, so many of whom I have since discovered in the West. I met people in St. John who had relations down the coast, and they kindly took me to visit them. The place was Chance Harbour (a name as romantic as any on the prairies) and I was introduced to lobster pots and, better, lobster salad. Everybody had a boat, and yet everybody had a field or two and some of the finest dairy cows I ever saw. Many of them worked in the lumber woods in winter and were as skilled in the use of axe and crosscut saw as they were in the use of the plough or the net. As for the coastline, I would have thought I was in Cornwall.

Once more, with Maple leaves on my tunic, I saw Udimore village, I saw Stocks. I saw the ducks at the drain, saw the rooks winging their evening way to the churchyard elms.

But briefly. Briefly . . .

And then it was France. And I was sent on a burial party. The dead were men of the Royal Sussex Regiment. They had gone into battle so young, these sons of Willum and Garge and Edwin.

So young.

So lately weaned from mothers, so lately parted from apple-cheeked sweethearts.

And when the full-throated guns had roared their deadly welcome they had fallen, these boys, facing the unseen foe.

I saw their flaxen, Saxon hair beneath the shattered helmets. I saw the goose-down stubble on their still ruddy cheeks. And I saw the Peace of God on their upturned faces.

"I am the resurrection and the life. . . ."

The weeping skies could not drown, the ankle-deep mud could not smirch, the hell-mouthed guns could not silence the honest,

earnest words, and we knew them to be true and faithful.

While back in Silly Sussex as ever was, shepherd met shepherd on the dawn-wet sheep paths all a-scent with downland mint, and greeted one another in the sober, quiet way of loss accepted.

"Well, Willum our Jack is gone, as you mought say, but 'is Bessie do be in the expectin' way, and we shall see what comes o' that."

And the South Saxon women of the downs and the weald still gathered their herbs and their simples. Around the sheep-pocked dew-ponds, on the sunny, primrosy banks, or in the dank oak woods, among the broken ore and rotted charcoal of the pits where men long laid to sleep in churchyard had cast King Harry's guns.

They worked a little harder, for work eases the pain of loss, and they watched over the widow Bessie, for she was now the hope of Sussex.

They still set their hens in the dark of the moon, still gathered their faggots by the evening light, still put the 'taters to boil when they heard the whistle of the Robertsbridge train at half-past eleven. And the men still trudged to their cottages below the high-lifted shoulders of the downland, on the edge of the sheep marshes of the Tillingham and the Brede, and tried to smile at their women over the rabbit pie. But they said nowt — neither men nor women. For that is the way of Sussex folk.

And Udimore and Iklesham rang out their sad yet hopeful bells, and Brede was close behind, and the answers came from Peasmarsh and Robertsbridge and Battle, where Saxon Harold fell on that Senlac day which brought the Norman speech to England.

And the lights in the little stone churches sent their beams to play with the swaying yew-boughs — the yews which had given the longbows for Agincourt — while the folks went quietly to their knees and prayed to the God of St. Edmund. Going home in the

dark, they could smell the wallflowers, they could feel the lift of the channel breeze, they could see the flash of guns lighting the sullen sky across the narrow water.

But they said nowt.

Suddenly I was on leave in England. Mother had moved to London, to Beaufort Street. Betty was about to join the W.A.A.C.s. I was to train for a commission in the British Army. I went again to Udimore but did not see Alfred Holmes. He, too, was at the front.

I went to Mrs. Beany's cottage. She showed me how well the budgerigars were getting along, told me to wipe my feet as we went into her tiny kitchen, and she made strong tea and bread and butter and her face was grim as she said goodbye, that hooked nose almost meeting the sharp chin, and she looked old and cross, but the worn hand she laid on my arm trembled and her eyes were dim as mine.

My poet cousin, Arthur, now lived at Island Cottage in Wittersham, and I borrowed a bicycle and went to see him.

After many years of city life (for Symons was not essentially a countryman) he was now in the depths of the rural scene, among orchards and hop-gardens. The nervous breakdown which had struck him in Italy ten years before had left its mark, quieter than I had known him as a child; more at peace.

The local gentry saw little of him. They were kind enough to leave him pretty well alone, and he for his part found little in common with fox-hunters and pheasant-shooters. He preferred the gypsies who sometimes camped in the lanes. No one knew better than Symons the embarrassment occasioned by mental illness, no matter how slight or how far in the past and his own troubles, linked as they were in popular opinion with Wilde's, ran the gamut of the detested press. Undoubtedly the hue and cry of Wilde's trial

had its effects on many others, but especially on Symons as editor of *The Savoy*.

Owen Seamn, editor of *Punch*, had called him "Simple Symons," and *Punch* was in every gentleman's house. Even his evident breeding did not save him, and as for the yokels, they thought him mad, if only in the same sense that today's proponents of beer and sports consider all artists mad. Arthur, however, cared little for the opinions of others, and now the ardent, eager man-about-town poet who had been more at home in Paris, Rome, and Madrid than even in his beloved and cosmopolitan London, had been healed and soothed by the quieter hands of nature. The charm of his speech and manners remained — that almost mystical charm which I remembered — and we went for a walk together at dusk, he in his black sombrero and cloak which so embarrassed the country folk.

Nor was his writing put aside, and those who cruelly said that Arthur Symons's star had declined and his muse deserted him were wrong, as anyone knows who has read such works as his *Outlaw of Life* or *From Toulouse-Lautrec to Rodin*, and other later works.

Symons greatly admired the eldest of his cousins, not only for Mark's paintings but also for his gentle and easy Catholic philosophy. When Arthur wrote his poem, "Crucifixion," he most certainly had in mind Mark's painting of that title, a painting of which Stephanie Wines wrote: "to meet the need of the age its presentation had to be arresting, challenging, vital. Before Mark Symons painted it was difficult to think of any new Catholic conception of the Crucifixion." These words would apply as aptly to Arthur Symons's poetic rendering in *Jezebel Mort*. Needless to say, the same slings and arrows were directed at Mark after his painting was hung in the Royal Academy in 1933.

I mention my brother Mark here only because he had a pro-

foundly "settling" effect on our passionate and sometimes unhappy cousin.

"Mark Symons' candid soul," wrote Roger Lhomheard, "his naive symbolism, had their attractions for Arthur, though the latter remained an inveterate individual and was never to take the step . . . which would bring him into a spiritual family."

Yet we knew that Arthur never doubted the deep truths of Christianity; the Awful Truth of the Cross, of which he wrote:

"Satan behind the Cross like smoke
tossed in the wind his hair . . .
Of man — and Gods – terrible solitude he gave us this:
He, the crucified,
nailed by the cruel nails, the wound in his side
that bled, the feet that bled, his head whose pride
was more than man's. . . ."

Although at this time he was, in common parlance, "buried in the country," his friends and admirers visited him constantly up to the time of their own deaths, for with the exception of Augustus John he outlived them all. Henry James, then living at Rye – not far away – visited him, as did Havelock Ellis. Joseph Conrad (died 1924) and Thomas Hardy (died 1928) were among his closest intimates. But it was for Augustus John, a fellow Welshman and as fiery a Celt as himself, that he felt a special affection.

Symons and John alike had the true Celt's appreciation of freedom:

"it is the beggars," wrote Symons,
"It is the beggars who possess the earth. . . .
Wandering on eternal wanderings,

They know the world, and tasting but the bread
Of charity, know man. . . ."

For John he wrote a piece which they both signed:

"There is a link between Symons and John
For we are both Cornish and we were Welsh born
And both love the gypsies, the tents with the thorn
. . . And by John and by Symons an oath shall be sworn."
Perhaps it was the gypsy spirit which took him so often to the sea-shore. Only there, as the ocean waves broke in bubbles at his feet, did he find a kinship of restlessness to match his own.

And perhaps the same instinct to wander was what led him to leave the Hotel Europa in Ferrari on that October day of 1908 to stroll in the hot streets till he found himself outside the gates. He was spotted by some peasants as he rested on a haystack. They chased the "mad Inglesi" with pitch forks, and he ran, falling into ditches He eventually came to a farm house only to run into the arms of two Bersaglieri who brought him back to Ferrari. He was savagely manacled and thrown into a cell.

This, in brief, is the story of Arthur's break-down, and he was no more mad than the dull peasants who had called the police. But it took some months in a private nursing home to restore the nerves shattered by his arrest and brutal treatment.

As I have indicated, Symons was no countryman, or he would have stood his ground or not, in the first place, have so outraged rural tradition as to climb on a stack of hay!

Although our family had for hundreds of years farmed at St. Columb Minor in Cornwall, Arthur cared little in his earlier days for the rustic scene and its people, which my father painted so joy-

fully.

Next to the city, with its comings and goings, its cabs and traffic, its wetly glowing lights, and its cries and snatches of song, it was the sea he loved best of all, the heaving, molten, moaning sea of Masefield and Conrad.

Listen:

"O water, voice of my heart, crying in the sand,
All night long, crying with a mournful cry,
As I lie and listen and cannot understand
. . . the voice of my heart in my side, or the voice of the sea,
. . .
Unresting water, there shall never be rest
Till the last moon drop and the last tide fail . . ."

Arthur Symons saw all life with the artist's eye, and his writings betray the painter, the musician, and the architect as well as the poet and playwright. Art was all one art to him. The expression was what mattered, not the medium. He saw them all as one aesthetic expression of beauty, which are one and the same science.

To him the ornate flourishes of chamber music differed not at all in kind from the convolutions of Byzantine painting and design, both being disciplined yet completely covering their surfaces like well-trained vines coaxed by the hand of man to cover a trellis.

John Betjeman, seeing the poet a few years before his death, in the Cafe Royal, wrote on the spur of the moment:

"I saw him in the Cafe Royal,
Very old and very grand.
Modernistic shone the lamplight

There in London's fairyland.
Devill'd chicken, devill'd whitebait
Devil if I understand.
Where is Oscar? Where is Bosie?
Have I seen that man before?
And the old one in the corner
Is it really Wratislaw?
Scent of tutti-frutti sen-sen
And cheroots upon the floor!"

Stricken with a chill, Symons died peacefully at Wittersham in 1945 at the age of 80; his last words being, "Oh, Mother."

It was not the restless sea that held him then, as "the last moon dropped and the last tide failed." His epitaph might well be expressed in his own words: "I have believed more than I have doubted."

I WAS EVENTUALLY COMMISSIONED to the 7th London Regiment — not, as I had hoped, the Royal Sussex in which Jim had served. Our colonel was an Afrikaaner. He had been with De Wet at the wind-up of the South African War. His name was Sir Pieter C. Van B. Stewart-Bam, which indicates some Scottish blood. He was a fine soldier and a good officer. We also had two other Canadian officers and three from South Africa, one from Natal, of French Huguenot blood, a sugar planter I think, and two Afrikaans chaps from Orange Free State. Our camp was not far from the big house where the ex-Empress Eugenie (widow of Louis Napoleon) resided.

One day I was called to the orderly room and told by Sir Pieter that I should be ready at 3:00 P.M. to accompany himself and six other officers to the ex-empress's home to partake of tea on the

lawn. I expect this was not the first time the old lady had invited officers of nearby regiments. Dress would be slacks, no Sam Browns, *plain* socks and brown shoes.

We eventually arrived, all crowded in one motor car. We were met on the spacious lawn by a manservant who led us to the tea-tables in the shade of a cedar tree, and invited to make ourselves comfortable in the wicker chairs, since "*Madame*" (he did not say *Her Imperial Highness*) would not appear for ten minutes.

Finally we saw a wheel chair approaching, pushed by another manservant, in which sat the regal little lady. We all got to our feet and as her chair stopped at a table she bowed and extended greetings in a beautiful voice.

With quick intuition she suddenly turned and, in French, asked Lavoipierre — the Natalian — had he ever been at Isandhlwana? Of course this was the site of a fierce battle of the Zulu wars when a small British force was wiped out to a man by Cetewayor's savage impis. Among those who fell, to lie unburied for days, was the Empress Eugenie's son, the Prince Imperial, who was then serving with a British regiment.

When a British patrol finally reached the scene, they were to find the dead un-mutilated, and they were told by a wounded Zulu that the leader of the impi had held back his men from that brutal custom for, said he, "they were men, and they died like men."

The ex-Empress had caused a memorial to be erected at the spot to commemorate her son and the action. She was delighted when Lavoipierre told her that he knew the place well.

Speaking again in her beautiful English, the ex-Empress had a word or two for each of us, expressed her admiration for Canada and indeed the whole British Empire, ending with compliments to our colonel. During this chat we were served tea with an as-

sortment of sandwiches and bon-bons such as only a French chef could create.

After perhaps three-quarters of an hour "Madame" excused us and we rose to take our leave. I still carry the impression made on me then by this fragile-looking and still very beautiful Austrian Princess, with her enchanting smile and wonderful eyes. The ex-Empress must have been very old then. Already more than forty-six years had passed since her husband's ill-balanced throne had toppled before the iron forces of Bismarck.

Soon I was back in France, attached to the 123rd Londons, brigaded with the London Scottish.

So I saw war. A tale told by an idiot, yet a song from angel lips. A story which baffles interpretation to the civilian world, untranslatable to a younger generation, which is why I write so little of it and tell less.

A story of living flesh welded into a wall of stone, as it were to protect innocent children from the very sight and sound of snarling beasts that they might play in safety.

Each stone the bones and bowels of a man, and the breath too, for if these stones were as immovable as granite, yet they were much more, for each was spirit too, and spirit spoke to spirit and cried "stand fast."

The very air was full of spirits — spirits of those stones which had fallen to lie insensate in the miry clay as stones should.

I saw flesh minister to flesh, and spirit to spirit in that sacramental fellowship. I saw the stinking, wound-shredded feet of what in a world of peace we should call a man, washed by the bloody hands of another man, his comrade; and clean once more, kissed, so that the healing of the spirit could enter them.

The wall has, today, become a mere fact of history, to be referred

to casually. But it was another world, another dimension to those of that brotherhood, who must forever see by the spirit, know by the spirit.

Can we doubt what we learned on the Wall?

OUT OF THE LINE FOR A REST PERIOD, I found myself billeting officer. My knowledge of French (far from perfect) stood me in good stead.

"*Madame, avez vous place pour un soldat*?" I had to say at many a door in the village of Lillers and the answer was rarely anything but "*Oui, Monsieur le Capitane*" (I was a Lieutenant!) "*Entrez, s'il vous plait.*"

For myself I chose a room in the house of a Madame Simon — I think the name decided my choice. In any case, she was entranced to claim relationship. Her old father and mother lived with her. The old gentleman would invite me to share a bottle of *vin rouge exordinaire*, and tell his recollections of *soixante dix* and the invasion of his village by the German armies of 1870, "*Ce'st le meme chose encore,*" he would say and spit. "*Les Allemands sont a des salles Boches, des voleurs, des criminelles, seulement.*"

My small bedroom was furnished with a bed so high that I must needs use a stool to climb into it. The feather bed below and its mate above me kept me as securely and warmly ensconced as a mouse in its nest.

Each morning at seven there would be a knock on the door, and at my "*Entrez!*" Madame Simon would bring me in a huge cup of coffee with a smile and the words "*Voici votre cafe Royal, M'Sieur!* Good for ze belly, good for ze bust!" For she was proud to show off her knowledge of the English words for stomach and chest, and if she laced her own cup with as much cognac it was not hard to ac-

count for her own "busty" corporation.

One day somebody got hold of an old paper, left in the billet, and after glancing at the front page said, "Listen to this, you fellows. Here's a couple of headlines a foot high," and he read "*Emden* Sunk. Victory for the London Scottish!" How we roared.

The German battleship had indeed been sunk after a good run for her money; and on the same day the London Scottish had made a successful attack at Beaumont Hamel. Victories being scarce at that time, the papers had been only too happy to give it a good headline.

Thereafter, when our boys met a group of the Scottish they had only to shout, "Who sunk the Emden?" to start a good fight. The hottest action I was in was at Priez Farm, at the end of which action I found myself commanding a much depleted company, all the other officers having become casualties.

Towards the end of the war we found ourselves at Lille, and this being not far from where John was on service with his heavy-gun battery, I managed to borrow a horse and went off to see him. The headquarters of his lot was in a fine old Chateau, and being directed there, I found John. He was by then Captain and had won the M.C. at first Cambrai. There was a fine grand piano in the chateau, and after mess he played to me. Something of Debussy first, a composer I never appreciated, and later Chopin, which I did. Then he worked slowly into something else which I had not heard. "What was that?" I asked. John reddened uncomfortably. "Oh," he said, "just a composition of my own." I was amazed and asked him to play it again, but he said he thought another of his "things" was much better, and played that. It was even better.

The other thing he had picked up at Cambrai was a pretty bad gassing. He had been treated, but probably not adequately, and

he had no business to be in the line again. He did overcome it sufficiently to put in several years on the Northwest Frontier of India, but finally had to be invalided home. I never saw him again after the Chateau incident, although he lived an invalid for another twenty-five years.

November 11th came, and the cease fire. I was at a little village called, curiously enough, *Fin de la guerre* — an echo of the wars against Napoleon, for this was near the site of Waterloo. My forward group — I was in charge of scouts — felt the name was a good omen, and we strove to reach the village before even the date of the Armistice was known.

John went on with the occupying forces to Cologne, but I had enough of soldiering and by great luck returned to England just after New Year's of 1919 and stayed on indefinite leave pending repatriation to Canada, staying mostly at Beaufort Street. However, I did get down to Udimore toward spring when Lord's Wood was in the glory of early budding, and I walked over the Tillingham marsh to find the lapwings starting to nest. Reg Eldridge, our erstwhile water-boy, grown and thickened and tanned, was there, recovering from wounds.

And I went for a full week's stay at Farnborough, the headquarters of the Royal Flying Corps. Stephen was there. He had pretty well recovered from the wounds he had received when shot down in no-man's-land, from which he narrowly escaped capture by the enemy. He had lost part of a hand and also had a foot injury which had incapacitated him from further active service, and he was now a flying instructor. He took me up several times in various rickety (I thought) "crates," but I did not care for it much. Looping the loop may thrill some people, but not me.

He was now engaged to Marjorie Le Brasseur. He told me that

the doctors had advised riding horseback to help his general health, and he commissioned me to obtain a mount.

At that time a lot of army horses were being sold, and seeing in the paper an advertisement of Tattersall's for sale of light horses at Newmarket, I took the train there, and managed to buy a useful looking Basuto pony. I could see he had been "salted" for he was as flea-bitten as a setter. I paid twenty pounds (of Stephen's money) for him.

I then went to one of the many Newmarket saddlers and bought a good second hand hunting saddle with a numnah [a pad placed between a horse's back and the saddle to prevent chafing], a snaffle bridle, and a nosebag and hay net. I rode him from Newmarket to Winchelsea where Stephen was spending a few weeks by the sea, "getting as much salt into me as I can," he said.

I rode right through the heart of London to try the pony in traffic. He was as sweet as candy, and would step along without flinching with motor-cars and buses almost on top of him. I reached the open country at dusk and put up at an inn which had good stabling and good beer.

Two more days took me to Winchelsea easily and at a pace which allowed me to enjoy the countryside, grazing the pony on the grass verges at noon while I ate a sandwich, and stopping for the first night at another inn. Stephen had arranged for stabling at Winchelsea. He had ridden very little up to now, but he soon got to be quite at ease in the saddle, and the light exercise of riding did wonders for him.

To me that ride was unforgettable after the mud and the weary foot slogging of the trenches.

THE DECIMATED CLANS HAD FOREGATHERED from the ends of the earth. At last war had come to an end, and over Silly Sussex as ever was, over down and weald and salt-marsh, the new day was dawning. Ways and means were the topics of discussion. The past was past. The future unknown. Mother and Mark had met Stephen and me at Winchelsea.

Stephen turned to me. "Well, young fellow, what about you? Not going to waste your time knocking about Canada any more, I hope? How about University or Art School? Doing something worthwhile? With your commission now you'd be eligible."

"I don't know" I said.

I went to the window. I looked out into the soft misty evening across the marsh to the darkening bulk of Lord's Wood with its hint of early primroses. A shoulder of the ridge loomed above the blur of hop-pole chestnuts and a star winked in the West. From far-away a cow bawled softly, and a faint scent of wood smoke made my nostrils quiver. Somewhere below the hill gypsies were camped.

And all at once my doubts melted as snows melt under the Chinook wind, and I did know.

In May of that year I was notified by the War Office to meet the S.S. *Grampian* on a date two weeks away, when she would sail from Southhampton for Canada. I would be demobilized as from my arrival in Moosomin, Saskatchewan, where I had joined the army. I was to please let them know my future address for purposes of forwarding my war gratuity. I went back to London, closed out my account at Cox's Bank, and spent the remainder of my time with Mother. I saw *Chu Chin Chow* (with Jackie Stevens) for the third time and *The Maid of the Mountains* for the second. I squired a young lady to that — the daughter of a friend of Mother's — called

Pauline, and next day she and I took the top deck of a bus and went all over London in the rain. I went for a last look at the paintings in the National Gallery and then to a cinema where, after the main attraction, a short war film was shown of the British Army's first entrance into the city of Lille, and saw myself at the head of my platoon. I remember that when we entered the city the inhabitants crowding the pavement could be heard to say — between shouting "*Vive les Anglais!*" — "*Comme ils sont jeune! Comme ils sont jeunes!*" And young indeed, no more than boys we looked on that screen, and I understood the French people's exclamations.

HALIFAX I HAVE ALWAYS LOVED, for I have some personal and very happy memories of that port, which is sister to so many others all over the world, and yet is unique in herself. To paraphrase Kipling, that least understood of poets, she is still "the Warden of the Honour of the North;" still she "puts forth her guardian prows;" still she is "Veiled," for the Atlantic fog is no respecter of cities.

I had seen her first in 1917, and the mingled smell of fish and coal smoke lingered with me far over the Atlantic. I saw her again in the year of grace nineteen hundred and nineteen, and to those of us old enough to remember that was indeed a year of grace, for in that year Canada welcomed home her sons after four years of high endeavour — and not only the sons of her own bone and blood, but the many who like myself were the sons of her generous adoption.

It was the old S.S. *Grampian* which nudged into the dock that day, and a band played, and the good people of Halifax crowded the wharf and wept — some from pride, some from reunited love, and some from sorrow. The tears of its people enrich a nation, and we, the troops, responded and wept too — we who had not wept at

hunger and cold nor shot and shell; but reaction saved the day, and soon it was cheers and smiles that took the place of weeping, and the city tolerated both, for she is old and she is wise.

So we Westerners said goodbye to comrades in arms. It was "*au revoir*" and "*bon santé*" to the gay Vandoos, and "*so long*" to the Cape Breton Highlanders, while the pipes sighed and the kilts swayed to "Scotland the Brave"; and we went our separate ways and hit the road of steel for points far away beyond the neat farmsteads and orchards and sheep-pastures, beyond the dimpled waters of the Miramichi, across the St. Lawrence, across Ontario's commercial belt, across her rich farmland and the dark forests and shining lakes, to Nipigon and Lake of the Woods and Rainy River, each moment bringing us nearer to our heart's desire, while the bumping wheels click off the words of Henry Drummond:

> "Oh, I was thine and thou were mine,
> And ours the boundless plain,
> Where the wind of the West, my gallant steed,
> Ruffled thy tawny mane."

On the way west, I stopped for a day in Winnipeg to visit Judge Patterson and his wife. "Pat" had been a brother officer. He was killed at Priez Farm and I was able to tell his parents a good deal about him. They were very kind to me.

Part IV

The Locust Years (1919 – 1927)

I FELT A SENSE OF FREEDOM on my return from the war. After a brief stop at Moosomin where I exchanged uniform for "civvies," and then changed ten crisp Bank of England five-pound notes into Canadian currency, I boarded the transcontinental for Ashcroft, B.C. (Little did I think that never again would I see a five pound note, let alone exchange one for twenty-five dollars.)

I was headed for Chilko Lake, 200 miles northwest of Ashcroft; in the Chilcotin country to which this small town in the dry belt was the nearest rail point, until (later) the Pacific Great Eastern was completed.

At Chilko Lake I expected to meet a man who had told me of the ranching possibilities in that region. I had not enough money to establish such a venture, but I had interviewed the Soldier Settlement Board representative in Calgary, and when I told him my plan he said, "You find the location you want and we will loan you up to $5,000 under the S.S.B. Act to purchase stock."

I had met Frank on the boat coming back from overseas, and his description of Chilko Lake and the Chilcotin, in the interior of British Columbia, had fired me with the desire to see that country.

So here I was, having come up the Cariboo Road with horses I had bought at Clinton. All the way up The Road, as it is called, I kept thinking that now I knew what this country looked like; but

presently it would change again, and I decided I would have to see a whole lot of it before I would be able really to grasp its distinctive features.

Here are open rugged hills and buttes which remind one of the Cypress Hills — for the Chilcotin is also in the dry belt. Next we see great forests of evergreens broken by long grass muskegs, just like parts of Northern Manitoba, except for being tipped on edge instead of lying flat. Then we come to a series of grass benches — cut by coulees (called gulches in the province) — which look like the side-hills of Saskatchewan's Qu'Appelle Valley on a broader and larger scale; while the sage and cactus grown river flats might be those at Medicine Hat, and the dense rolling poplar woods remind one of the Eagle Hills near Battleford.

But the mountains are British Columbia's own — that jagged ice-capped range which is the Cascades. This range, an extension of the Cascades in the U.S., is now commonly called the Coast Range in Canada. They dominate. True, one catches only occasional glimpses of the peaks from the road, but one *feels* them — feels that all these gullies, and ravines, and rugged hills are but an introduction to those high peaks and inaccessible alpine meadows.

Perhaps it is the wind that makes one feel them — that wind laden with the odour of evergreens and having the sharpness of ice in it. Or perhaps it is the rivers; for in place of the placid and steady flow of the prairie rivers, these — the Chilcotin, and its tributaries the Chilko, the Taseko, and the Chilanko — hurry toward the Frazer impatiently, swirling around sharp bends, fretting away sold rock, and foaming over the gravel bars with a steady roar.

From the 150 Mile House on the Cariboo Road, to Alexis Creek Post Office — from whence the narrow pack trails branch off to Chilko Lake and the Tatlayoko Lake Country — is two or three

days travel by pack and saddle. The route is a winding wagon road, which traverses Riske Creek prairie, and thence more or less parallels the Chilcotin River. This is cattle country, and the log houses and roomy corrals of the ranchers are mostly located along the river flats, which are irrigated for their hay crops; the patches of green timothy and clover in rich contrast to the burnt yellow hills which rise in a series of high benches, dotted with bunch grass.

At the highest bench begins the general level of the country — for rugged as it is, this interior plateau has a general level, rolling away east to the Cariboo country and westward to lap the feet of the mountains.

It appears to be all timbered "stick country," covered with aspen, poplar, and lodgepole pine, with here and there fairly open stands of Douglas fir; but on riding over it you can see its value as summer range, for there are numerous open, grassy hills, and dozens of old beaver meadows which, with the rich grass and peavines of the more open timber stretches, make very good grazing.

By pushing the cattle up over the rimrock — as they call the crest of the hills — to scatter out for the summer, the ranchers are able to conserve the bunch grass hillsides nearer home for their winter range.

At Chilko River crossing, I met a party of Chilcotin Indians camped among the willows, who told me in broken English and Chinook that the river was too high to cross, and like them, I should have to wait till the flood went down. The high water was the result of the extremely hot weather, which was thawing the snow and ice on the peaks to the west.

So I made camp, hobbling my saddle horse, and leaving the pack horse free till night; when I put him on picket. My bedding and grub were soon unpacked and all made snug, with coffee boil-

ing on the red coals and sending its aromatic odor to mingle with the scent of pine and melting snow. From the Indian camp came the sound of talking and laughing until their fire went out, and all was quiet except for the roaring of Chilko River.

Crossing mountain rivers looks more dangerous than it is. When the flood subsided, the water was little more than knee deep; but so swiftly did it flow over the gravel bar at the ford, and so white with froth, that it certainly made one uneasy, especially as it was a quarter of a mile across. Mine were mountain horses, however — bought at the Indian rancherie at Clinton — and having once put their muzzles down to gauge the depth and swiftness, and the quality of the footing, they stepped in willingly enough and made for the further shore. I got used to it afterwards, but that first time I didn't like the feeling of moving sideways as if the current had one in its grasp, but it was only the foaming water swirling past that gave that impression, and by looking at the bank on the other side, the proper sense of balance was soon restored.

Of course these rivers can be dangerous, and accidents do happen — poor Frank himself finally met his death by drowning while crossing this same river a few years later.

In winter, when high ice forms on either shore, it is quite a trick to get one's horse off it and into the water; and more of a trick to pull and coax him out on the other side. Unlike the prairie rivers, these streams rarely freeze completely over in winter. A common trick of the Chilcotin Indians is to cut down a few young, green spruce or pine during their summer trips; somewhere close to these fords. Then after a winter crossing which leaves their legs encased in ice, they only have to set a match to one of these trees, now dry and red-needled, and presto! there is a hot fire in a minute to dry them off.

THE BLAZED TRAIL WOUND ON THROUGH lodgepole pine which had been burnt over some years before. The black fallen trunks criss-crossed in all directions, impeding the progress of the horses as they stepped over them. Many pack horses had done this in the past years, so that the narrow trail was worn into deep holes where they had stepped between the logs.

This was an Indian hunting trail which led to Chilko Lake and around the shoulder of Tenas Mountain to the Nemiah Valley and therefore, an important travel route to them, but unless a fallen log was breast high, they did not bother to chop it out — and not even then if they could find a way around the end. Through this tangled brule, sturdy second growth pine was pushing upward in hundreds, about four feet high already.

I stopped to shoot a fool hen for supper, and profiting by the teaching of an old plains half breed in my prairie days, tied it in front of the saddle by winding the leather tie strings around the base of a wing. Birds carried like this are safe all day, and never annoy one by banging about; for the natural crook of the bird's wing together with the stiff flight feathers precludes the thong from slipping as usually happens if a bird is tied on by the feet; while to tie by the head may mean only a head at camp that night, for the body wrenches from the neck fairly easily. The bird I shot was a lovely one, slightly different from the spruce grouse of the Saskatchewan woods. I got to know this form of the Canada grouse as Franklin's grouse, with the tail darker and narrowly tipped with dingy white rather than buff.

We finally left the pine ridge and debouched into the valley of Tsuniah Lake, a long narrow body of water, almost an arm extending easterly from the much larger Chilko Lake, but separated by a narrow neck of land with a short connecting creek.

After the weary brule, the hay flats and bunch grass sidehills of the valley were a welcome relief; the horses broke into a smart trot which soon brought into view Frank's cabin. The cabin was built mountain-style; that is, with the door at one end, over which the roof of poles and sod — fuzzy with weeds and grass which had seeded themselves thereon — projected some six feet and formed a porch. On the door was a roughly penciled note to tell me that Frank was away, and for me to help myself to grub until he came back.

Francois Real Angers was the only white man living closer than the Bayliff ranch at Chilankoh, which was fifty miles away, and where I had received real western hospitality on my passing. Angers is, of course, an old French-Canadian name, and Frank was the son of a former Lieutenant-Governor of Quebec, the late Sir Auguste Angers.

I stayed in Frank's cabin all winter. This was Indian country and these were the only people I saw all winter except for a short while when Frank was at home.

I made many friends among these semi-nomadic hunters, who were seldom (then) seen off a horse. They are all inveterate gamblers. I remember one Indian who had been baptized Charlie Frances by the French missionary from down the road — for most of these people are nominal Christians — who thought nothing of literally "losing his shirt." He rode by the cabin one day, complete with bright shirt, and decorated chaps, topped off by one of the stiff brimmed Stetsons so beloved by the older plains Indians and still worn — at the time of which I write — in the mountains. He rode a splendid little roan horse equipped with a fine new stock saddle.

He stopped and visited for a while, and drinking sweet tea, told me he was on his way to a Potlatch or "Give Away Dance" at Nemiah Valley. "Plenty good time stop. Plenty dances, plenty song,

plenty play 'la Hille.'"

La Hille is the "stick game" rather like "See-Sep-Wuk" or "game of the ducks" of the Ojibways. It is a sort of hunt the slipper game, but there are many slippers and the guesser has to locate them all. It is played with tremendous enthusiasm, the players sitting in a circle and chanting the la hille song long into the night.

"Mebbeso," Charlie went on, "Helo Chickamun stop I come back," meaning that he might return broke. And so it proved.

About a week later he returned a somewhat sorry figure; bare headed, stripped of his gaudy shirt and his fringed chaps, and be-striding a boney old mare without benefit of saddle.

"Hi-ya Tillicum," he greeted me. "You plenty muck-amuck stop? Me hyu sick tum-tum. That place" — indicating the Nemiah Valley with a wave of his hand — "plenty no good, plenty cultus Siwash. Me helo hat stop — helo saddle stop — helo chikamun stop."

"Never mind Charlie," I said, "I'll feed you this time and p'raps you'll win it all back next time."

"Sure," he grinned, quite happy at the thought of good grub. "Me plenty evert'ing stop *next time*."

"Crazy" Jack Loola used to regale me with weird stories of the Antkiti Siwashes (from the French "antique Sauvage" — now commonly called "Saskwach") the Indian giants who lived in by-gone days at Chilko Lake and who, the Indian thought, still turned up unexpectedly.

"One tam," Jack told me, "me see 'm that Antkiti Siwash — my hyu scare — all he dlaid hyu tall — he helo shirt his back; he helo moccasin his feet; helo hat his head stop — just plenty hair like bush. Me no savvy see-um that fellow before — me hyu cutux him Antkiti Siwash! Me go way that place all same cultus coulee."

The fine Indian summer weather did not break till December,

then suddenly we had quite a deep snowfall. Frank had gone down the road to Ashcroft and I was alone — and would be most of the winter. One night, soon after going to bed, I heard a shout "hy-yi-hy-yi" — the greeting with which to approach a camp. Presently an Indian thumped at the door, and then came in, pulling long icicles from that part of his scarf which enveloped his lower face. It was Jack Loola.

"Hi, Jack," I called from the bunk. "What's up?"

He knelt down by the little sheet iron camp stove, and blew the sparks to life before he answered, "ma hyu sick tum-tum. My papoose going mamaloosh I t'ink. All same he girl fell in fire. All his back he burn — Gimebye you come mebbeso? — Mebbeso savvy fix-um?"

"Where did this happen, Jack?" I asked, pulling my pants on.

He waved to the south. "All same Taseko Lake my camp stop," he said.

"Are your wife and kids there?" I asked, forgetting he was a widower.

"Goman (woman) he long time mamaloosh. All same t'ree boy, two girl stop me. Me fix 'em all time. Goman he mamaloosh."

"O.K., Jack," I said, "we'll have some tea and bannok, and I'll saddle up and come with you and see what I can do."

So we fed and hit the trail. I took some tea, sugar, and flour, well knowing the meagerness of Indian larders. Also some carbolic ointment. But what I relied on most was a large jar of "Denver Mud" (antiphlogistine) and several old but clean white shirts.

It was twenty-five miles to Taseko Lake — a wild and almost unknown territory — to reach which we had to take the pack trail over the hogsback of Tenas Mountain, where the wind blew our horses' manes and tails at right angles. The cold was intense, but

the snow not very deep. Jack led — a muffled figure, dim and indistinct in the starlight, as he wound his way between pines.

Half way we stopped and built a fire, drank hot tea, and had a smoke, while Jack told me more of the situation. Deer were scarce and wild in the Choelquoit Lake area where he usually lived. He had taken his family with him on a hunting trip in the Taseko bottomlands, camping at the edge of the Lake. He got one deer and left the children to take care of the hide and meat, while he went to follow another fresh track he had seen. When he got back with a second deer, he found that his eldest girl, age twelve, was badly burned. The term papoose is commonly used among the natives to note children of almost any age, but still I had expected a much younger patient.

Jack went on to explain that the child had tried to rescue the deer hide which had fallen into the camp fire, from where she had hung it to melt off the fat — a childish sort of prank. It was a naughty thing to risk damage to a deer hide, because the Indians depend upon these for tanning into moccasin leather.

Somehow she had tripped and fallen into the fire which was much too large — no doubt the children felt the eeriness of the dark forest during their father's absence and replenished the blaze too readily. In attempting to get up her foot apparently caught under a kettle stick, so that she laid just long enough to badly burn her back.

The stars had dimmed and grey dawn was breaking in the east when we got to the camp. Wild looking dogs raised their hackles and barked as we approached the brush shelter in front of which the ashes of last night's camp fire still sent up a faint blue wisp of smoke. With the barking the shelter came to life, and out popped four heads of tangled black hair from which eight big black eyes stared.

Jack spoke in Chilcotin and I suppose he told them not to be frightened of the white man. At all events they came shyly forth, three smallish boys and a very small girl; all in dirty nondescript garb and worn moccasins, evidently their attire by night as well as by day.

Within lay the injured child, lying among a collection of shabby blankets and rabbit-robes. She lay on her stomach, and as I knelt down to investigate, she shrank back into her tangled hair and stared with wild frightened eyes. I patted her arm and Jack spoke again, and she lay still. Stripping off the dirty blankets, I saw the worst burn I have ever seen. From between the shoulders right down to the base of her spine she was one horrible crusted mass, in which bits of her shabby print dress were embedded.

I covered her again, and melted snow until all the various pots and kettles in camp were full of warm water. Jack made no attempt to help, thank goodness, for his dirty fingers might have increased the danger. Slowly and very carefully I softened up the crust enough to remove the half burned bits of cloth, and then washed her as much as I could without moving her. She was a splendid little patient and neither moved nor moaned, although my attentions must have been torture — so much so that I thought she might have fainted, and stooped in concern to see her face, but her eyes were wide open.

The washing completed, it was only a matter of minutes to plaster her back thickly with the healing clay, which would exclude all air and dirt, and then cover up with a clean shirt bound on with strips torn from another. The ointment I did not use at all.

Then we all had sweet hot tea without milk — that panacea for all troubles to the Indian, flavoured strongly with spruce from the needles picked up with the snow for melting. Jack Loola's injured papoose drank with the rest.

I gave him instructions simply to leave everything as it was, and not move her for a week — and above all not to try to pry under the bandages — and then I would try to come and see her again. Not caring to share the Indian's bedding, and having brought none of my own, I then started for home.

About a week later — in milder weather, for the Chinook was at last blowing — I went to see my patient. The healing was almost perfect, but I repeated the process and told Jack to let the girl take the bandages off herself in another week, and then she would be all right.

Many weeks later Jack Loola again called at the cabin with his ragged family.

"You good mans, Shomons," he said, shaking hands. "Gime bye you mamalooshe. You go Saggali Tyee. Saggali Tyee say, 'You good mans. You savvy fix-um lil' papoose stop Jack Loola.' " And Jack Loola's papoose, from her perch on a spavined pack horse, gave me a very shy smile through the thick tangle of matted hair which almost hid her face.

TOWARD SPRING I FOUND THE LOCATION I WANTED. It was in what was called Elkin's Valley, named for a bachelor white-man who had met with a mishap. Some said he had been killed by an Indian from Nemiah Valley who had then burnt down his cabin. News travelled slowly, and by the time the rather casual Provincial Police of those days had made the long journey to the site from their detachment at Riske Creek, there was little evidence to prove anything.

I reckoned I could run a cow herd of about 100 head in the valley, as there were some good beaver-meadows.

In May I rode to Alexis Creek and took the stage to Ashcroft to

file on the land I had chosen. 320 acres would take in most of the hay land, and I would "camp" on that. As to pasture, the range lay wide open for miles.

Having finished at the Land office, I went on to Victoria and the Office of the S.S.B.

Imagine my disappointment when I was told that while I had been out of touch the Act had been altered to read that *no* loan would be granted to any soldier who settled further than 20 miles from a railway! I saw the hand of the land-sharks in this; obviously those gentlemen had no land for sale on the frontier.

Since the interior ranchers hired mostly Indians, there was little work to be got. I saw that I could not make a start on my small capital without some extra money from jobs, so reluctantly, I took the train back to Saskatchewan and its harvest fields, poorer in pocket but wiser (if not yet wise enough) in the dark ways of bureaucracy.

I thought I would look up another chap I had met in France. This was Leland Bradford, whom I knew as an officer of the Canadian Machine-Gun Corps. He had told me he would be returning to his father's home in the Allan Hills southwest of Watrous. I found him home. It was late April and he spoke of looking at ranch land on the Beaver River north of Meadow Lake. He invited me to go with him.

At Spruce Lake, the nearest rail point we ran into a rancher, Jack Crow, who was about to trail about 100 horses to the Beaver River. He needed help, so we set forth on the infamous Boggy Creek road which ran through forest and swamp, a mere trail on which we passed several settlers' teams bogged to their bellies. At the ranch we received hospitality and looked over the hay lands Leland was interested in. He stayed there, but I had seen enough of swamps and didn't think much of the possibilities of cattle in such a place.

I learned later that after two years, swamp-fever had left but five horses of the 100.

I returned to the Bradford homestead, because I had already seen the head of the Arm River valley just a few miles west, and it looked good to me. There was a homestead — with a spring on it — which I could take, as well as several sections of the finest grazing land I had seen, which was open to lease.

I inquired around and found that many farmers on the level land beyond "The Hills" (which was all turtle-back knolls with sloughs between) were getting short of pasture and would like to send their cattle out on "summerherd." I reckoned that with a young fellow to help, I could handle about 400 head, which at five dollars per head for the five-month grazing season would net me a fair return.

I had also received my gratuity money, which would get me what horses I would need, lumber for a shack and a few cows to form the nucleus of the herd I hoped some day to have. I engaged Marna Bradford, then 16 or 17, and he, raised on the homestead, proved himself a good rider who knew cattle, as well as a loyal companion.

Here I must mention how kind the Bradfords were. Tom Bradford, the father, had come from Ontario with his family. He was one of the finest and most honourable old gentlemen I ever met, and his wife one of the finest ladies. She used to make butter for me, and also baked my bread. I supplied the bags of flour and she baked a dozen loaves at a time, six for me and six for them; for they were not endowed with much in the way of worldly goods, since the last years had been too dry for good crops. I traded two of my loaves back on each bake day toward my butter bill. I sometimes employed Marna's brother Fred, as well.

In cool April we had freighted in with three four-horse outfits

and led saddle stock. The snow still lay in soggy drifts in the lee of the hills and the trail was soft and boggy in the draws. Sand-hill cranes were going through their weird spring dances on the knolls. Wedges of ducks passed overhead, while godwits, willets, and killdeer plovers clamoured about the sloughs. The curly grass, bleached white by winter, formed a dimpled and woolly mat which delayed the thawing of the ground on the northern slopes where the wagons bumped and rumbled noisily.

My headquarters were to be a few hundred yards up a side cou-lee which opened its wide mouth into the river valley. Here by a flowing spring we put up a small frame shack with the lumber we had bought, and within it stacked the summer's grub supply. Next a saddle horse stable and corrals. These consisted of a large herd corral, for the cattle would have to be confined at night owing to a few five-acre patches of crop scattered here and there within four or five miles distance, and we certainly did not propose to night herd.

It used to gall us to think of thousands of acres of good range all around us ruined for free grazing by these wretched little patches that the homesteaders would not fence — or if they did, so inad-equately that no self-respecting range cow would be discouraged — especially at harvest time when the binder chucked their mea-ger sheaves right against the wire.

There was also a catch pen for branding and for holding or rop-ing out saddle stock.

I left one man there after the corrals were finished to take care of things and run a fence around a few hundred acres to make a wrangle field for our twenty-odd head of saddle horses. Then Fred and I went for the cattle.

It was on the afternoon of a June day that Fred and I pushed the

herd down over the steep hills into the valley, some three hundred head of cows and calves with a few steers and yearlings. As they smelled water they spread out and broke into a faster walk. The heat-drool from their jaws hanging in the air like cobwebs.

"Look at them flowers!" said Fred, and we paused and looked. Where in April the valley below us had been sere and brown with dead and rustling herbage, it now gleamed yellow and bright for its full length in the evening light. To the height of a rider's knee, wild sunflowers rippled in full flower and bent to the cattle's flanks as they crowded to the water, from which frightened ducks rose in clouds. Our ponies pushed the plants aside with strong shoulders, grateful for the brushing away of mosquitoes from their legs and flanks; blowing through their nostrils to clear away the pungent pollen; sometimes pausing to nip at a yellow blossom.

EXCEPT WHEN TORMENTED BY GADFLIES or drifting before a cold, lashing rain (what misery to sit in the saddle all day soaked through one's slicker), the cattle usually bedded down soon after noon as we quietly circle-rode. Sometimes when all was quiet and we knew the cattle would stay put for a while, we raced to a pool in the valley, stripped ourselves and our ponies and rode into the cool water until the horses — who loved it as much as we did — were swimming. Then we would slip from their backs and let them make their way to shore for a mouthful of grass while we disported ourselves.

On one occasion the ponies decided to go home and started off holding the trailing lines to one side, as cow ponies do, so as not to step on them and jerk their mouths. Seeing this, Fred and I raced bare naked after them, but they began to trot, and we were a quarter of a mile from our clothes when Fred shouted, "Duck!"

Turning I saw what he saw: a buggy load of young ladies. It turned out they were schoolmarms on a picnic, spanking down the prairie trail not two hundred yards away. We threw ourselves into the tall sunflowers and kept as still as mice until they had passed, in spite of the prairie needles.

By six o'clock in the evening the old herd leaders — foremost among them a grey outlaw steer — began to graze toward home. Slowly the younger stock followed and soon the whole herd would gather, and by force of habit be walking several files along the winding trails they had made, all of which spider-webbed out from the main corral gate, till all were within and the gate shut; which meant supper for us about eight.

After days in the hot fly time, when cattle stampeded in small bunches over the prairie, when we sometimes changed horses three times a day in order to keep them out of the crops, it was a delight to follow the homeward herd along the valley's lower edge with the purpling hills to the west and the golden sea to the right.

I've seen parks and gardens in two continents designed to show off all varieties of gorgeous blooms, but no such elaborate planning ever made me catch my breath as did this golden valley with its silver pools in its setting of low treeless hills. And perhaps of all the people who rode, or homesteaded, or worked in that district, I got the most happiness out of that valley -- and I didn't own a thing but my saddle, my horses, and a few cattle running in the herd.

Among the rolling hills were the large sloughs I have mentioned, and here water birds nested in their hundreds, while the head of the swampy little river also teemed with migrating sandpipers as well as snipe, which latter stayed to nest.

The smaller ones, though beloved by birds in the spring when they are full of the run-off from the melted snow banks, are apt

to dry up, and so by July or August they may contain very little bird life. Not so the larger ones, which simply teem with life from spring till autumn.

Seen in winter, such a place looks desolate and forgotten — the surface frozen, great banks of snow heaped about the edge by the wind, half burying the reed-beds and willows. Only the quavering mink and hungry weasel know that beneath the dry matting of tules and cat-tails, there is a hidden life of vole and mouse and muskrat.

But the swamp bursts into glorious life with the melting of the snow, the clear blue of sky reflected in its mirror contrasting vividly with the snow drifts which still lie in the shady places. After the dead silence of winter, the sounds of spring strike up with a new intensity; the ripple of water seeking lower levels, the timid chorus of the frogs, hardly yet awake from their winter dungeons, the thin voice of horned larks from the higher prairies.

But the great mystery of the world made new is brought to us more keenly by our nostrils than by eyes or ears, for during the cold days of winter nothing has given off scent. Now we can smell the sweet earthy odour of frost coming out of the hillsides, and a faint but sweet perfume fills the air as the pussy willows open. Very soon the last snow bank has yielded to spring, and added its share to the growing pool, while through the water, stained brown from last year's sedges, the first green shoots of the new crop are to be seen pushing their way up to the sun.

The stilt people have arrived in their hundreds — phalaropes and sandpipers, godwits and curlews, willets and graceful avocets. They probe the cozy edges of the sloughs and pools, to collect in groups on mud banks and sandbars, to wheel and counter-wheel in the sunshine, enjoying a brief period of community life before the pairs retire each by itself for the season's housekeeping.

How daintily they feed in the shallows, nature's provision of long legs and long bills keeping their plumage dry, although the bulk of their food is obtained under water. The phalaropes alone take to the water itself, swimming high and daintily, rather like miniature gulls, and playing tag with a zest that makes the water fly. These dainty and beautiful birds share the midwaters with other new arrivals: puff headed, solemn grebes, and rather self-conscious coots, that swim with bobbing head and remind the watcher of hens in a rainstorm.

The aristocrats among the stilt-walkers are not so restless. The godwits sit for hours on the mud banks, one leg tucked up, the light glowing ruddily on their long, curved bills. Only on the approach of humans or dogs do they become alert and noisy. Later on, when their eggs or young are in peril, they will vociferously show their resentment at anyone's approach by swooping at him with a terrified yapping.

There are other birds inhabiting the slough grasses and weeds — birds which are not shore birds, but members of the perching order: redwing blackbirds and their yellow-headed relatives, as well as the cheerful little marsh wrens. But still, these birds, too, could aptly be called stilt-walkers, because, lacking long legs to keep themselves dry, they make use of the grasses and weeds among which they nest, reaching with their feet from stalk to stalk, and progressing rapidly with hardly a flutter of wings. They build their nests over the water, as on piles, and there, safe from weasels and cats, if not from snakes, the nest with the brooding mother swings to a rustling breeze, while the male redwing, like a gay toreador, flaunts his crimson cloak to his enemies.

All is not the perfect peace it appears, however, and there are many tragedies. In waters containing fish I have known more than one redwing fledgling to fall from its basket only to be snapped up

by a waiting pike. These hungry water tigers love to lie in wait near the edge of the tule beds, and all is grist that comes to their mills. Young muskrats, essaying a trip to the other side, will not adventure long if they come within vision of those cold, jeweled eyes.

As the desert places impress us by the scarcity of life — a coyote loping or a pipit rising, being an event — so do the marshy places impress us by life in such abundance, and with such vocal manifestation, reminding us of that far distant period in the earth's history when all life began in the mighty swamps. The croak of frogs, the boom of bitterns, the chattering of marsh wrens, the chattering scolding of blackbirds, are but an accompaniment to the steady volume of the Franklin gulls mewing, and the "peet" of black terns, while the flute-like and tremolo notes of the stilt people provide an obbligato sweet and haunting.

Too short is the sojourn of the stilt people. Hot summer days bring added household cares, and the songs of spring are forgotten in the absorbing work of feeding hungry mouths or leading downy youngsters to safety.

The tules become dry with the autumn days, and even before early morning shows a delicate glaze of ice at the water's edge, the shore-birds have "bunched," and after a brief revival of their spring community life, have quietly moved south to other mud flats where cypress trees take the place of willows, and alligators bask in the sunshine. Only the brown snipe remains well after the hard frost, to lie well to the sportsman's dog, or zig-zag with a "scaup" from his pointed gun.

ALAS, ALL GOOD THINGS COME TO AN END. In 1922 I received notice that my lease was being cancelled and the land opened for homestead entry. This cancellation clause in government grazing

leases was what ruined so many ranchers of those days. In many cases a great mistake was made, for the settlers who rushed onto these rough lands nearly all went broke. The area I write of is now a community pasture, natural successor to the old herds, but no longer run by free enterprise.

In the meantime, I had, from the year before, been courting a young school teacher who had recently come to the district from Manitoba. I shall write as briefly yet as plainly as possible about this. It was the kind of affair which I now recognize as all too common on the prairies of those days, and under another form (looking for love) equally common today, but safer, because science and sophistication now offer protection to the unwary. A state of affairs based on loneliness, on isolation from society — of a wish, perhaps, to escape something. It was born of those things. She was the only girl for miles around not engaged or married. I was the only young bachelor who was not a rustic, who was able to talk to a person of her intelligence, for she was intelligent, but also shy and unfriendly in a queer, hard-to-understand way, with most people. She was not only red-haired, but had the prickliness usually (and unfairly) associated with that colouring, and the country boys danced but once with her for reasons on both sides.

There was something slightly fey about her, something about her eyes which led one to feel that what she said was not what she thought, a heritage perhaps from her Highland-Canadian blood, and it intrigued me. And so often I thought she was such a pretty girl, and then her face clouded and I was shut out from her thoughts, or so it felt, and it was from this, no doubt, that other young men drew back.

And she was clever, with a fine mind for history and a finer for mathematics, yet often curiously closed to ordinary, everyday

practical things. I could talk to her quite easily on books and even poetry, and she would respond, yet I did not know if the response was automatic or really felt, so quickly did it come and go.

Our affair was born on mutual loneliness. It blossomed in springtime rides (for I lent her one of my saddle horses) when all the world was dew-green. She was my first girl, and many rides we had on Sundays. Sometimes we dismounted in some low, grassy hollow between the dry hills, to sit and talk awhile, with the horses standing quietly by, whisking their tails against the early flies, until the sun began to withdraw his great flame behind the treeless, darkening horizon.

It was at one of these rests that it happened, as it has happened since the first man had a way with a maid, and so shall the last, I think. So we became engaged and would marry in the fall. Yet there was something between us which did not spell happiness. Things I put from me, for I was young, and I was ignorant in so many ways, and it was easier to do so.

This something I could not recognize, nor know, nor compare with other girls, showed so little at times, but it would pop up when I spoke of children, for example. She did not say she wanted none, but there was a secret look which made me wonder.

I knew her body, and I thought I knew the mind which agreed to marriage, but her heart, I found, was as far to seek as her soul. She made no slightest objection to my religion (except in one re-gard), but she herself had little.

She showed that startled look whenever I spoke of her people, for I told her that now I must meet them, for they would nat-urally be concerned to meet me, and make arrangements for our marriage. I had been urging this for some time before our engagement, for I longed to be allied again to a family, and be-

long, as it were, and was prepared to like them no matter their background or ways. But I was usually interrupted as soon as I started, and she would speak of other things and smile so prettily that I thought I should give her time. She had said enough in a roundabout way to leave me to think that she and her mother did not get along. So I bided my time. And then, when the marriage was only a few months away, I said we must go together to the family, or at least she must let me write to her mother. But at this her eyes dilated, her nostrils quivered, and for a moment I hardly knew her.

It was then that she began to speak in a rapid flood, to tell me her mother hated her, that she was not the daughter of her father (who had died only recently), but "of some very important person, not of common stock," that her mother was not what she should be, and so on and on in a way to frighten me. "They" would part us, she said. She would lose the only friend she ever had. Her mother, she said, despised the English and hated the Catholics.

I calmed her fears, dried her eyes, and agreed to see one married sister who would understand and have the wedding from her home in Saskatoon.

Her father had been a C.P.R. telegraph operator and in his married life had been frequently transferred from one point to another. It was due to this circumstance that, although usually he worked at points west of Winnipeg, he and his family happened to be at Rainy River in the year 1904 when the second from the youngest child was born and so she said she could claim "good Ontario breeding" and seemed to get considerable satisfaction from it.

Back in the West, however, her mother persuaded her father to take a homestead, and here, while the breadwinner worked in a

town some fifty miles away, the mother brought her up, with a sister and a brother, the three elder ones soon leaving to go to work.

Whatever her suspicions of her mother might have been, I was later quite unable to find any grounds for believing what she told me, or that it was anything more than a figment of her imagination and what were to turn out later to be hallucinatory dreams of a sort of grandeur, coupled with a persecution complex. But I knew nothing of such things then, and I comforted her and said it was alright, I was not marrying the family. And the curious, frightening thing retreated.

And happily, I knew nothing of the years ahead and what they would bring, or how sketching and bird watching would give me ease from the thousand difficulties which I would have to meet before I found why my instinct tried to tell me that I was making a mistake right up to the day of my marriage.

Instead, I determined to go ahead and do my best, with the help of time. Today we have a new morality, for better or worse. But I began gradually to see my mistake, for she was not for me; and I saw that I was becoming alienated from a church whose priest could only advise from a book and urged that children must continue to come.

And the beginning was that, although I had prayed to resist temptation, I became over-confident, and the day had come when I forgot God and broke his law. And not because she was bad, but because she could not help it, this woman grasped me firmly and squeezed out the juice. There was no voice to say nay to us, no friend, no counselor, and without that voice, that word from a friend, neither of us could help what befell because of the wrappings of mystery which enfolded her.

Yet the fault was mine, totally and utterly mine, and what

it taught was that one unpremeditated act of sex, thorny and thoughtless, committed without regard for responsibility, set in motion a series of events which, like ripples on a pond, continued and widened for many years, touching many people to their hurt, and to mutual reproach and recrimination, not to say separation.

So we were married, with her sister in attendance, in a tiny manse long since replaced by office buildings; and we entered into a state which would be indissoluble of solution for half a lifetime. Many straws would be grasped and torn from my hand before fate took a hand.

At least I loved her then.

SINCE I MUST NOW FIND A NEW HOME, and since I had my wagons and haying outfit as well as some horses and cattle, I decided at the insistence of Mr. Sealy of the S.S.B. to try farming. (Since the ranch was over twenty miles from the railway, I had not tried for a loan there.) I found a good quarter section for sale closer to town. It had a wooded coulee, which would be a good place to winter stock, and also a good well. There was a Hudson Bay section adjoining, all rough prairie land which I hoped to lease and eventually buy.

Mr. Sealy seemed sure that the S.S.B. would approve this location. There was a house and barn, so with the owner's permission we moved in that winter just after our marriage.

However, the board would not O.K. this purchase since they thought there was too much pasture land and not enough arable. They took no interest in cattle raising and stressed wheat as a cash crop.

Mr. Sealy showed me another piece of land owned by the same man — one Townsend — which I found later the fellow had bought just as the war ended for $400 from the widowed first owner who des-

perately longed to go back to England. I have not the slightest doubt there was collusion in this matter, as Townsend had another buyer for the place I wanted. But I was more trusting in those days, and anyway I had to have a home for my wife and pasturage for my stock. In the event of having to sell them I would have sustained a heavy loss, as cattle were at rock bottom — about two cents per pound!

I had enough cash to pay the ten per cent down which was required. The contract with the S.S.B. was for twenty years at five per cent, compounded. Since the price asked for this land was $3,000, my initial payment was $300, and the annual payments thereafter $140. (This land subsequently, in the '30s, would have been, on the market, about $300, or what my down payment came to.)

I was milking nine cows and shipping cream at Renown, so I had no debts in that line, and knew I could keep the larder well stocked, so we moved on to this other place. I set to farming with a will. At least I was still out in the country, and still where I could see and hear and breathe the country environment, as well as write of it.

Surely, there is no outdoors occupation that gives the naturalist more opportunity of observing certain birds than that of ploughing. The steady methodical tramp of the horses and the dull fall of the furrow slice became such accustomed sounds that, like the roar of traffic in large cities, they become hardly noticeable, and seem no more than a low accompaniment to the sweet notes of plovers and meadowlarks, or the harsh calls of gulls and grackles as they follow in our wake.

The wild things, too, become accustomed to the movement of the team, scarcely noticing the widening land made by its progress, and little heeding the teamster, motionless and dust-laden on the plough seat. Most ploughmen have the habit of keeping their

heads slightly down to the right, to see that the plough is cleaning properly and burying weeds and trash.

The monotony of sound, the monotony of the tramping movement, and the steady flow of the furrow slices, like water over rocks, induces a pleasant state of reverie which allows one's mind to be particularly acute to small incidental happenings, while at the same time the hands control the team or alter the levers to suit the nature of the soil.

It was while ploughing summer fallow that I first became aware of the havoc annually wreaked by crows among young game birds. In this case, the summer fallow to be ploughed was grown up almost knee-high with weeds — wild oats, tumbling mustard, pigweed — an ideal nesting place for ground birds. As the first land began to widen, I noticed a single crow approaching and circle around more or less indifferently. Suddenly he put on the brakes and almost stopped in mid air, then, with a loud caw, he turned and winged away, to return almost at once with two more of his kind, who also quartered low, and cawing perched on the fence which bordered the field a couple of hundred yards to the west. Soon after, the horses threw up their heads, and fluttering piteously, a prairie chicken left the weeds and dragged herself across the open ploughing. I guessed at once that she had either a nest or a brood hard by, and was attempting to lure away my heavy-hoofed invaders before they crushed her treasures.

Stopping the team, I searched weeds to the left and soon found a brood of chicks lay in scattered hiding. Several of them I captured and carried out to the ploughing near their mother, where they immediately froze to the likeness of earth clods. As the team moved on, I saw my mistake. In the heavy weed growth the crows were unable to attack the chicks successfully and knew it, and had

been awaiting the time when the downy little fellows would be exposed by the plough.

Hardly had I got the outfit under way again than the three black barbarians swooped down, and in the face of the mother bird's brave but rather hysterical onslaught, and quite heedless of my poorly aimed clods, carried off two of the chicks in triumph to the fence posts, where they ate them in horrid gulps, and then wiped their smug bills on the barbed wire. After that, nothing would induce the mother bird and her remaining chicks to venture forth from the safety of the weed-forest.

But by now I had finished the land and was ploughing, left-handed, the strip between it and the fence, and next day as the green weedy strip grew narrower, I did my utmost to drive the birds across the newly ploughed strip and under the fence to the shelter of the prairie wool and rose canes in the adjoining pasture. But all my efforts proved in vain; they would not be driven. To carry the chicks over and leave them without their mother to lead them into deeper cover, would mean that the crows, now numbering about a dozen (for their beaks can scent opportunity from a great distance) would pounce on them as soon as set down.

The sinister-looking black birds had taken up their usual position on the fence; each post for several rods being topped by one. They sat quietly, grimly awaiting the reward of patience. As the strip narrowed down, one or two became more bold and slightly impatient, and flopped to earth, walking on the newly turned furrows with the roll of drunken sailors, and keeping a wary eye toward the weeds. There was nothing I could do. I had no gun. My shouting hardly disturbed these sable murderers, who seemed to know that I was unable to enforce my commands to depart. Each round of the plough brought the final tragedy closer. As the last

round swallowed the green and joined the two belts of chocolate, the mother grouse and her brood, having miraculously escaped the horse's hooves, debouched in straggling formation up the dead furrow. In less time than it takes to tell, the crows were among them and the slaughter of the innocents was on. Not one chick escaped.

For many days thereafter Rachel mourned for her children, yet hardly realized that they were gone. Days later, I was harrowing the same field, and the wild mother was still there, walking aimlessly and clumsily among the rough clods, calling softly for her lost brood.

My first crop told the story. It was completely choked out with wild oats. I cut it all for hay while green and did not thresh one bushel from 125 acres. I tried one more year but that was a dry one and the wild oats were still thriving. (A wild oat seed will stay five years underground and still germinate when you turn the soil over.) I threshed about 300 bushels.

Seeing this could not go on, I sat down and did some planning. I reckoned that if I first summer fallowed all the land, letting cattle graze down the weeds, then I could sow brome grass the following year for hay and grazing, and clean the land in four years. I could make our living with the cattle, but the problem would be the annual payments, and I was already behind one year.

I went to Saskatoon. First I saw Dean Shaw at the College of Agriculture. He fully agreed with my plan, and offered to go with me to the S.S.B. superintendent. Off we went and explained the problem and the solution. At my request that the payment owing, as well as the payments for the next four years, be amortized over the remaining fourteen years of the contract (to 1944), he nearly went wild.

"We must have a cash payment and you must grow a cash crop," was all he could say.

Suddenly I knew what to do. I must trust the security within me, not the false face of security without. I said, "Please pass me a quit-claim deed."

The superintendent stared. "Do you not realize," he said, "that when you took the loan you mortgaged your implements and stock as collateral security. Don't you see if you quit you'll lose them?"

"Of course I do," I said, and added, "now if you'll just give me that deed to sign, the whole caboodle is yours, and may you find a man to sell it to, for I wouldn't have the heart."

He produced a deed. I signed, a stenographer witnessed, and with a word I left. I was broke. But I was free. I sold what belongings were not mortgaged to a neighbour (who never paid me).

THAT SUMMER OUR FIRST CHILD, Robert, had been born at Watrous. My wife stayed at a nursing home in Watrous for nearly six weeks, and the bill (with the doctors') came to about $500, of which I could only pay part.

In the fall I butchered a big veal calf (of the S.S.B.'s!) and took the meat to Watrous in the hope of buying some winter clothes for myself. Dr. Stipe, who had attended my wife, had his office across from the butcher shop. He saw me go in with the carcass and as the butcher paid me he demanded the money on his account. I tried to remember what my Uncle Joseph had said: "Never let yourself be insulted by the lower orders. The *blood* in you must not allow you to even take notice," and with that thought I handed him the $12.

I was probably not the first struggling young farmer who pulled on two pairs of pants that winter in lieu of heavy underwear. All that mattered was keeping warm.

I had kept up my sketching and did some writing as well as reading on winter evenings. It was a great solace in those hard days. Not, of course, that we wanted for essential food and clothing; the noble cows saw to that. I was as keen as ever on natural history, and already planning a book on prairie birds which I would illustrate.

When in Regina during my training for the army, I had met Chief Game Guardian Fred Bradshaw and had kept up correspondence with him. He too, was a bird man, and had already started a small museum in the Normal School building at Regina. I sent him various sketches and notes. He now asked me to take an appointment (unpaid) as Honorary Game Guardian, which I did.

Bradshaw sent me a badge and a copy of the *Game Act*. This gave me a greater interest and I managed to assist in putting down the spring shooting of wildfowl. I had to stand up to one notorious and very large poacher, a big farmer who thought he owned the country. I must say I came out better than he, and got a letter of commendation from Bradshaw.

These experiences opened my eyes to the decimation of wildlife, and I began to study conservation methods.

Our first move was to Saskatoon, where I had heard of a sign painter who needed a man who could paint free-hand. He had a contract with the Daylight Theatre on Second Avenue to supply weekly posters to advertise their films. This was in the time of silent films, and before the film companies put out their own posters, which only had to be dated.

I got the job. I also got along very well with Mr. Scratch, which I thought a most appropriate name for one of his trade. I thoroughly enjoyed splashing about with bright primary colours (tempera) on the big poster boards. I did one of Mons — all blood red sky and black mud and infantrymen going "over the top" with fixed bay-

onets, and there were many others equally lurid. The pay was quite good, for in between posters he had me at other work, and we found a small flat for the three of us.

I also met a young man who was selling sets of encyclopedias from door to door. The books themselves were good, but a man of rather dubious record had the selling right for Saskatchewan, and he employed a staff of salesmen to work both city and country. I had heard several complaints from housewives and school teachers about the sales methods used, so when my acquaintance began to tell me, in most flattering terms, that with my English accent and gift of the gab I would make a good salesman, and suggested I take a month's course in salesmanship with his company, I pricked up my ears. Nothing could have induced me to become a salesman, but I thought that here was a chance to improve my knowledge of the big, wide world and of people in particular. The course involved three evenings a week and was free, so I accepted the offer but kept my own counsel as to the reason.

That, of course, was a revelation which proved that a sucker is born every minute; indeed, that was the cynical slogan which prefaced each lecture given to the ten or twelve of us budding hijackers! The classes were held in the boss's office, and we were told exactly and in detail not only how to pick the suckers but how to make suckers of ordinarily intelligent women. For it was the women we must concentrate on. Having "sold" them by every device of flattery, cajolery, and misrepresentation, they could be trusted (we were told) to drag their husbands into the net rather than lose face by admitting they had been persuaded by a salesman!

We were told how to get a foot in the door (in hubby's absence) and how to proceed from there to a cozy chat in the living room. We were instructed to introduce ourselves as *representatives of*

the "*Education Department of Oxford and Cambridge.*" We should drop vague hints about "making a survey" for the *Department*. That word "department" was particularly telling (the lecturer said) with young schoolteachers anxious to please their inspector, for it would be equated by the innocent girls with the Provincial Department of Education.

Flattery and mild rebuke could be used *ad lib*. If a housewife suggested that she should consult her husband before embarking on such a costly venture, she was to be soothed by an earnest reminder that since she was mainly responsible for the children's welfare, surely her busy husband would trust her, and expect her to make her own decisions; especially as only a limited number of sets were available and she been specially chosen as being interested in education. (It was probably the first time she had heard *that* one). In any case, there would not be another opportunity because the "survey" closed in a few days and the "report" must be prepared for the "Department."

It was also suggested that we make casual and nostalgic reference to our dear old Alma Mater which had conferred on us our master's degrees, and in addition to learn by heart certain profound and learned quotations in respect to the sacred matter of parental responsibility toward the growing mind of the potential young genius who might be even then peering at us in freckled curiosity over his after-school bread and jam. Head patting could help (we were told) to give Mamma the bright thought that without these books poor Freckles would have to dig ditches all his life.

I passed the course with honours and several large notebooks crammed with information, after which I refrained from signing a contract as a salesman — which resulted in a few hard words from the boss.

This experience confirmed my suspicion that all advertising consisted of appeals to the seven deadly sins. Argue it as you will, all selling and advertising is, stripped to the bare bones, an appeal to pride, gluttony, envy, and sloth — as well as the rest, but these are the chief.

What is the reference to Freckles's genius but an appeal to pride? As barefaced as the advertisement which says, "People of discernment drink so and so." "Convenience" is the word they substitute for laziness — "So convenient to let the pup be your furnace-man." "Gracious living" is another genteel camouflage. As to gluttony, every woman's magazine has coloured pages of invitations towards that vice. All of which explains why I have never bought anything from a salesman, not even insurance. Nor do I read advertisements except to analyze them.

I was soon convinced that city life would never be for me, so I began to look for something else. Shortly, I heard of a homestead west of Battleford, so thither we went. I found the land still open. It was not a very good quarter section, but it had possibilities and I filed on it. I boarded my wife and child with a lady in a nearby town and got myself a job on a farm.

During threshing time I took advantage of wet spells, when work and wages stopped, and with an old horse I bought for $10 went to the homestead to cut logs for a house. These I dragged up from a coulee with the horse, and as soon as freeze-up came and all work ceased, I began to build.

I had made about $400 stooking and threshing and this was enough to buy lumber for floor and roof as well as a winter's grubstake. That money was hard-earned and all the sweeter for it.

Stooking — or as they call it in the States, "shocking" — grain is a hard and a monotonous job, and usually a lonely one. Except

for odd chats with the man (probably your boss) running the binder — wonderful invention of Samuel McCormick — and at meal times, one was alone. A man stooks better alone as a rule; there is less tendency to stop and chat and no getting in each other's way, for some fellow workers are *too* chatty; and as your muscles harden up to the work and your back gets over its first soreness, the actual picking up and stooking of the sheaves becomes practically automatic, and the eyes, ears, and mind can be intent on other things.

Going out to the field just as the bright sun gilds the slopes is like going into a new world. Prairie chickens pose on the stooks or fly up with their clucking notes. And I have come to quite close quarters with various animals out stooking. A badger, or quite often in the cool of evening a skunk out for a stroll, and once I nearly picked up a porcupine squatting among the sheaves.

And what joy it was to take the odd rest and smoke in the shade of the rusting wheat, to ease the back muscles and watch the hawks overhead. Or better still, if there was a grass slough near, to lie in the cool green herbage and press your nose right down into the smell of wild peppermint and damp moss.

A few decades ago the steam tractors were still in their glory, and a threshing outfit looked like a small army when on the move. The great steam engine with its piercing whistle, tall funnel, and colossal wheels was attended by a proper steam engineer with "papers" and a fireman for stoking. Behind it was a straw-rack — a tender kept full of fresh straw, which was the monster's fuel. Then came the big separator or grain mill with its yawning mouth, its tall grain weigher and dinosaur-like straw-blower.

The separator man stood all day in flying dust and fragments of straw and grain heads picked up and flung so freely by the wind, amid the eternal glare of bright sunshine reflected from machin-

ery parts and the pale yellow of ripened grain. The job put a fearful strain on the eyes and so hard was it on the exposed skin of the face that separator men commonly refrained from washing all through a "run" since that process only increased the soreness. After the first week only the whites of their eyes flashed from blackened faces, with a dirty white rim about the lips, caused by chewing grain, which they did consistently — unless they were tobacco chewers — as the continual spitting served to clear dust from their throats. On all such hot dusty jobs, smoking is dangerous as well as time wasting, and there is no doubt of what brought about the prevalence of chewing tobacco or "Copenhagen Snuff" throughout the West. While spitting may be rude in polite society, it is a perfectly natural act under such circumstances.

Following the machinery are the stook teams, which load the sheaves direct from the field and draw them to the "set," where the separator has been leveled and located. This is a careful operation, but speedily done. The separator was hauled in place, the big draw pin pulled and the steam tractor circled around in position. The separator man, usually assisted by the fireman and perhaps a stook pitcher who already has his load on, connected the foot-wide drive belt, gave it the necessary twist, and expertly shoved it on the fly wheel.

The fireman stoked the fire; black smoke puffed forth, the revolution speed was increased and the separator began to hum. Up jumped its operator onto the wooden deck, swung around the straw blower, and made adjustments. He signed to the steam engineer who nodded and pulled the whistle cord, and before the high note had died away over the prairie, the teamsters were urging their nervous horses alongside the feeder. When the wagons were properly placed, with the lines wrapped around the upright

standard in front of the rack, and the horses cocking uneasy ears at the grind of cog-wheels so near their heads, the separator man nodded at the teamsters who stood with sheaves already poised on their light, three-pronged bundle forks. They responded with a bundle deftly dropped on the slatted feeder, head forward, and now the sheaves came, well placed, head of one to the band of the last, and the blower began to spout straw. This may have been six o'clock in the morning, and, barring an hour's shut down at noon, that blower would spout straw steadily till eight o'clock at night, or later if a field could be finished by, say, nine o'clock.

It took twelve stook teams to feed this monster, and about four grain teams to take the wheat away to the granaries, unless the threshing was into a field bin. There was a boy with team and rack to haul straw for fuel. He loaded up by simply driving around and having the separator man direct the blower so that the straw fell on his rack. All he had to do was build his load with a straw fork, and when loaded, to drive back to the tender and fill it for the fireman.

So with a crew of about twenty men with thirty-six horses, a visit from the threshers was a visitation indeed, and meant terrific work for the womenfolk. Potatoes were peeled by the bushel, and beef roasted by the twenty-pound piece. And what wonderful meals those women did prepare. Usually they had the help of neighbour women, who they would help in their turn, and threshing was not only hard work, but often a pleasant visiting time as well. For western women visiting is great fun, and commonly carried on to the accompaniment of ordinary household duties. The children ate separately, usually with the women, for it was to keep the menfolk fed that was the big household task.

ON THE FIRST OF DECEMBER we moved into snug quarters. On the twenty-third our second son, James, was born. The doctor came

and I arranged for a reliable local midwife. James was a husky youngster who thrived on Borden's Eagle Brand milk.

That winter I cut wood for sale. There was plenty of good poplar on that homestead even if the land was rough. After piling up about forty sleigh loads, I borrowed a team from the farmer I had worked for, and after pulling up ten loads for household wood I hauled the rest to town for a dollar a load.

In the spring I worked again on the Larson farm and after seeding, he lent me some horses and I broke up ten acres at home. The Larson farm was three miles away and I left home every morning at five-thirty to get there in time to harness four horses and be on the land by seven o'clock. I had dinner there and worked on from one to six p.m. when we quit for supper. After that I walked home, carrying our daily milk, which Larson's housekeeper let me have for a nickel a quart. I got $40 a month for seeding, and in the summer I dug out big poplar and willow roots from the new brush-breaking for a dollar per ten-hour day. I was healthy and strong, if not altogether happy, but the latter was due to neither hard work nor low wages.

At least there were plenty of books to read in winter, and I still sketched when I could. In fact one of the plates for *Hours and the Birds* (not published till 1967) was painted on the homestead by the light of a coal-oil lamp, and from sketches I had made in the field. It represents a killdeer plover at her nest.

It must be remembered that in the '20s and '30s there was absolutely no work except farm labouring for one like myself. I could not teach school, for the authorities considered me uneducated when I could not produce a Grade XII certificate. Nor could I go to Normal School unless I went through Saskatchewan High School first, which was out of the question anyway as I had

a family to support. My entrance certificate from Mr. Sargeant was considered a very doubtful piece of paper. I might have got work in a store, but that was hardly a thing a countryman could stomach.

The homestead, if not profitable, was a delightful place, the cabin surrounded by groves of Saskatoon bushes, backed by poplar, with a deep wooded coulee to the east, while to the north was a superb view across the Battle River, with the outline of Blue Hill on the horizon.

The next spring I wrote the following:

"It had rained all day with that persistent, steady downpour unaccompanied by wind typical of June in the West. All day we had listened to the steady drip, drip of water from the eaves, as though Mother Nature was counting the drops of the precious life-giving fluid. With evening, however, came a slight breeze rustling through the drooping poplars, and all of a sudden the clouds broke in the west, and a single beam of sunlight piercing through turned the green hillsides to molten gold.

"Wearied with enforced confinement to the house, which had been my lot all day, I went to the open porch just as the leafy woodland aisles awoke to the music of the birds.

"As though at a signal from some unseen orchestra leader, their melodies gushed forth until the wooded slopes of the Deep Coulee rang again and again. From a grove of slender poplars the robin, who had been silent all day, now announced in liquid tones that the rain was over, and seemed to invite his feathered friends to 'come and see,' 'sun's out' 'Plenty of worms.' In answer, there came from the deeper woods the oven bird's oft-repeated 'teacher, teacher, TEACHER,' beginning faintly and swelling in crescendo, rising and falling on the air in a steady monotone as

though the author were deeply preoccupied, as he doubtless was, for had he not a bowered nest among the fallen leaves of the forest floor?

"Then vireo and yellow warbler added their trills and cheeps in a medley of half-heard notes, now far, now near, so that none but the keenest-eyed bird-lover might determine the whereabouts of the tiny musicians. From a vantage point on the porch roof, below which his mate brooded, a brown wren burst into song, throat swelling and body vibrating in the effort to outdo the larger birds.

"Stepping out into the rain-washed world, and drawn by the freshness of the evening, I took a vagabond cow path as our highway, and presently wandered down the Deep Coulee where the trunks of the lofty poplars gleamed wetly, and knew from the muffled roar that greeted me that our tiny, spring-fed brook was already swollen to the dimensions of a creek.

"Every spray of Saskatoon and chokecherry was laden with iridescent drops of water, which at the touch showered down upon the passer-by, turning for that brief moment into precious jewels as they caught all the colours of the rainbow from the descending sun. The early roses which had dropped their heads all day, now began to lift shyly, wafting their perfume on the air, to mingle with the Balm of Gilead, and that delicious clean, earthy smell which rain always unlocks from the bosom of old Mother Earth.

"As I neared the creek the avian chorus increased. 'Conkeree,' sang the blackbird, and spread his wings to show his crimson epaulets. A flicker, scuttling round the trunk of an ancient rough-barked and worm-eaten black poplar, paused at his work of searching the crevices for grubs, to peer curiously at me.

"From his rotten and mossy log by the spring, a ruffed grouse drummed his accompaniment, 'ruff, ruff, r-r-rrrrrrr,' then strut-

ted proudly on his stage till, on sighting me, he made off — not a hurried retreat, but marching with measured step like the proud drum-major he is, with much nodding of the head and flicking of the tail, never deigning to hurry till safely concealed in the shrubbery. Although his courting days were over, his mate long since having completed her nesting preparations and started to brood, the gallant bird still let the woodland neighbours know that he was on guard, and ready to defend her with claw and beak.

"Slender birches nodded to their reflections in the tiny pool, their trunks blushing pink in the evening light, while there arose from the water's edge a misty vapour which lent to the whole scene an air of fairylike aloofness. Too soon the mosquitoes, humming their wicked war song, arose like an army of Lilliputian airplanes, forcing me to retreat uphill.

"By now the sun had set, but his banner was still unfurled, painting the fleecy clouds with rose and pink and mauve, a perfect background for the rounded hilltops rising above their shadows of blue and purple.

"The birds had settled down for the night, with only an occasional cheep to mark their presence, only the vesper sparrow trilling sleepily from the prairie level his good-night song, and a pair of nighthawks wheeling dizzily in pursuit of moths, their sad 'pee-it' drifting down from the upper air, one or the other at intervals sweeping down with a sound like the snapping of a bow string. A horned owl hooted his hunting song across the Deep Coulee."

I HAD ALWAYS WRITTEN TO MY MOTHER every month, but forbore to mention my difficulties in any detail, because I felt my life would be so strange to her that she would not even picture it. She always answered my letters in her firm hand, giving me news of the

family, and she always remembered my children's birthdays and sent them little presents.

About this time I had a letter from which dropped a postal order for twenty-five dollars. This was the first and only money (except for small Christmas presents) I ever had from England. Mother's letter explained that this was not from her. It seems our old governess, Miss Power, had died, and left her small savings to her favourites among her erstwhile charges. I remembered the times I would not go to sleep in the afternoon, and how poor Miss Power would bribe me with a sweet.

That fall, in the middle of threshing, I caught a terrible cold. I had to lay off work and began to worry about the winter when a letter arrived marked "Government of Saskatchewan." I tore it open. It was from Chief Game Guardian Bradshaw, and it offered me a position as Provincial Game Guardian at a salary of $75 and expenses up to $50 monthly. This was like a gift from heaven, and I wrote at once to say I would accept. They sent me transportation to Regina and instructed me to report for swearing in and briefing.

"You will now," said the Chief Game Guardian, "subscribe to your oath of office. Repeat after me — 'I, Robert David Symons, do solemnly swear . . . without fear or favour, so help me God.' "

The little ceremony over, the chief resumed, "Here is your badge and your appointment as Provincial Game Guardian. You are to enforce these ordinances," and he handed me a copy of the *Game Act* and another of the *Migratory Birds Act*, of which he said, "Remember this as a Dominion Act covering ducks, geese, cranes, and other migratory birds that do not come within jurisdiction of the province. Your authority for this is vested in the section of the *Game Act* which declares that all provincial officers shall be ex-officio officers under the *Migratory Birds Act* regulations. Remember to quote this

authority in cases you may have to prosecute; otherwise some smart lawyer may throw out a case on the grounds that there is no evidence in the charge to show that you are properly authorized to act.

"Copies of all reports under this Act are to go to the Chief Federal Migratory Birds officer at Winnipeg — Mr. Dewey Soper, whom you will probably meet some time.

"Here also is a *Constable's Manual*, which will guide you in law and court procedure. I advise you to study it carefully. Stop in the outer office as you leave, and Miss Green will give you transportation for Battleford and a fifty dollar advance for expenses. She will also give you necessary forms and paper. Don't worry about reports getting to us if you're too busy to make them or post them, because you may be in a place or a situation which prohibits that unless you neglect more pressing duties. Reports can always wait, but the job cannot. Your patrols are the all-important thing. Circumstances over the past years have led to a general disregard of the law, and you are to correct that at whatever cost. Try to make your own decision without reference to us, because we are not on the ground, and anyway you're bound to be out of touch with us for perhaps weeks on end.

"You will have to feel your way and use your head, and never forget that you're backed by the full power of the law, so you need have no fear, while at the same time you must be careful never to abuse your power. Remember, too, that the first consideration must always be the prevention of crime, and you may find that in many cases a few words of warning may have as good an effect as a prosecution. We must never persecute, for that will defeat our end. Prosecution should be used only as a last resort.

"This isn't a job — always remember that. Your pay — the best we can do — of seventy-five dollars a month is nothing. Your work

will be, rather, an opportunity to serve your country in the best possible way, by putting into effect the only effective measures by which we can save our wildlife for posterity. If I didn't know that you realized this I would not have offered you this position.

"Remember, I'll take no excuse for slackness in patrol work. You're now on your own — absolutely on your own, and I wish you good luck."

MISS GREEN WAS VERY KIND. She explained that I would be entitled to five cents per mile for the use of a saddle horse. I mentally calculated how many nickels it would take to pay for Billy, the big bay, and Chief, the buckskin, which I had purchased for a hundred dollars each, plus their shoeing, stabling, and fodder. Patrol sheets, monthly diaries, pens, ink, and paper could be requisitioned on the forms provided.

For patrols on foot there was no pay. A man was evidently worth less than a horse. Boat hire, when needed, would be paid for at fifty cents a day. When in the settled country, meals at thirty-five cents and lodging at one dollar was allowed, but under no circumstances would the department approve expenses in excess of seventy-five dollars per month. Car mileage, if I ever used one, would be at ten cents. For sleeping on the prairie or camping in the bush there was no allowance.

I said goodbye to Miss Green with the feeling that here was a friend upon who I could depend, and events proved this to be true. She, and only she, was able to decipher with speed my crooked English hand and type it into readable form. I was later to bless the wisdom of a system that required no time to be wasted in office work and duplication, a system that left the Game Guardian free to work by night or by day, to stay with his work free from nagging

thoughts of paper work awaiting him. Reports could be written in longhand and sent in when feasible to be put in order for the office files by the devoted lady who wished me good luck on that day in 1927.

My headquarters were to be at Battleford — Old Battleford we called it, to distinguish this early seat of territorial government from the brash young city just across the swift Saskatchewan.

The area I was to patrol was an empire in itself – from the Shell River just west of Prince Albert westward to the Alberta border at Meridian Ferry, Lloydminster, and Macklin, and from Biggar and Big Manito Lake on the south to the Bronson and Meadow Lake forests in the north.

The scenery here is among the finest in the prairie provinces. South of the North Saskatchewan from Sonningdale westward lie the wooded heights of the Eagle Hills, broken by many deep and tortuous ravines. To the south and west lie the open plains of Wilkie and Unity, merging into the rolling, lake-gemmed sandhills of the (then) Manito Forest Reserve, at that time still under the wing of the Dominion Department of the Interior with a resident ranger. Just south of Battleford are the Mosquito, Grizzly Bear Head, and Red Pheasant Indian Reserves, while westward along the Battle River Sweetgrass, Little Pine, and Poundmaker Reserves were still held by their original owners — or at least their descendants, for of those who had accepted the treaty of 1876 in person, only a few like Sam Swimmer and Fine Day remained.

Northward and westward is the rough area of Big Gully Creek and precipitous slopes of Pikes Peak, where Augustus Kenderdine the artist had his original ranch. Still north across the river are Frenchman's Butte, famous from rebellion days, Horse Hill, and the English River. Further east again are the Moon Hills, the Thick-

wood Hills, the lake country of Marcelin and the rolling beauty of the Mistawasis Indian Reserve. At Battleford I was able to get a nice little house for twenty dollars per month.

In those days the southern part of this area was dotted with sloughs of all sizes, offering both resting and nesting sanctuary for water fowl, while north of the river lay that chain of wide, placid lakes which, with the exception of Jackfish and Murray, had not yet seen the summer cottage or heard the power boat. These were all famous for their whitefish and pickerel.

From the prairies in the south to the aspen parklands of Battle River and Maidstone, from the mixed forests and sombre spruce woods of Midnight Lake, Mont Nebo and Bellbutte, to the tangled brule and treacherous muskegs of the Bronson, every aspect pleased, and only the poacher was vile. For woodlands that might have supported thousands of deer held but few. Killing out of season, killing for sale to camps, the killing of does and fawns, wastage and greed had done their work.

In the fall the ducks and geese of the wetlands had little rest, and hunters loved to be photographed in front of long strings of bloody and disheveled wildfowl taken far in excess of either need or sportsmanship.

The nearest Game Guardian had heretofore come from Saskatoon, and his few and hurried patrols had been by the Ford car of that period, which confined him to the few main roads fitted for that type of transportation. Poachers operating by horseback, team, boat, or on foot, and knowing every inch of the country, could easily evade apprehension. The man they had no fear of was content to draw his salary. The blame lay not with the guardian, however. Both he and the cause of conservation had been betrayed by that political slant which still exists, and which the Chief Game

Guardian was determined to circumvent even if he could not end.

The few beaver dams left were annually depleted of their increase by the fur poachers, who well knew how to smuggle them to the marketers in the larger cities, thus evading both the royalty payable to the province as well as the danger of prosecution.

PART V

Without Fear or Favour (1927 – 1942)

EVERYTHING WAS NOW LOOKING UP AT LAST. I felt that my wife would be very much more satisfied with life in town; and for my part, to get back in the saddle was a pleasant prospect.

Times were getting hard for country people, what with dry summers and low prices for grain and livestock. The depression of the '30s did not really come in with a bang for prairie people, for the signs were there to read as far back as 1925, when we began to see the sloughs dry up; which should have told us that the water-table was shrinking.

All the more welcome then, was the knowledge that my salary, however small, would ensure some stability for us.

INDIANS CAME TO BATTLEFORD FROM MILES AROUND, and they never had a better friend than Paul Prince, whose father, the old Senator, had built up not only a store but a tradition which lived on in spite of the shiny new chain markets in the "North Town." During those desperately hard years of the thirties, so close to the horizon and yet unthought of at this time, I knew of no man — white, Métis or Indian — whose family ever really wanted for necessities, as long as that sign, "B. Prince and Sons," faced the main street of Battleford. One can only guess at the extent of the unpaid bills that accumulated, but Paul was a man who held sim-

ply to the faith in which he had been reared, a faith which taught the blessings of giving, and if his natural concern for the welfare of his own family may have shortened his life, that is how he would have wished it.

There were others too, perhaps of different belief, but equally faithful to the common precepts. There were pagan Indians whose word was better than many a man's bond. There was Tommy Turnham the butcher, and only the angel with book and pen could tell you how often he turned his back when the Indian women came to the slaughterhouse for offal and took something better which might fill their hungry children with good broth.

Battleford might well have been singled out as expressing for the whole province that feeling of live-and-let-live, help-your-neighbour spirit which prevented those hungry years from working altogether for evil; a spirit which has brought about so much good work in the alleviation of poverty and hopelessness, and if some of us feel that socialism has gone too far and that the welfare state may perhaps present an evil face at times, this is not to belittle those who gave their goods and their time to hasten it. The spirit of Battleford had been forged in troubled times. This town had been the seat of the first government of the Northwest; a country of many Métis and more Indians, proud in their poverty, wise in their simplicity, representing a day whose sun had set.

There were traders, French and English, who foresaw a great city, only to be finally disappointed when the railway passed north of the river instead of across that beautiful scenic plan, sheltered on the north by the banks of the Saskatchewan, on the south by the hazy blue ridges of the Eagle Hills; that plain might have held one of the finest cities of the empire, had the dreams of the founders been realized.

The Rebellion was not kind to Battleford. There had been ugly whispers of a threatened attack by the poor Crees — whispers which may well have been born of wishful thinking on the part of some who sought military glory. And the result of the near conflict further embarrassed those once proud hunters of the buffalo, so that more and more the church must be their mother and the Indian Agents their father.

Forged in the furnace of different religions, races, and ideologies, the spirit of Battleford emerged a little crooked, far from perfect, but still the best thing of its kind; for it was hammered out by men of good will, men of purpose, men free — or as free as those days allowed — from the petty racialism which then characterized so much of the civilized world.

The Indian remained stoical and accepted his fate with dignity. The bond of the frontier still embanded the alloyed and transmuted metal and, in the remaining government offices, the Ballentines, the Naults, and the Latours polished their stools side by side with Lindemeres, the Ridingtons, and the Burlinghams. Harry Adams, the Okimowsis of the Hudson Bay Company (by now Town Clerk), was as English as the Clinskills were Scottish, or the Davises Welsh, but all were heir of the tradition of the old Northwest, and French, Cree, and English were the tongues they spoke. But one result of the Rebellion, so soon to be followed by the inrush of settlers from Europe and the States, was that the *coup de grâce* was given to the French language and to bi-culturalism in the West. Bishop Grandin, Father Lacombe, and the great French families who had done so much to help the builders of the West in these parts were forgotten; and as for the newcomers, passing rapidly through Eastern Canada on the way to the new Eldorado — few of them knew any more about Indians than that they were a vanishing race that had retreated to the fast-

nesses of the northern wilderness.

It took most of the first year to become thoroughly acquainted with my district, and I suppose by the end of the second there was not a trail Billy and Buck did not know, nor a livery-barn which had not sheltered them. Often, in summer, I camped out where the grazing was good, sleeping in a blanket I carried on the saddle. My papers and shaving tackle lived in my saddle-bags. The district was not in good shape, and I had a pretty large number of convictions, from shooting out of season to beaver poaching and spring wildfowling.

By the summer of 1930 Billy was showing his age and I looked around for another mount to replace him. Saddle stock were scarce, for the farmers had been breeding their light mares to heavy-draught horses to produce young stock for work on the land. However, I happened to be talking to Dick Lindemere in Prince's store, and he told me that Ed Southwick on Battle River had some good young stuff coming along, and he suggested I try there.

I located the Southwick's place, a big white house and a big red barn above the river breaks was what I had been told to look for and, about noon, there it was. I rode in by the big gate, dismounted and knocked at the door. Mrs. Southwick came to the door. I announce myself and asked for the boss.

"He's at the barn," she said, and pointed. I led Billy over to the big sixty-foot-long barn with its hip-roofed loft. Mr. Southwick was feeding a team, but he put down the hay fork and came to meet me.

"Ain't you the game warden?" he said.

I admitted I was.

"Yes," he went on, "I knew you by your hoss. I raised him as a colt and sold him to Nelson at Battleford and he told me he'd sold

it again to the game warden. Well, what can I do for you?"

I told him.

"Well, young fellow," he said, I've got two or three colts you could pick from. Fours and fives and maybe a six year old. You'll have to break him yourself. I'm asking a hundred and seventy five each. But say, it's most dinner time, so put your hoss in and I'll slip to the house and tell the Missus you'll be here to dinner. I'm as hungry as a coyote and we can go through the colts after. They're down the pasture about a mile 'long the river."

We went to the house. Mrs. Southwick indicated washbowl and towel and I noticed the table was not set in the kitchen, which is usual on a week day for farm folk. They led the way to the dining room, complete with Congoleum rug; heavy furniture, lace curtains, and big oval photographs of an elder generation. Beneath one was a black coffin plate bearing a name and the words "mother at rest" in gilt. Evidently, I was company.

The meal was delicious, and the homemade bread showed a master's hand. Conversation was stilted. Southwick was not a talking man, although a very good eating one.

I knew her at once for a type which, while the salt of the earth, was just so narrow that you felt they saw sin in all around them. The kind that mentions certain animals by such deceptive names as Gentlemen cows and Big horses, and only when mention is unavoidable. I felt sure she kept away from the barnyard, and would not even venture there for the hens' eggs. The meal finished, I felt for tobacco and papers.

"May I smoke Mrs. Southwick?" I asked in my best company tones.

"Indeed you may not!" she replied. "*None* of my family have ever contaminated themselves with tobacco. Besides, it smokes up

the curtains — "

I thought Mr. Southwick choked, but he recovered quickly.

"And furthermore young man," she went on, "I hope you do not carry spirituous liquors with you. *None* of my family even know the taste of rum. My father and my grandfather devoted themselves to the cause of temperance and fought Vice and Sin to their lives' end." She looked at me severely. She was a handsome woman and her white hair gleamed like silver. I assured her I did not carry any rum with me and added I was sure her parents were to be congratulated. Could I, however, smoke on the porch? She bowed gracious consent and I sat on the porch steps with my smoke.

Presently Mr. Southwick came out. "Let's go see them colts."

We went to the barn. He saddled his horse and I mine. He said, "Before we go I must show you the sire of them colts." He led me to a gloomy back quarter of the barn, where, in a roomy box stall a fine stallion whinnied softly.

Mr. Southwick let down the bar and we entered. He told me the horse's pedigree with some pride. I patted the animal's neck and talked to him. Mr. Southwick had disappeared.

"Hello?" I said.

"Coming up!" was the reply.

I turned. Rising from his knees in the far corner was Mr. Southwick. In one hand he held a bottle, in the other a plug of chewing tobacco. He came across the straw to me. He pulled the cork from the bottle, took a good swig, passed the palm of his hand over the bottle's neck to render it sanitary, and held it toward me. "Don't be afraid of it, young feller," he said. "It's White Horse, best in the west."

I took a swig, complied with sanitary precautions, and passed it back. He took another and offered the bottle again.

"Enough for me, thanks," said I.

"O.K." said he, "have a chaw?" offering me the plug of black Macdonald with the tin heart still embedded in its side.

"I'd rather smoke," I said, "but I'll wait till we get outside."

He held a pawkish finger to his nose, and, "Beware of fire," he said, "hell or otherwise, hah!" He replaced his booty in a hollowed out log: we mounted and he steered me across a field to the pasture gate; not a word was said.

At the gate, I, being the younger, dismounted and held the barbed-wire-and-post contraption to one side for him.

As he rode by he checked his horse slightly and, stooping over the saddle horn, he spoke huskily in my ear, "Young fellow, remember: what the wimmin folk don't know don't hurt 'em." With a sly wink he clucked to his horse. We looked over the colts and I chose one. We made a deal right there, but I got the animal for a hundred and fifty dollars. Perhaps he forgot that he had said a hundred and seventy five, or perhaps the whiskey had mellowed him.

THE FOLLOWING WINTER WAS A HARD ONE. Just after New Year's I received a complaint from a rancher south of Baljennie that someone was snaring coyotes, for he had lost a horse on the winter range, or at least had to shoot it as a snare had tightened on its fetlock causing the loss of its hoof. The use of wire snares was strictly forbidden, so I set out early next morning. The snow was deep and crusted, for the trail had hardly been used all winter. Few settlers lived in the Eagle Hills. Monte, my new horse, was soon slowed to a walk.

I already had him gentled down and hardened up, but he felt his oats and plunged impatiently at the drifts for the first hour at that racking half-trot which throws a horse up and down as he pulls

his legs from the snow, that gait which every winter rider knows and hates. One can only stand in the stirrups like a cameleer and bear it as best one may. But five miles of that changed his mind and he slowed down to a steady plod, his hooves breaking the crust noisily. This was a lonely road. For the first twenty miles, only two holdings adjoined it, and now both houses were empty. One family had moved out and the bachelor who used to live in the other was dead. Monte wanted to turn in at the buildings, but only half-heartedly. Even he seemed to perceive the vacant aspect of the untrodden yards and the frost-closed eyes of the small windows.

We called this the "old Saskatoon Trail," for the other end, finally lost in a network of roads where the hills flattened far to the South, could once be followed to Saskatoon. But at that end it became the "Old Battleford Trail," for it was up this trail that the Barr colonists had urged their oxen, horses, and wagons from the Temperance Colony to Lloydminster in 1903.

Many were the axle trees which fell apart on this narrow, gullied track, with its ravines and sharp turns, and, always, the steep hills to the south and the river to the north.

Some of the settlers near Baljennie first started up this route; but seeing lush meadows and grassy lands had halted their gaunt cattle and fallen-to with axe and saw, content to rear their log homes where fancy pleased them — content, too, that the rest of the column should push on into further hardships. One of them was Arthur Bater.

There was no wind and little sign of life. A few rabbit tracks padded between the willows and the slots of a deer crossed the road and disappeared up the slope, zig-zagging though the greenish-grey blur of poplar boles. Once I hear a soft note, and looking, saw a group of pine grosbeaks in smokey grey alight in the brush

to pick daintily at some late cranberries.

It was getting colder. My horse and I were hoary with frost, and we both had icicles on our noses and mouths. I stopped to breathe Monte and took off my mitts for a quick smoke; but my fingers were clumsy, and Monte's heaving sides made them clumsier, and paper and tobacco floated to the snow.

"Come on," I said, and my voice sounded far away. We plodded on. The dusk thickened –- the sun set early at that season. Monte's breath around us, the somber brush slipping by so slowly, the creak of leather, the muffled "brunch, brunch" of hooves; in this I lived, small, wizened, a speck of dust in a frozen cosmos. If only the road were good. It is not hard to keep warm at a trot, but this plug, plug was different.

I peered ahead for the first light I could expect — twenty miles out. I was making probably three miles an hour, but perhaps less. I would be about five o'clock; the sun set at four. Bater's ranch must be near.

I was cold. Even with three pairs of socks and good moosehide moccasins; even with the buffalo coat, the heavy mitts, the wooly chaps and the muskrat cap — none of these were enough against the biting frost. It must have been forty below and my face felt stiff.

I dismounted, slowly, stiffly, and felt my feet break through the crust. I stood gripped to the knees, as was Monte. He clicked his bit and rubbed his nose on my chest to dislodge the icicles from his lip, and his rough push almost knocked me down.

"Come on," I said, and slowly got ahead of him. Tramp, tramp — Monte stepping in my tracks. A moon was coming up. Not more than a hundred yards could I make. A snow-covered log made a bump by the trail side. I sat down, my leg muscles trembling. I saw the same flutter in Monte's shoulder muscles and I thought it was

like a poplar leaf in the evening breeze.

I felt sleepy and my head swam. But something said, "Don't sit, get on with you." It took me what seemed hours to mount. The walk had warmed my feet but although I brought Monte up to the side of the log, I found that even with that advantage my arms would hardly draw me up; but I finally mounted and urged Monte on.

I was in a semi-daze, cold beyond shivering, when Monte raised his head with a jerk that brought me to. With a mittened hand I clawed the ice from my lashes. There, to the right, was a dim square of yellow light. Bater's ranch!

Then I thought – the gate! For the buildings were three hundred yards off the road, and I well knew there was a gate where the trail turned off. If that gate was closed, as it usually was, how was I to get off and open it? And if I did, could I make it to the house? For I knew I could not remount.

Suddenly the muffled hoof-beat changed to a sharp, staccato squeak. I was on a good sleigh road, and opposite the buildings. I did not need to turn Monte's head to the right. Like a homing pigeon he swung toward the gate, his keen instinct sensing a warm barn. In such intense cold there is no scent, not even from a bran yards.

And now for the gate. Monte did not pause and I realized we had passed it. By a lucky chance it was open. The square of light became larger. The big log house loomed up. Monte was by the window on the right of the door. I could look in. I could see the warm glow of the wood heater. I could see Mr. Bater, slippered and snug, reading his paper, Mrs. Bater knitting, the youngsters deep in their homework at the table.

I had no voice. I felt that what I saw was far removed from me but I managed to urge Monte a few feet, and then, with my moc-

casined foot I thumped the porch door as hard as I could.

Country people have ears for sound. Every noise means something to people who are alert to a horse in the barn, or a dog scratching to be let in. Their ears are not dulled as are those of city folk who are subjected to all the sounds of traffic, of slamming doors, of whining refrigerators or bubbling steam pipes.

I heard Mr. Bater's voice: "Jack, there's someone at the door!" and a shrill voice, "Aw, Dad, you're always hearing something." Then Mrs. Bater saying, "Your father's right — go and see what it is."

The door opened, there stood Jack, a well-grown youth, just looking. His father brushed past him and, "It's the Game Guardian, Mother," he said as he pulled me like a child from the saddle, calling over his shoulder, "Jack, put Mr. Symons' horse in."

My heavy outside clothes were torn from me. Hot tea found its way like a blessing to my inner parts. In fifteen minutes I was tackling a hot meal, and then, relaxed and smoking, I answered the questions which my kind hosts had patiently kept back. When that was over, Mr. Bater looked up over his pipe and said dryly, "It's only fifty-two below zero. What's the matter, you getting soft?"

The patrol was successful. But it took three days of plugging through deep snow, three days of following tracks in the steep, heavily wooded hills, before I finally ran down the man I was after. One of the things he said ruefully was that he didn't think anyone would bother him in that weather!

The date was January 5th, 1931, and I was out on that patrol for six days before I finally tracked down the culprit. Sometimes a quick-witted person got the best of me. Women were the best — twice as smart as men and far less clumsy!

Once I had a long chase after a couple of town dwellers who

had been shooting ducks at dawn long before season. I got the one fellow but the other got away. I was practically certain I knew who it was — the lumber-yard manager in a nearby town. So I went to the lumber-yard office. The man was not there so I went to his house. The door of the back porch was open.

As I knocked on the lintel the lady of the house was putting a sheet through the wringer of a gasoline washer, which thumped and sputtered. She turned the engine off and looked at me inquiringly. Behind her was a big pile of soiled clothes. That's where I slipped up.

"Is your husband at home?" I asked.

"In the sitting room," she inclined her head. The machine started up again. It's clatter set the shotgun, leaning by the sitting room door, a-dancing on its glossy stock.

Clever, I thought to put that gun in plain view for my benefit. It looked so naïve and innocent, though I well knew an old duck-hunter would have it neatly hung up. The lumber-man, deep in an arm chair, puffing his cigar as he looked over the paper, I knew to be another set-piece for my benefit. His paper rattled and a cuckoo clock struck ten-thirty — hardly the time of day for its owner to be at home.

"Hello, good morning." He looked up.

I announced my business.

"Oh sure," he said, smiling, "you have a job to do, I know, but I've a touch of rheumatism." He rose stiffly, limping slightly. "Pity too, when we are so busy at the office — the Chavros brothers are building a new barn, and it's got to be figured out for them. However, you'll find my gun in the hall — had it down last night for a cleaning. Guns get a bit sticky when they're hung all winter, and it won't be too long till the season opens. Then, oh boy, I reckon to

get a mess of those green-heads. There's a lot of good barley this year, and they'll sure be fat!"

Stupid of me to let him keep me talking. I was pretty tired, and I'd had no breakfast. Suddenly I realized the washing machine was silent.

"Well, you'd better come with me and I'll look around."

Together we passed though the back porch. The pile of coloured washing looked different, I thought. The lady of the house was not in sight. We wandered out. No sheets on the line yet. I searched the garage and the garden. Not a sausage!

Suddenly, a thought came to me. "Where's your wife?" I asked.

"How should I know? Stepped out for some shopping, I suppose."

One building was left, a tall narrow building set in the shrubbery. I stepped forward, tried the door — shut from the inside. Then all was clear to me: the ducks hurriedly hidden under the dirty clothes, their quick removal as I listened to the man in the living-room, the quiet exit, and the only place of inviolate privacy!

The lumber man grinned and lit another cigar. I spoke through the narrow door with the half-moon cut out near the top.

"Madam" I said, "you win. I haven't time to get the police matron and, if I did those ducks would not be fit to appear in court. The case is closed, *but* let me hear one word about being smarter than the game guardian, let me hear one *whisper*, and I'll publish this story all over the village."

I heard a muffled exclamation and withdrew. The lumberman never spoke. But he no longer grinned. I noticed his limp was gone.

Not a word was ever heard of that incident, but there was a definite lull in before-season duck shooting from then on. Once in a while, after that, I would pass this lady on the street, and once she

served me at a church tea. I thought on these occasions a slight twitch seemed to afflict one eye.

AT WILLOWFIELD (a country post office in the Eagle Hills) lived a family called Dounais (or "Doner" to their neighbours). Wilfred Dounais came from Terrebonne, Quebec. He was related to the Richards, a famous French family at North Battleford. His wife, Flora, had been an Eddy (an equally famous pioneer family of Winnipeg) and her brother was local Ranger at the nearby Keppel Forest Reserve. Her middle name was Macdonald. She was reputed to be a direct descendant of Flora Macdonald (famous in the '45 for assisting Prince Charles Stuart).

As a young man, Wilfred had been a singer with the Carl Rosa Opera Company; but on the death of his brother Charles (the first Indian Agent at Battleford) he had inherited the ranch operated by the latter and known as Plateau Ranch.

This couple had three sons, Charles (about 16, known as "Bubbins"), another (I forget his real name) who was always called "mon home"; and Nicky, the youngest, red haired like his tall, handsome mother — a bit of a young devil at 12.

I often rode into their place when in the neighbourhood, and sometimes stayed overnight. It was wonderfully restful to be in such company. Wilfred still sang wonderfully well, and of an evening would give us *Celeste Aida* or the song of the evening star from *Tannhauser*, while Flora played accompaniment on the piano.

Books in plenty they had, too, but best of all was the witty conversation, which reminded me of my early days at home. Actually, I often felt starved for good music, good conversation, and gracious (I don't mean expensive) living.

Not far from Plateau Ranch lived a small settlement of Métis

squatters — the Beauchesnes, Trottieres, Sansregrets and Pritchards. They occupied small log houses on the marge of a small body of water called Eleven Slough by virtue of being located on Section Eleven.

John Pritchard seemed old even then. He had been at Frog Lake at the time of the killing of the traders and the priests by Wandering Spirit and his disaffected followers in '85. It was he who had been chiefly instrumental in saving the lives of Mrs. Delaney and the other white women involved.

In 1967 John Pritchard was still living, at the age of 105, at Cando, about fifteen miles from Willowfield. So much of the rebellion story I had I learned firsthand from Pritchard and other participants that I now began to plan a novel which would look at those events from a slightly different viewpoint to the accepted idea of an Indian uprising. I knew Battleford had never really been under siege by Poundmaker's half-starved warriors, and that most of the Indians stayed at least neutral between the forces of Louis Riel and General Middleton.

I received much valuable information from men like the late Sergeant Major Parker of the N.W.M.P.; Fine Day the Cree who had been the war chief (but was a chief no longer); Chief Sam Swimmer of Sweetgrass; Arsene Prince (uncle to Paul); Harry Adams, one time okimowsis (clerk) at the H.B. store; C.J. Johnson, J.P., who had been with Bolton's Horse; and the Rev. Father Cochin who had been in Poundmaker's camp during the "troubles."

For over 30 years I gathered information, but the novel was not completed until the mid-1960s. I chose the novel form as much more interesting than strict history. My tutor had insisted that *understanding* was the important thing, and I realized that in *Oliver Twist* Charles Dickens had brought a better understanding of

workhouses to the English people than a dozen "white" or "blue" papers could have done. In a novel one can speak through fictitious characters so that the reader may get the *feeling* of the time and place.

Perhaps it will not be amiss to quote here one chapter inspired by tales told to me by Indians now dead and gone:

"Curtis was in the saddle again before the sun was up.

"He had swung away from the lake, and now he found a draw running easterly which would take him in the right direction.

"He felt better, and urged Peigan to a trot — he hoped to make good time now. He should already have been at Eyehill Creek, that meandering stream which connects Sounding Lake with the salty water of Good Spirit Lake far to the North East.

"Now he would have to hit straight east and cross the creek well above the lake, but it took him longer than he thought, and it was high noon when he saw ahead of him that typical break in the prairie level which indicated a watercourse. He could see the tops of poplars, and, nearby, something like a rough scaffold. The traveler recognized this at once as the last resting place of an Indian warrior, and rode up to it.

"A few crooked and withered aspens had been erected to support some cross-bars, the whole bound together with willows now dried and cracking apart. On the scaffold lay the dried and desiccated remains, wrapped in a mouldering robe. Directly beneath, grass of a greener and luxuriant growth protruded between the rib-bones of a horse's skeleton.

"Peigan snorted and shied from the thing, and Curtis permitted him to trot toward the break, which proved to be a narrow and tortuous stream of pure water, fringed by a few straggling stunted aspens and clumps of wolf-willow.

"This must be Eyehill Creek, he thought, and he dismounted on the gravel. Man and horse drank together. Then Curtis scrambled to his feet, while Peigan took deep, rib-filling breaths, followed by a low sigh of content. It was very quiet here. The sun struck hot on the farther bank. A sandpiper cried "wheet-wheet!" and alighted on a rock.

"Peigan threw up his head and snorted, giving a jump of fright which dislodged pebbles right and left. Curtis reached for his carbine and levered a shell into the breach even as he turned.

"To his left at the bend of the creek squatted a strange figure. It neither spoke nor moved, and Curtis saw that it was an old woman — older than he would have believed possible — wrinkled and stooped and dressed in rags. About her head was the remains of an otter-skin cap, from which thin whisps of grizzled hair escaped over her face. Her toothless mouth was a puckered line. Only her eyes showed a spark of life. They were bright and restless, groping over every detail of the scene before her.

"The two gazed at each other for perhaps half a minute. Suddenly the old woman half rose, bared her shrunken breast with her gnarled, sinewy fingers, and made as if to speak. Finally the words came, but in a voice so rusty that in a Cree so stammering that Curtis could barely understand.

" 'Shoot then, if you must, with the bright fire-stick, O man of the red jacket.'

"Curtis lowered his carbine, and with Peigan's reins looped over his arm approached slowly, keeping a sharp eye to right and left — this could be a trap.

" '*Tansee, tansee, nokomis*,' he said. 'Greetings, my little grandmother.'

"At those words her grim face softened. She drew her rags

around her and stood awaiting his approach. As he came up to her he could see that just around the bend was a sort of camp — a mere apology. This was no tall, painted tipi, only a rough shelter, a sort of *wikiup* make of bent-over willows covered with ancient rotting skins, crouched against a low bank as if it were a mere encrustation. The whole affair was little more than a den.

"Littered about the narrow space between the bank and the creek was a vast collection of small bones and skulls, the remains of rabbits and gophers and birds. The gray ashes of a small fire lay within a ring of small flintstones, many of which had been chipped.

"He had taken in all this at a glance, and now Curtis found himself facing the ancient chatelaine of this establishment.

"Again she spoke. Again she had difficulty formulating the words, seeming to mumble land whisper them to herself before being able to utter them.

" 'Is your jacket red — or is it the setting sun that deceives me?' she queried.

" 'The sun is still overhead, little grandmother,' he replied. '*Tapway* — this jacket is red.'

"She nodded. '*Miowasin* — it is good.'

"She did not reply at once, then: '*Astum* — come — Red Jacket! I am old, and I would sit a while and think on this matter.'

"She beckoned and he followed. At the entrance to her den she squatted down, while Curtis stood, his eyes roving up and down the shallow creek bank for signs which might bespeak people or habitations; but apparently this ancient one was alone — everything in the camp pointed to that. There were no tracks of horses; no droppings; no sign of dog or dogs; no meat-racks; no piles of *travois* or tipi poles; no trail leading to or from the little dell, save a dim track such as might have been worn by old and sluggish feet.

This climbed the bank in the direction, he guessed, of the death scaffold, a corner of which he could see etched against the bright sky.

"He brought his eyes back to the crone as she sat in listless thought, as if unaware of his presence.

" 'How many moons have you been alone, my little grand-mother?' he asked at last.

"She did not seem to hear. Only her already-narrowed eyes now closed, pinching up the wrinkled face till the cheek-bones gleamed white.

"Curtis was about to repeat the question when her gums began to move, and swaying a little she answered slowly, as one talking to herself.

" 'Moons? Moons? Not moons, Red Jacket.' She paused a moment and wiped the spittle from her lips. Then, holding up her crooked hands, one fully open and the other with but two fingers exposed, the scraggy talons of the remainder held into her palms till the flesh was pinched, she went on. 'Thus many times has Kee-wadin forced me deep into my den.' She inclined her head toward the gloomy depths. 'Thus many times have I crawled within with my dried rabbit legs and my gopher ribs, drawing the dry grass about me, blocking the hole with the sweet dry grass, coming out only on the days when the great sun beckoned, to warm my bones in his sight.'

" 'Seven years!' thought Curtis, aghast.

"The old voice went on. 'Thus many times have the wild geese passed over me and called to me as they passed. Thus many times have the *sisipwuk* — the duck people — cleaved the bright waters with their breasts. Thus many times have the grasses greened and the flowers bloomed and died, since my husband, Stoneman the

Cree, was called to the Sandhills.'

" 'But you are not a Cree?' hazarded Curtis.

" 'A Cree? Pshaw! *Numoova* — no!' The old woman seemed to straighten a little where she sat. With something like coquetry she patted a wisp of hair and smooth her ragged apparel, even relaxed her mouth as if to smile. Her voice took on a new and more vibrant timbre. 'I — I — was one of the Handsome Ones — a woman of the Crow. Listen! Long, long ago I was young, and they said I was beautiful. I had a husband then — a Crow.

" 'We were far south in the Boston country. But always the soldiers of the Father were angry with us. They took our land.' She spat suddenly, as a snake strikes. 'They drove us from our hunting grounds. They sent many Long Knife soldiers against us. My husband and I were camping alone, hunting. It was winter.

" 'One day a Long Knife came to our camp. I was alone. As is our custom, I gave him food and drink, and spread a robe for him. When I passed him a pipe he seized me, and would have forced me. My husband returned from the hunt, and seeing this, he slew the Long Knife.

" 'We left that camp, but the dead soldier was found by his people. Soon we were in a great camp of our people. The snow was deep. Most of the warriors, including my husband, went hunting the buffalo. One evening when the ponies had been brought in from the grazing grounds, the fires had been banked and the camp slept in peace, we were awakened by noise and screams. The old men tried to defend us, but their eyes were heavy with sleep and their naked legs numbed with cold.

" 'As for me, I escaped behind the camp, jumped on a loose pony and fled up a coulee, where I lay among some rocks. Finally the noise and shooting stopped.

" 'Daylight came, and I looked down. Many Long Knives were at their cooking fires. They had rounded up and shot most of our ponies. The tipis were burning, and so were our gear, our store of pemmican, and our robes. Our people lay where they had been slain, old men and women, children and babies.

" 'I saw no Indians alive till I heard shots further down the valley. Our hunters were riding in at a full gallop, but the Long Knives had set a trap; their men were in the rocks on either side of the valley. The Long Knives began to shoot. The warrior at the head of the Crows carried a shield of black and rode a spotted horse. I knew it was my husband, Night Shield, and even as I knew I saw him fall dead.

" 'I thought my feet were freezing in the snow. I caught my pony and rode away.'

"Curtis neither moved nor spoke till the wizened figure resumed the burden of her tale.

" 'I rode all day and saw nobody. That night I slept on a tall butte — that night I lost my unborn child.

" 'And as I lay sick and in pain I had a vision. I was on a big prairie looking for my child, when, turning, I espied a buffalo bull — a white buffalo bull. He stood looking at me. I began to walk away. He followed me. I walked faster. He was close behind. I turned and felt something beside me; it was part of a log corral — an old buffalo pound. The logs were rotting, but I climbed up on them. I could smell the salty blood of the pound. I could see the bones and horns of many buffalo.

" 'The white bull came closer and spoke to me. "Leave this place of death," he said to me. "Leave the land of the Father, where all is blood and my people, the *Mustusuk*, will soon be but bones. Turn your face to Keewadin, take your feet across the Medicine Line to

the land of the Mother. You will find a bear making a den; there wait till one comes with a red jacket; from that day, if the buffalo are many on the Plains all will be well with the red people; but if there are no buffalo, ye shall know that in that moon blood must be shed!" And I saw the white buffalo bull no more.

" 'Many weary days did we travel, I and my pony. Sometimes I thought to go back, but my pony was bewitched and would only go north.

" 'Finally I met a hunting party. They were Crees. They said "What shall we do with the Crow woman?" and a man said, "I shall take her." And he took me and was my husband, and today he — Stoneman — lies where ye see him.' She indicated the bank above.

" 'And how came you here?' Curtis asked, when it seemed she had forgotten him.

" 'How else but by travel?' she replied. 'Many, many moons we hunted and travelled, but Stoneman was blinded by a grizzly bear and could no longer hunt, and he made arrow heads — for his fingers had eyes — and I, a woman, made shift to be the hunter. Once — *Wah! Wah!* — I did kill a buffalo bull, but by stealth. I crept behind him in the dark and hamstrung him with my buffalo knife; but mostly it was rabbits and gophers and snakes and birds.

" '*Aiii!* Berries a-plenty there were in the summer, and in spring I raided the marshes for eggs of ducks and geese and cranes. Prairie hens I snared at their council grounds, as I do to-day -- see?' She pointed to a fresh-killed grouse, with a horsehair snare around its neck, lying with the *wikiup*.

" 'Moons came and went, and still we travelled, Stoneman and I. *Uh-huh*, he was a good man, that one. For when I told him my dream — for I soon learned the Cree tongue, though not well — he said to me, "It is good, *Neecheemoos*, we shall find such a place."

" 'Sometimes we fell in with hunting parties — *aii!* and with war parties, too — but we tarried not, and went on. My husband traded many arrow heads for pemmican and robes. We had but one horse, for mine had died. His horse had been his buffalo runner and was now old. The horse carried what we had, and we took turns to ride. We had no tipi when I got too old — and he too blind — to put it up or take it down.

" 'And after much travelling we camped near here, for there are many flints. It was the moon of ice-making, and one morning I heard something moving and grunting, and behold it was a bear — a *mishimukwa* — digging in the bank. He had been digging his den for many days, for there was much earth thrown out. And I fitted an arrow to my bow, and said I was sorry, and I slew the bear, and we slept in his den and built a shelter before it. We filled it with sweet, dry grass and crept within, and when Keewadin shortly turned his knives against us [winter] were snug.

" 'And my husband began to make many arrow heads. "For," he said, "when the moon of the red jacket comes, mayhap they will be needed."

" 'And in the Hungry Moon of the Hungry Year my husband Stoneman went to the Sandhills, and I put him where he could see the face of the Manito, and I laid with him berries and dried meat, and put his quiver at his side. And I took his horse to the scaffold and shot it with an arrow and said, "Carry your master well in the Sandhills!"

" 'And I remained here to this day.

" 'And I am not the Crow woman now, but White Buffalo Woman — see, I have wrought it here!' and reaching within the *wikiup* she produced a square of antelope hide glazed with age and smoke, on which was pictured in beadwork the story of her vision.

A Country Boy | 221

" 'Now, take it, Red Jacket — take the medicine picture to the people. Then shall they know if it be peace or war. I am old — I cannot tell.'

"In the long silence that followed, Curtis thought of the lonely years that had passed over this woman's head. He hardly thought of the significance of the piece of hide in his hands.

" 'And in all that time, how many human beings did you see, grandmother?' he finally asked.

" 'Few, Red Jacket, few. Sometimes a hunting party passed and traded for the arrow heads, giving us pemmican and beads and salt — but fewer and fewer. Perhaps the people of the Crees no longer use arrows. *Aii!* — few passed this way till yesterday, when first I saw you.'

" 'You saw me yesterday, little grandmother?'

" 'Who else, my grandson? But you were not alone — and I thought on a different horse.'

" 'Where?'

" 'Crossing the creek beyond the willow clump with the crow's nest, no less,' was the answer. " 'I was on the prairie hens' council knoll setting my snare. I saw two riders. One had a red jacket like yours — it must have been you. But I thought that both had back hair on their faces and black hats. *Aii* — and sashes about them. They rode straight east and did not see me. I was minded to call, but held my peace — for in my vision Red Jacket was to come to me. Surely, now you were one of those I saw?'

" 'Nay, grandmother, I think that was a vision you beheld yesterday.'

" 'Doubtless — *maskootch* — we will say no more of it. I am old, and to sleep is good. *Tapwa*, but it is in my heart that I see Stoneman beckoning me from the Sandhills; and I see blood, for I think

the buffalo are gone, and you are here.

" 'I make an end of speaking, for the same it is good.'

"Curtis was now looking at the medicine picture. From a boy he had been accustomed to reading the picture writing of the tribes. What he saw made him look across the prairies eastward. Had some riders really passed? Who could it be wandering with a red coat? And at once he knew — the emissaries from Riel! Why had they gone east yesterday, yet turned west again to camp at Sounding Lake? They were looking for something — and he had that something in his hand!"

IN 1930 OUR THIRD BOY, HUGH, WAS BORN. Again, we had a nurse in the house for a few weeks. I naturally got home as often as I could on weekends, but if delayed by an investigation had to depend on any free week day to see the family and make up my patrol sheets and weekly report.

One morning of the following winter I was on a patrol north of Helene Lake. I felt very seedy, and when I broke camp on the second day found I was feverish and dizzy. Wanting no breakfast, I harnessed my dogs to the toboggan and headed south for the nearest shack I knew, which was the camp of a Saulteaux hunter call Katchik. I prayed he might be there and not at his other camp on Turtle Lake.

It was Katchik himself who met me at the door (a blanket!) of that small unfloored cabin. And it was his woman who spread my bedding on the ground and covered me up; and she who nursed me though pneumonia.

What strange concoctions of herbs she used, what steaming potions of spruce twigs, what fat of skunk and bear she fumed and rubbed me with I was past knowing. But when I woke, weak

but cool, it was she who knelt by me. She held up two fingers and closed her eyes and I knew I had been out of this world for forty-eight hours.

Katchik came in from his trapline and stood, tall and silent in his capote, and croaked, "Tansee!" and his leather-mask cracked in a smile as, with braids swinging, he turned and crooked a finger to his four children who came softly on moccasined feet, wide eyed, and finger-in-mouth to stare and see the haggard *moonias* sit up to drink a brew of tea into which I swear Mama Katchik had put gun powder and tobacco and skunk-oil for good measure!

They have gone to the Sandhills, those older ones; and the young ones are grown up now and have no trapline (for the government wanted the land) and there is a liquor store, and they wear leather boots, perhaps donated by the charity of those who now hunt the deer and moose in their stead.

Henry David Thoreau was right when he said: "the Indian does well to be an Indian."

ONE ANCIENT REDMAN WITH WHOM I OFTEN TALKED was Old Mokanase, who lived near Jackfish Lake. A missionary friend and I once came together to his camp. The missionary was a friend of mine, and while travelling together we had come to Old Wabanase's camp. He had been saying that it would not be long now before he would be called to the Sandhills. The missionary asked him if he would not like to be baptized and receive the Sacrament — the Cree rendering being "Holy Bread."

Old Wabanase listened patiently, then he arose, and with the easy eloquence of an Indian he said, "I have heard my friend the blackrobe. What he says is good for the *moonias*. I am not a white man. The Kisa Manito sees me, and knows that. Do you see that

fish net hanging outside? *A-koosa* – when evening comes I take that net and set it in the lake yonder. In the morning I take my canoe and go to see my net. There will be fish — perhaps many, perhaps few. I do not make these fish — I do not put them in the net. It is the Kisa Manito who does that for me. They are his fish and he gives them to me. That is how the Great Spirit gives me my Holy Bread. I thank you my friend, but it has always been like that with us."

As we left the camp the priest turned to me and said, "That pagan is a better Christian than you or I."

THE YEAR 1932 BROUGHT MANY CHANGES. In that year the old Department of the Interior at Ottawa gave up control of forests, lands, and fisheries, transferring these resources to the various western provinces from which they had hitherto been withheld.

In the sorting out which followed the formation of the Saskatchewan Department of Natural Resources, we all wondered what our fate would be. The older employees of the Department of the Interior were retired on pension, and the pick of those remaining were retained and the best of the game officers of the provincial government were amalgamated with these to form the new department. I was among them.

Each game officer — the title was now "Field Officer, Department of Natural Resources" — thereafter had the full responsibility of all these resources in his district, and these districts were cut down to more workable size. I retained about two thirds of mine.

Charlie Illsely, the fishery inspector from St. Walburg, took over at Prince Albert as Northern Assistant to George Macdonald, and I was then left with the heavy burden of the string of lakes north of Battleford. Jackfish, Murray, etc. — which were the great com-

mercial whitefish lakes of that time.

About this time, too, an RCMP Sub-Division was set up at North Battleford. Inspector Spriggs, a good friend of mine, was in charge, and in times of stress he was always ready to spare me a constable to assist. In turn, I helped them when called on with my intimate knowledge of the people and the country, which often came in useful. It was the happiest possible association, and I look back with satisfaction on the patrols in which I accompanied Staff Sergeant Chalk (Radisson); Corporal Fielder (Lloydminster); Corporal MacRae (North Battleford); and many others.

Following this change I was moved to Meota on Jackfish Lake. I was lucky to be able to rent a nice little house from Joe Dart the storekeeper.

One important activity of the fisheries branch was the operating of a fish-hatchery at Fort Qu'Appelle. It was a simple affair, operated by gravity.

The principal spawning station for pickerel was at Cochin, across the lake from Meota. The hatchery supervisor, Oliver Bright, came each spring for about six weeks and I was his assistant. We had several local Métis to help. Chief among them one Napoleon Delorme, or "Nap."

We started to put in the guide nets, the trap net, and the retaining net during March when two feet of ice on the creek made it easier work than from boats. We cut long channels through the ice and dropped the nets down. The first run of pickerel came early in April, and when the ice melted we used a rowboat from which to lift the nets.

I shall say no more of the technical operations except that as the fish "ripened" in the retaining net, they were caught one by one by Nap, who used a dip-net, and these he passed to Oliver or

me simply saying "buck" or "doe" to indicate the sex. We spawned the fish out by hand into a bucket with a little water in the bottom. It took about three males to fertilize the spawn from one female. There was a shack at the water's edge in which tubs of water stood. In these the eggs were "water-hardened" before shipping to the hatchery.

I was often on night duty there, for the water in the tubs had to be changed every hour. It was here, between one change and the next, that I wrote my diary and drew many sketches by the light of a coal oil lamp. These were mostly of specific details of fish of many kinds. Later these were useful in investigations and even in court, for under the Statutes of Definitions of the *Fishery Act* a fish was *a fish, alive or dead, of any species; and the part or parts thereof.*

I also put down observations of water birds. The fish culture shack at Cochin, on Jackfish and Murray lakes, was a place that teemed with bird life. In the spring of 1932 and again in 1933, I used to be on night duty at the shack, taking care of tubs of pickerel spawn, washing them and water-hardening them, preparing them for the trip to the fish hatchery at Fort Qu'Appelle. All night the coots and grebes would stir up a clamour among the reeds of the little connecting creek. The harsh "Ka-a-a" of the red-necked would be answered by the soft musical "Karee? Karee?" of a pair of westerns from far out on the lake itself. Then, at the first whisper of dawn, at the first soft film of morning fog, the smaller birds would add their notes. The sing-song of the yellowthroat, the murderous, hoarse calls of the yellow-headed blackbird, and the "Conkeree" of the red-wings, the fluting of the larger waders and the soft grunt of phalaropes would mingle into a symphony of spring, while from the brush would come the under notes: the wheezing of white-crowned sparrows, the lisping of a Tennessee warbler, the soft "Me,

me" of a red-breasted nuthatch. All this, mingled with the soft lap of water and peeping of frogs, is to me the beating heart of Saskatchewan.

I NOW HAD TO BUY A CAR OF SORTS, for the following summer I was given a long list of inspections by the Lands Branch. The car was also useful where the roads were good, for many duck hunters were now using them. Checking the shoots at the many lakes scattered over such a wide area involved a lot of driving, and I would combine two jobs. Early in the morning I would check licenses, guns, bags, etc. at a lake, then have breakfast. After that I would start in the general direction of another lake, perhaps seventy miles away. On the way I would already have plotted those areas of land I was to inspect, and having dealt with them was free to check the evening shoot at the lake I was headed for. And of course on all the driving from one place to another I might meet with hunters who in between the early and late duck-flights were shooting grouse or partridge.

But with freeze-up and deep snow it was still my horses who took me around when checking deer hunters in the Eagle Hills and other rough wooded country.

In the meantime, as ice began to form on the lakes, the whitefish (which are early winter spawners, unlike pickerel), began to come into the shallow water by the hundreds, and the poachers were organized and active. A man with a few nets could, at spawning time, catch hundreds of fish in one night, so that in a week he would have as much as he could catch in a three-month open season. What they did not *realize* (though they knew it!) was that what were poached must be sold on the black market at five cents per pound, while in the open season the New York buyers paid

twenty-seven cents per pound! It was the old fear of someone getting ahead of them that led men to this folly which furthermore depleted the lake for future generations, by killing fish before they finished spawning.

I was out night after dark cold night. Poachers dare not operate in daylight hours. Had it not been quite exciting work, my activities would have been wearisome.

Only once did I know large scale poaching to be carried on during moonlit nights. The men were using a fast team and a caboose, and depended on the moon to watch for my approach. Several times I rode quietly to the north end of the lake, where they were operating, and actually saw them. But no sooner did I ride toward them than they left at a good clip, before I could even identify them or their team. All I got for my pains were some nets and fish. Had I given chase I might have had a little proof.

I borrowed an old horse and a go-devil (a sort of sleigh) from Old Mokanase. Billy was broke to harness, and I put the two nags together, hitched them up and started across the lake at an "Indian jog." One old Indian crossing the lake would not alarm my friends. There was a store on the other side which the tribesmen often visited at odd hours.

I got closer and closer, the two men were lifting a net and I could hear catch thudding into the fish boxes. One a short, stout man, looked up, apparently talking to his taller and younger companion, and they went on with their work.

My ruse was so far successful.

Now I could see the team close up, and the caboose with smoke coming from its stove. Jove, they believed in comfort! In front of the caboose — which had its door in the back — was the usual plank platform which fishermen use to pile their nets on, and sure

enough, there was a big pile. If they ran all those in before midnight, they'd really have a catch by dawn.

I had approached slightly angling, but now I left the twin sleigh tracks in the snow and drove straight for them. They dropped the jigger line and ran for the caboose, and I stood up and lashed the Indian shag. He was holding back Billy when he tried to run. I jumped for the net shelf in an endeavour to get the lines from the outside and stop their team, which the men were urging on.

Wow! I landed on the back of my head, stunned, covered in a mass of nets and gear and planks. Those damn planks! They hadn't been fastened down and when I jumped on them I had upset the lot. My team had only gone a short way and then stopped. I ran for them, gathered the lines, and jumped in. The caboose was swaying and disappearing down the lake.

In a frenzy, I lashed that Indian horse and cursed him horribly. No good, we were losing ground. I saw the caboose lurch up the Frenchman's trail, heard the runners squeal as they cut through the snow to the soft sand below, and with one last belch of smoke the outfit disappeared over the banks. I too, reached the bank, but the shag had no more stomach. Quickly I unhitched Billy, leaving the shag to stand with heaving flanks still hitched to neck yoke and eveners. I knew he'd stand for hours. I gathered up the one line, seized a hame [the collar attachment] and threw myself on good Billy, who leaped to the bank at full gallop, with me low on his neck and the heel-chains on the traces flapping against his flanks.

A quarter of a mile and, where the road went north and south, I saw to the north the caboose top a rise at full gallop. So . . . they hadn't gone toward home. They'd likely drive all night and try to throw me off somewhere.

"Come on, Billy," I said, and I swear he gave a chuckle. Two

miles and we had gained a good half mile. Three miles — past Old Esquirole's corrals — and I could hear the men shouting to the blacks. Another half mile and I was at their rear door, calling on them to stand in the name of the law!

The door at the back opened and the taller young man — I knew him — threw something at me. I found later it was a bag of fish. Had it hit me, I would have been spilled in the snow, but good Billy swerved and it hit him on the rump, giving him that added impetus that brought me alongside the off black.

I seized his foam-flecked bridle and pushed against his head with my shoulder with all my might, Billy holding me there like the good horse he was. Another hundred yards and the team slowed up, and with another strong shove and Billy's shoulder ahead of the blacks, the whole outfit came to a standstill in the ditch, the caboose at a dangerous angle and the blacks heaving and choking. The tall fellow came out in one jump with an ice pick, a heavy thing of steel and five feet long, but I shouted: "Stand back you idiot, look at your fire." For, true enough, the angle and the heave had slid the hot little stove up against the plywood side of the caboose. The man turned to fix that, and the older man said to him in French to be careful, as they didn't want a serious criminal charge for the sake of any number of fish.

I seized the team and sleigh with its load of nets, tools and half spawned whitefish (if you touched one the spawn ran out like golden meal). The men were told to appear in court next day, and they started walking for home. I then drove the outfit ten miles to Meota, trailing Billy (white with frosted sweat) behind. I asked the storekeeper to see that Mokanase got his horse and go-devil, and to give him two dollars for their use.

THAT WINTER I ALSO RAN DOWN a suspected illegal fur buyer. I found he had a quantity of furs including beaver on which the season was then permanently closed. I prosecuted him and sent the seizures to Regina as usual.

This affair had a rather humorous backlash. The previous summer, while visiting Dournais' ranch at Willowfield I had, at Flora's request, made a water-colour sketch of their picturesque log house, which gleamed with whitewash and was set off by a blue sky and the bright green of the surrounding poplar groves. Flora had it framed and hung it in the dining-room.

Shortly after his conviction, this man called at the ranch. He was buying hides for a tannery. (He had used this occupation to cover up his other activities.) The Dounais invited him to stay for dinner, and he sat down opposite the sketch. He kept looking at it and said, "Missus, I sure like that picture. I could look at it all day."

"Thank you," said Flora lightly, "it was painted by a good friend of ours — Mr. Symons, the Game Guardian."

"*What! That devil-man?*" exclaimed the hide-buyer. Whereat he betook himself, his chair, and his plate to the opposite side of the table, with his back to the unfortunate reminder of the fine he had paid.

IN ANOTHER OF MY NUMEROUS CASES I had arrested five men one dark night peddling liquor to some Indians. The magistrate before whom I took them was an ex-officer of the Bengal Lancers, red-faced and white-moustached. He was one of fairest magistrates I met, but a bit testy at times.

When asked his religion by this magistrate, the offender replied, "Jehovah's Witness, Sir."

"Jehovah's what? said the Magistrate.

"Witness, Sir — Jehovah's Witness."

"There's no such thing," said His Worship. "I'll put you down a Protestant." (The law only recognizes Protestants, Catholics and pagans).

The next question was: "Heavy or moderate drinker?"

"Teetotaller, your worship."

"There's no such thing," said His Worship again, "I'll put you down as a moderate drinker."

The accused was still protesting when he left the court, having paid his fine. He thought it most unfair that teetotalism did not have legal recognition.

The same magistrate once interrupted a young Mounted Policeman who, in giving evidence mentioned in rather injured tones that the accused had sworn at and lied to him, by barking: "That's what you're a policeman for! Spare us your personal feelings and get on with it!"

Looking back, I realize how varied my work was. By this time, having something of a reputation as a prosecutor (I lost only one case in all those years), I took care of a good many of the cases where the Mounted Police had apprehended persons under the *Game Act*.

In addition I co-operated with them on a good many cases. Inspector Spriggs tried to get me into his noble force, but my height was against me, although as Spriggs pointed out, there are other ways of getting your man than by force.

In one case I spent days in successfully tracing stolen nets. And in another I had to deal with a suicide away back in a lonely bush shack. A boy of 16 had shot himself on his bed with a .22 rifle. I had to get the parents and a sister away to a neighbour while I cleaned up the mess, washed sheets, milked the cow and made the

poor body presentable. After which I took it to the police with my report.

On still another occasion I had to get hold of a lunatic who was threatening his wife with an axe. He was a Ruthenian settler who had succumbed to isolation, rot-gut home brew, and the influence of deep snow and gloomy spruce woods. Shades of Tolstoy and Dostoevsky!

Sometimes the offenders I had to deal with were juveniles; as on the occasion I took three husky youths before the Juvenile Court Judge, a kindly, grey-haired woman who wore pince-nez.

They all pleaded guilty.

The Judge asked whether the Officer would explain the implications of the offence. I did so. She then lectured the boys, explaining that the mother fish must have their young ones or all the fish would die out. She concluded by saying they were naughty boys, and she was fining them a dollar each, hoping it would be a lesson. They left.

I closed the court and as I crossed the street, the boys were walking down the sidewalk with serious faces and fingers upheld, peering over imaginary glasses, and saying to each other:

"The little mummy fish must have their babies! Oh — fie, you *are* a naughty little boy!"

Again, two boys had killed a team of horses by shooting them with .22 long rifle bullets (very dangerous). Hunters were suspected. I thought otherwise.

The lads had been shooting gophers and I proved the case against them. When I told them what I had found, one boy said, "Well, we thought they would *only flinch* a little. Gee Mister, we didn't know they were *dead*. They just *laid down!*"

The horses were their father's, who was away, so I kept this "in

the family." The mother said grimly, "Those were purebred percherons. I reckon the boys can go without pocket money, and they'll have to do one hell of a lot of stooking to pay for them!" A good woman, that one!

THE OPENING OF THE LEGAL SEASON for commercial fishing brought a slightly different activity.

December fifteenth, and the season opens.

For the last few days I have been frantically issuing licenses, for, under the *Fishery Act*, it is the Officer of the Department who does this, because each commercial license is only good for the lake to which it applies.

This involves a lot of office work and I, therefore, bought a portable typewriter, on which I hunted and pecked to record the monthly reports of license fees and sales of equipment; and realized I was responsible for a lot of public moneys.

Now the season is open I get a little breather, not that I am idle. There are the confiscations to sell. The several tons of seized fish are soon bid up by the peddlers, who load their purchases and start off to tour the country-side. Many farmers will buy a hundred pounds or so for winter Fridays.

Bids are brisk too on nets, on jiggers, and on ice picks, but the small mesh nets (illegal) are, if in good condition, sent to Regina, while the poorer ones are destroyed. Cars, trucks, and teams are mostly bought back by the original owners. With a nicety of feeling, which is much to their credit, few others will bid on this equipment, scorning to take advantage of a neighbour in difficulties by purchasing his erstwhile team at a cut-rate price, or by adding their bids to run the price up.

There is still patrol work to be done, but it is easier now, for the

fishermen are in the open.

Nets, yardage, and mesh have to be overseen. Various disputes arising out of priority of fishing grounds must be settled. Both sides try to win me over, but a decision has to be made and, under the Act, mine is final.

At two main points on the lake, fish buying stations have been established by the agents of the New York dealers. In order to keep track of poundage, these have to be constantly visited.

Many hours have I stood in the rough lumber fish-shed amid the cacophony of the ice-crushing machinery, into which one man throws ice blocks, while another scoops up the crystals — enough at a scoop to pack into each box in which the fish lie head and tail.

Hammers ring all night, putting together the wooden boxes; packer's helpers tear oiled paper from big rolls for a lining; the packers sort out fish for size and species from the big pikes just released from the weigh-scales. The catch is not all whitefish, there will be some pike and barbot to be consumed locally. But there is also pickerel, which New York loves.

Quietly, deftly, the fish are packed, the crushed ice put around, the paper folded over, the lid nailed down. The stamp is applied with a thump — "50 lbs. Canada 'white' or 'yellow.'" (Yellow means pickerel — not more than seven per cent of the catch.)

The boxes are piled by the back door. Trucks back up for loads — crash, slither, the boxes are stacked — a roar of exhaust and the truck heads for the railroad, passing its empty mates *en route*.

On the lake-side, if you stepped out, the moon would be riding high, the lake-ice stretching away to lose itself in the frost fog. Lights twinkle all over the lake — the lights of cabooses. You hear the snarl and screech of sleigh runners, muted sound of horses and men.

A caboose looms suddenly from the fog. You see the horses' frosty heads as they pass into the light from the door — the icicles hang on their noses, their harness jingles. A muffled, "Whoa thar!"

Horses stand puffing from the uphill pull. The squeak of feet as men bring in the catch — writhing fish, silvery fish, flapping still as they cascade to the plank floor.

The weighing. Credit slips fumbled into shirt pickets.

"How's the run?"

"Good so far. Running good for size too — all two pound fish, eh?'

"Got to dock you for those Jumbos!" (Extra big whitefish — from five to ten pounds).

"Aw — hell . . . Giddap you!"

The team wheels. The caboose lurches down the bank out onto the lake again — is lost in the haze.

Another team approaching — dimly lit, smoke billowing bright in the moonlight.

Squeak and thump, grinding screech of ice-blocks; tapping of hampers; tearing of paper; dry scratching of scoop shovel, voices — "seven whites, three yellows" — "O.K.! That's your load." Exhaust fumes, pencils scratching on pads.

Daylight begins. The pale yellow wash grows in the eastern sky. The cold strengthens. Sun's early rays touch the lake fog with gold and pink.

Full daylight. The last caboose crunches away, horses eager for hay and oats. The ice crusher stops — men yawn, shiver. They turn to their breakfast. Fish run best from dusk to dawn, and all hands will put their feet up.

I return to my office. Click — click — clumsy fingers hit the keys and the paper rolls up. Figures, more figures. Catch last night,

twenty thousand pounds; total catch so far, fifty five thousand pounds. File the report. Coffee. Bacon. A smoke and now I can at last stretch out for a bit.

I HAD A LOT OF LAND WORK TO DO NEXT SUMMER. Some of the required investigations had to do with the use and sale of School Lands (sections 11 and 29 in each township). The old Department of the Interior had been lax. I was astonished to find many school sections fenced and stocked with cattle without a grazing lease from the government, and more so by finding lands which had been purchased at the School Lands Auctions of 1909 and 1919 on which nothing had been paid since the initial payment.

In one case a French-Canadian of limited education (but extremely shrewd) had been taking good crops off a school section for thirteen years and pocketing the proceeds. I required him to sign a lease-purchase whereby he had to deliver one-fifth of the grain to his local elevator in the name of the Department. I, myself, drew this up, and for my own protection I took an interpreter, although the farmer spoke English perfectly well.

When fall came the Department informed me that no grain had been delivered. I found he had taken all his grain to different towns and cashed the grain cheques.

My instructions were to take civil action. The case was heard by the late Judge Bence, and the significance of what he said I have never forgotten.

The defence lawyer (Stan Mighton) had pleaded that his client had no education and could not understand his responsibility to the Department; that he was hard up, known as a good worker and provider, and that in addition he had nine children. He asked for dismissal on those grounds and promised the court that thereafter

the terms of the lease would be adhered to.

His Honour then addressed the court in the following words: "It is necessary to remember that we must never presume to know what is in a man's mind, nor that a man is honest or dishonest by virtue of his circumstances. Let me go further and say, that because a man is well educated, successful — rich, if you like — we must not therefore presume that he is unfair, heartless, or dishonest. We must never presume that he uses his wealth, his power, or his education as a cloak for dishonest dealings — even though he may be a childless bachelor!

"Contrarywise, we must not presume that another man who is unlettered, hard working, the father of a numerous family, is therefore honest and straightforward; notwithstanding that in such a case public sentiment will be on his side, as it would seldom be on the side of the well-to-do.

"We have heard of a number of 'mistakes' made by the defendant; mistakes which learned Counsel now explains are the result of ignorance of the terms of the lease.

"If the defendant was so ignorant, surely at least *one* mistake might have been made in favour of the lessor. We find, however, that they were all in favour of the lessee, that is to say, himself."

The court was lenient with this man. No one knew better that His Honour how difficult the economic struggle then was, and what raising a large family involved. Generally speaking, French-Canadian farmers are noted for their honesty and, in this case, the Court mentioned this fact.

I did not enjoy this work.

At that time the drought in Southern Saskatchewan was at its height, and many farmers had abandoned their holdings and were travelling north with trucks or horses (mostly horses) to look

for new locations in the bush-lands. In addition, the municipal authorities were sending many relief families from Saskatoon to the south side of the Meadow Lake forest, lands where my Indian friends had been wont to trap and hunt.

As mentioned previously, I had, as a boy, been interested in veterinary work and had learnt to operate on poultry. Later, as a ranch hand, I had learnt to alter bull calves, assist at calving and lambing, and use a hypodermic needle. I was therefore quite often asked by settlers from Saskatoon (city types) to lend them a hand with such chores.

I wasted no time on these occasions; it was simply that if I stopped somewhere to feed my horse I might be asked, and I did these little jobs in the noon hour.

On one patrol I ran into a Métis, Joe Maresty, the same at whose stopping house on Rabbit River Leland and I had eaten moose meat on our way to Meadow Lake. I was at Vic Anderson's trading post on the Boggy Creek road when he rode up.

Joe had brought some good furs in and he regaled me with tales of the doings of the local beauties, the Pichet girls, now both happily married. Joe was a kind-hearted man and an honest one, but how he loved a horse trade. He had with him a young horse, but it was a bag of bones and stunk something awful as the result of a wicked looking fistula on its withers. He had been ridden right to Cochin a few weeks before by Joe's son. The lad was using an old saddle with a broken tree and this meant that the fork bore down on the animal's withers with all the rider's weight.

This horse, with much cajolery, Joe now tried to trade to me for my own grain fed buckskin with his glossy coat.

"By gar 'ees liddle bit t'in, mebbe so. But is mos' fine cheval, my fren'. I can take yo' poor horse for trade no? You betcha plen' please, no?"

I said, "Nothing doing," and pointed to the big scabbed up sore, which was oozing matter on the swollen and fevered withers.

"I'll tell you what I will do," I said. "I'll fix that fistula for you."

Joe stared. "How you do that?"

"With a knife," I said. Joe shook his head.

"She's plenty sore, that place," he said. "She's mebbe-so no heal over. I try by damn for heal him over — now you say knife? Sapree!" and Joe spat.

"O.K." I said, "It's been done lots of times," and turned away. Joe caught my elbow.

"Mebbe, by gar, you got somting. Dat cheval she's look like die — so wat's matter?"

"Got a real sharp knife?" I asked, "Long blade?"

He produced a six inch narrow steel. "Just the thing," I said. "Now Joe, put a twitch on his nibs and hang on. This will hurt a bit. Wait, let's put him in Vic's single stall so we can stop him rearing up or backing out. And Vic, bring a couple of lengths of lamp wick will you?"

We soon had the horse in stocks and I took off my coat. One good aim and a thrust to the hilt of the knife, which entered eight inches below the withers to travel upward at a sharp angle. The animal grunted with pain and rolled his eyes. I withdrew the blade and out gushed a green and yellow mass. The same on the other side and nothing remained to do but push up the lengths of lamp wicks for drainage.

You could feel the tense muscles of the horse relax and you could sense the relief from pain which resulted.

"O.K. Joe," I said, "Wash him twice a day with a little salt and baking soda in warm water, and keep those drains open for a bit and he'll be all right. And say, Joe, throw that damned broken-back

saddle in Beaver River and get a good blanket from Vic here to pad the new one. That's too good a horse to have as a cripple."

"By gar, me," said Joe, "I'm goin' get this horse fat and trade him to for somebody for sure. W'at I owe you?"

"Not a thing, Joe. This isn't my job; just do something for me sometime."

"Mebbe catch beaver so you can pinch, eh? Not me, my friend; and say — why you don't quit this bizness and settle down some nice place for what you call Vet, eh?"

So many different kinds of people! So many different ways of handling them.

A Chinese, a Negro, a Jew — all these need to be understood for they have different backgrounds. The Jew is not mean; he simply loves to haggle, like any bazaar-man. The Negro has a complex as a result of years of slavery. He is hurt before he is hit. And if, as Brett Harte wrote, "for ways that are dark the heathen Chinee is peculiar," yet for downright honesty they are the peers of the human race — at least in Canada.

The following incidents will illustrate what I mean.

WARMED UP AT THE BARN OFFICE STOVE, I walked into Segal's office to see the fur records books. Up came the old gentleman:

"Officer! Officer! What are you not gefroze hein?' he exclaimed, "to be out on such a winter day! Just, I say to my wife, 'That good man someday he go for his death ride, oi!' It too bad."

I replied it wasn't as bad as all that. He called for his wife.

"Oi! Mama — gebring it yet that vaistcoat you make," then, turning to me, "Mama has the goodest hand yet for stitching something and she say to me, Isaac, I'm going to stitch it yet a red coat for keep it warm that poor man w'at comes already on the horse to see the fur'rs."

Mama came up, broad of beam, black hair decently smoothed back, a brooch at the throat and said: "See it here already," and opened out a waistcoat of thick red flannel; "it makes yet that pneumonia for such times to be in the outside. I make for you; I say to my husband Isaac, maybe for dying the goot officer will be. I know in Poland; already I see. We don't want that you die officer."

Such ready and simple good-heartedness was not be repulsed. I had sworn never to take a bribe, which in my dictionary, and in this work, meant a present, but I took the jacket and wore it on many a cold patrol when the stars winked down and the aurora tripped overhead.

I had travelled far that day and had made a great number of inspections and visits, and I needed a room, so I went to my friend Lee who kept a small café with rooms above.

"Sure I got loom, number eight vacant — you go up. I make somet'ing to eat. What you like? Mebbe plie and cloffie?" I said "thanks" and went up to wash, spilling rain water from the cracked pitcher into the big basin with red roses painted on it. The room looked clean and the bed invited rest, but there was no lock or bolt on the door, and here I was with something like four thousand dollars in my wallet — all Government money and no chance to bank it till ten o'clock next morning. "Well," I thought, "I'll see what Lee can do," because I wanted to make an early start next morning to Macklin, and I figured I could get there as soon as the bank opened. I dealt a good deal in Macklin, for I was there often.

But Lee said, "No kley — no lock — you put chair." So that was that. As I undressed I heard drunken footsteps in the corridor, and then two men talking in the next room.

Chinese flophouses don't always attract the best clientele, and so as a double precaution, I not only hauled a chest of drawers

against the door, but also put my wallet under the bottom sheet.

Lee called me bright and early. I shaved, breakfasted, and started the car and in an hour was half way to Macklin, and then I remembered my wallet! Turn back? Not much object in that. Lee would have made the bed by now. In a pretty good sweat I pushed on to Macklin. The bank had just opened and I rushed in, but before I could open my mouth the cashier spotted me, saying, "There's a phone message for you Mr. Symons — here," and he handed me a slip on which he had taken down a message from Lee to say he had found my wallet and was sending it to Macklin on the next post.

I nearly kissed the cashier! True enough, my wallet got there on the evening train and all was well. Lee had not even taken out the amount the telephone call and the express cost him. I made that good as soon as possible. I also made sure nothing like that happened again!

Then there was the time I visited a Negro settlement to persuade them to apply for title to their homesteads. They had put this off, for only land under deed was taxable.

The municipal secretary predicted trouble. I came to the first home and was met by a shirt-sleeved Negro. I told him my errand. He suggested we go to Gramma's.

"Ah hear you, young man," she said when I told my errand. "You done had your say. Now we see what de Lawd say." She raised her voice. "Sally, you go brung the Good Book."

One of the young women got up quickly and disappeared, to return presently with the most enormous Bible I have ever seen. I am sure it was two feet across. She laid it on the old lady's lap, half supporting it, and the old lady closed her eyes and turned her face upwards, with the second finger of her right hand held straight up.

"Open it then, child," she said, and the young woman flipped

it open at random, whereupon the finger descended like a bird's bill in the middle of one of the pages. "Read it then, child," she said; and the young woman, who must have had some schooling, screwed her head around and read out slowly:

"But he taxed the land to give the money according to the commandment of Pharaoh."

And with that the old lady looked up again and said, "Praise de Lawd." And since everybody answered "Amen," I did too, because you felt you were in church; and so we were in a way, because just then the old lady said, "Take de book away, child," and stood up. "I'se goin' to pray," she said in a very stern voice; and we all bowed our heads while she said: "Lawd, we gwine do what's right. We gwine do what your blessed word says. Amen."

Turning to me, she said, "You go ahead, young man. Make out dem papers."

It took me over two hours to make out the individual applications, my part-Cherokee friend marshalling up the applicants one by one with military precision. However, it was finally done; all the applications were duly signed and sworn to. But I had noticed one young woman sitting by herself in a corner of the room, nursing a baby and with a child of two or three clinging to her skirts. She had not come forward to what we might call the numbering, so I said to my worthy lieutenant, Henry Clay, "Who is the woman in the corner? Where does she come in?"

"Well," he replied, "I guess Andrew Jackson will have to speak for himself," and more eyes rolled. Andrew Jackson slow shuffled up to the table, looking as if he felt himself to be the black sheep of the family.

"Well," I said, "I'm sorry to be so personal, but the department does want to know everybody's name here. Can you tell me who

the young widow is?"

"Ah allow that-un ain't no widow," he replied. "She is my daughter, only you see she ain't got around to getting a husband yet, but she done have two spanking babies." Which remark seemed to make everybody happy, and they all rolled their eyes toward the young woman, who rolled hers in reply and smiled down proudly to the baby at her breast."

By 1935 I had over a hundred plates of birds completed, and had finished the manuscript of *Bird Life of Saskatchewan*. After getting a recommendation from the Department of Education and the Fish and Game League, of which Judge Bence was president, I submitted the whole thing to the Ryerson Press. Their representative, Mr. Gilbert Patterson, was most anxious it be accepted, and was kind to me in every way. However, three difficulties stood in the way of publication.

One was that colour plates are expensive to print. Another was that few people in the West bought books. The third was that with the general depression, even those who might buy were short of money.

There is still a hangover of not "spending money" on books. For the young, baseball bats or skates are still considered more appropriate. If you must have books, get them for free reading. At that time the government travelling library distributed the works of Ethel M. Dell, John Fox, Jr., and Harold Bell Wright. The best were those of Gene Stratton Porter, Zane Grey, and Nellie McClung.

Therefore, the whole matter of my bird book fell through, and the manuscript and painting remained in a drawer for many years. In 1935 Mussolini's bullying of Abyssinia exploded into war against that innocent and hitherto impenetrable country. Britain

appeared to be taking a strong stand, while here in Canada feeling ran equally high. All Militia Officers were notified to stand by. I, being then a Lieutenant of the Saskatchewan Mounted Rifles, immediately reported to my colonel. But the excitement was short-lived, the infamous Hoare-Laval treaty virtually betrayed Abyssinia — or Ethiopia, as it began to be called — and paved the way for rise of dictators in Europe.

The domestic situation had by now become almost intolerable. My wife and I lived in a state of mutual frustration that threatened the whole family. More and more she drew into herself, took less and less interest in the house or in neighbours, and was given to long periods of depression and recriminations, while some of her flights of fancy really alarmed me for her own safety and mine.

The children were becoming upset and nervous. Robert, the eldest (now going to school), became increasingly quarrelsome both in and out of the house. James took more to playing by himself, and Hugh seemed shy and listless. I always read to them and played with them when I was home, and for those short times we seemed close knit and loving, but their mother never joined in these activities. She had not (I knew) wanted the last child, and perhaps not the others. And by now it was not hard to see that she probably never had understood marriage as a sharing thing, and assuming of responsibility; but rather as a release from it.

In 1935 we parted, with the baby but one year old. It was due to a circumstance in which I was obliged to call a doctor, who told me most earnestly that my wife must have a mental examination. Thus a power beyond my control took over. My wife was taken to a mental institution, in which she was to remain for over a decade, but from which she emerged later to take up residence in a distant province well satisfied with a single state, leaving the problem still unsolved.

Not having sufficient means to pay for her care, I therefore transferred title to the homestead farm to her in custody of the trustee of the estates of the mentally incompetent.

Only then, when the doctors explained, was I at last able to realize the reasons behind the continual upsets, peculiar accusations and often violent demonstrations. I could see now that no matter what I said or did or thought, I was (and had been), up against a situation to which there was absolutely no answer. I was advised by the doctors that the parting should be permanent, and the superintendent, Dr. McNeil, talked to me for a long time in his office, saying I would do well to move the family away and try to rebuild my life so as to make a home for the children. He was aware that I had written to my mother-in-law (who lived in the province and was in comfortable circumstances), but that I had received no answer; nor could I expect any help with the children from my wife's people.

I did mention that it was all very well to say re-build your life; but surely he knew that the only grounds for divorce in Canada was adultery? To which he replied with a shrug and the remark, "There are other ways."

My own chief regret was that I had not taken professional advice earlier, for during the years I had probably (and unwittingly) added fuel to her illness by not understanding that it was an illness. She was a clever woman, of good background; had she not been I would not have fallen in love with her in the first place. She had also been very able to conceal her peculiarities in front of visitors, so that in conversation it was always made to appear that I was the one who was somehow lacking,

These things are not easy to write, and I only do so in order to correct those who really knew nothing of the matter. It is not easy

to say that I now had no wish to see her again, much less try to live with her, yet I could not hate her, the mother of my children, whom I had once loved. As I freely forgive the hurts she inflicted on me, I trust she long since forgave me the stand I took, for I now felt obliged to follow the advice of the experts, which was to completely sever all ties for everybody's sake.

One comfort only I had. Dr. McNeil said, "Do not blame yourself. Do not torture yourself. In a case like hers something like this was bound to happen. No one is at fault. Keep yourself from bitterness or regrets, for you now have the full responsibility of the children. It will be hard for you financially, no doubt. If the cases were reversed, no doubt there would be some government aid forthcoming, but somehow or other the law does not seem to be able to help a man as it can a woman."

All that was 34 years ago, and I remember what I thought: "You must close the book now." Others will have to judge whether I have been wise in reopening it again at this time.

R. D. Symons — Books and Pamphlets

The Broken Snare: The Story of a Frontier Family. Toronto: Doubleday Canada Ltd., 1970.

Early Building in Saskatchewan. Introduction and Drawings by R. D. Symons. Regina: Norman Mackenzie Art Gallery, 1967.

The First People: An Artist's Reconstruction of Five Native Canadian Cultures (by R. D. Symons and Lee. R. Updike) Saskatoon: Western Producer Prairie Books, 1978.

Grandfather Symons' Homestead Book. Saskatoon: Western Producer Prairie Books, 1981.

Grouse and Introduced Game Birds of Saskatchewan. Regina: The Saskatchewan Museum of Natural History, Popular Series #5, 15 pp., 1963.

Hours and the Birds — A Saskatchewan Record. Toronto: University of Toronto Press, 1967.

Many Patrols: Reminiscences of a Game Officer. Regina: Coteau Books, 1994.

Many Trails. Toronto: Longmans Canada, 1963.

North by West: Two Stories from the Frontier. Toronto: Doubleday Canada Ltd., 1973.

Silton Seasons: From the Diary of a Countryman. Toronto: Doubleday Canada Ltd., 1975.

Some Winter Birds of Saskatchewan. Regina: The Saskatchewan Museum of Natural History, Popular Series #8, 19 pp., 1963.

Still the Wind Blows: A Historical Novel of the Canadian North West, 1860-1916. Saskatoon: Prairie Books, 1971.

Where the Wagon Led: One Man's Memories of the Cowboy's Life in the Old West. Toronto: Doubleday Canada Ltd., 1973 (Reprinted Saskatoon: Fifth House Publishers, 1997).

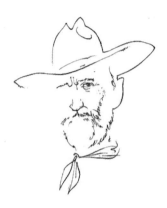

R. D. Symons
(1898 – 1973)

R.D. (Robert David) Symons was a Saskatchewan naturalist well known for his nature writing, paintings, and illustrations. He was also a rancher and game warden.

Born in England in 1898, Symons was the son of the English painter and professional illustrator, William Christian Symons. He migrated to Canada as a teenager and served in WW I. After the war, he worked as a cowboy and a game warden in Saskatchewan and subsequently ranched in the Peace River region of British Columbia.

As a game officer or warden, he worked in the Battlefords area and later in the Cypress Hills. During his career he managed to uphold the law while at the same time remaining fair to all people with whom he was in contact. He recognized the conditions and living situations of First Nations and Métis peoples on the many reserves in these areas, as well as the importance of treaty rights. However, preservation of wildlife was his priority. Visiting schools to educate children about conservation was also part of his responsibility.

In 1942, Symons was appointed a game warden with the Government of British Columbia and settled on a Northern British Columbia homestead in 1945, returning to Regina in the winter months to paint.

Rich in detail and humour, his stories impart a deep respect and understanding for an environment that is at once frightening and fragile. He retired to Silton, Saskatchewan, in 1961, where he continued to lecture on natural history, paint, and write.

Symons produced a number of books — both fiction and reminiscence — in the tradition of English nature writing. Many of his books are cherished as classics. *Where the Wagon Led*, originally published in 1973, offers a vivid personal account of life on the Canadian prairies before the land was settled for farming. Rich in detail and humour, his stories impart a deep respect and understanding for an environment that is at once frightening and fragile. His lush and graphic descriptions of blizzards, storms, drought, and other environmental hazards, of the many horses he knew and loved, and of the cowboy's creature comforts, such as a breakfast of hotcakes, bacon, biscuits, and syrup before a hard day's work, immerse us in a world long past.

As an artist, he worked primarily on paper, frequently in watercolours, drawing upon direct observation and a prodigious visual memory. Starting in 1951, Symons created many of the dioramas for the habitat exhibits at Regina's Royal Saskatchewan Museum of Natural History.

In 1965, Symons was awarded the Saskatchewan Conservation Medal. In 1970, he was awarded an honourary degree from the University of Regina. He died at Silton in 1973, leaving behind a substantive legacy as a naturalist, author, and artist.

(Courtesy of the Saskatchewan Eco-Network)